THE BEST OF STEAM

RAILWAYS OF THE WORLD IN PHOTOGRAPHS

KEITH STRICKLAND

The
History
Press

To Mary

who says she's been to some amazing places because of steam

Also by Keith Strickland:

Robert Gillo's Somerset
Steam Railways Around The World
Steam Through Five Continents
Worldwide Steam Railways
In Search Of Steam

Title page: France, July 1998.
Front cover: Peru, December 1981.
Back cover: Finland, July 2013.

First published 2015

The History Press
The Mill, Brimscombe Port
Stroud, Gloucestershire, GL5 2QG
www.thehistorypress.co.uk

British Library Cataloguing in Publication Data.
A catalogue record for this book is available from the British Library.

ISBN 978 0 7524 9939 0

Typesetting and origination by The History Press
Printed in China

Contents

Foreword
by Sir Mark Tully

I often wonder how much my love of steam is due to nostalgia. I belong to the generation who went to boarding schools in trains pulled by steam engines. First there were the gallant little engines of the Darjeeling Himalayan Railway which climbed to Ghoom, turned the corner and, if we were lucky, gave us a view of Kanchenjunga, then slid downhill into the famous tea town itself. When I returned to Britain there came what always seemed to me the oddly encased Merchant Navy and West Country locomotives of Britain's Southern Railway. Finally there were the handsome Kings and Castles of God's Own Railway, the GWR. But my favourites were the magnificent LMS Duchesses and the rebuilt Royal Scots which hauled the trains that started my journey to school. The start was Crewe. How could anyone who knew that Mecca of Britain's railways of the fifties not love steam? But now we, who had the privilege of living in the last days of steam, and felt the pain of watching it fade away, are fading away too. So it's particularly important that records of our times are kept and that is exactly what Keith has done.

This book is not just a record of British steam but of steam in many different countries. Though, as Keith says, the emphasis of the book is on 'real' steam railways (i.e. non-heritage, non-museum operations), his interest in railway heritage is evident. As Vice-President of the Indian Steam Railway Society, I would be the last person to decry heritage railways and museums. Without them, how will post-steam generations become enchanted by those engines, which have often been described as the most human of machines? There was a real danger that the entire stock of Indian steam engines would have been scrapped if it hadn't been for the heritage movement. Today's steam enthusiasts in Britain still get the chance from time to time to marvel at steam running on railways which are fully operational. Visitors to India can ride behind the world's oldest operating steam engine, the *Fairy Queen*, running from Delhi to Alwar on the mainline which goes onto Jaipur and Ahmedabad. Were it not for the heritage movement there would be no *Fairy Queen* and no preserved British locomotives. But with all its achievements, the heritage movement can't replicate the days when railways were entirely or mainly operated by steam. That is why Keith's amazing collection, amassed over forty years, is so valuable. It's not just a visual record of steam trains and the people and places associated with them. With the disappearance of steam on 'real' railways to the point of near extinction, it's also an historical archive.

A steam engine is a steam engine but they come in many sizes and shapes, as did the carriages they pulled. Trains nowadays are becoming more and more like motorcars in that they all tend to look the same. Their interiors are designed for air not rail travel. Not only are passengers denied the wonderful experience of an open window, they all too often don't get a proper view through a closed window. Modern railway management theory dictates that as many passengers as possible must be crammed into each carriage, even though that means many of them will have their views wholly or partially blocked out by the bodywork. No effort is made, except on special tourist trains, to make a railway journey an experience.

Keith documents the variety of the steam era. There is the striking difference between the locomotives he describes as having 'untidy exposed ironmongery' and the neat, svelte lines of my favourites LMS Duchesses and the WPs which hauled the transcontinental Indian expresses. He notes the variety of signalling, including the semaphore signals of the GWR – always one to be different – which dropped down rather than rising when the line was clear. There are the quaint operations now ruled out as too costly. Keith mentions

the trains making their way along Weymouth quay to the Channel Islands boat. I remember my excitement at seeing the Irish ferry berthed alongside the *Irish Mail* in Holyhead station. Keith says 'one doesn't often bother to photo station manoeuvres' but I loved marshalling yards with their variety of freight wagons, and the mystery of how the right wagon got joined to the right train. I was recently told by a senior Indian railway officer that marshalling yards would have survived if containers had come in a little earlier. Even the variety of food which used to be served in steam days is diminished today by the disappearance of dining cars on so many railways.

But for all the romance of steam which Keith documents, we have to be realists. A 'real' railway lover, and I have the temerity to count myself as one, acknowledges that the system of travel which means so much to us would have been knocked out by the car, the lorry, and the aeroplane if we hadn't progressed beyond steam. So we rejoice that China has expanded its railway system so dramatically with its high-speed trains, and that India is building a new rail freight corridor linking its great cities and so is clearing the existing tracks for faster passenger runs. In Britain more and more people are taking the train, and even America, the country which misled many other countries to believe that roads did away with the need for trains, is now regretting the neglect of its railways. But, of course, that doesn't mean that we 'real' railway lovers do not salute those who like Keith and others have done so much to keep the memories of steam alive and to document the time when it was still active on the 'real' railway scene. Keith has produced a fascinating book which deserves a wide audience, especially as the royalties are being donated to Railway Children, a UK-based charity which seeks to help street children who find themselves homeless in places such as railway stations.

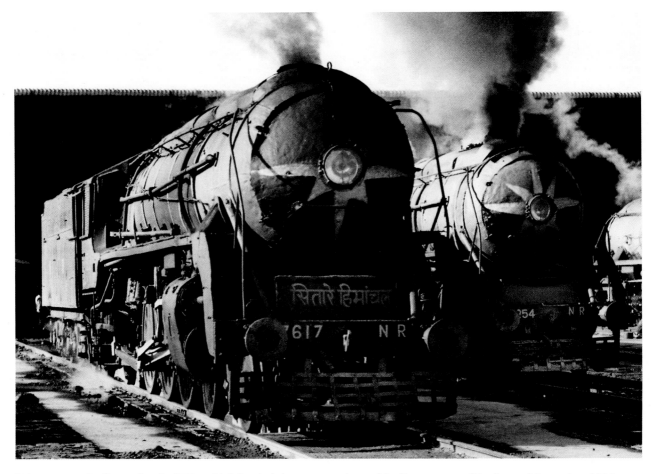

'The neat, svelte lines of ... the WPs which hauled the transcontinental Indian expresses.' Lucknow, November 1985.

Introduction

'To let a steam locomotive die is to let history die.' (Anon)

The genesis of this book was the realisation that 2014 marked the fortieth anniversary of my first foray abroad in search of steam trains. How that initial trip came about has been explained in previous books. Suffice to say that the impulse purchase of a second-hand album featuring European steam rekindled an interest which had disappeared in the mid-1960s when attention was taken up with university – and a girlfriend, now my wife.

That first overseas visit in February 1974 took the form of a long weekend in Austria where the State railways still used steam locos on some secondary routes and a handful of narrow-gauge lines. Thinking that the trip would be a one-off, it didn't occur to me for one minute that a boyhood pastime would turn into a serious hobby. Neither did I foresee an interest in photography. To start with I had no more than a snapshot camera. Only later did I acquire more sophisticated kit and set up a darkroom. It was some years later still before any of my work appeared in print.

This book looks back over those forty years. With, at a conservative estimate, 15,000 to 20,000 images to choose from, deciding which to include has not been easy. In the end I have concentrated on areas of the world (or, as in the final chapter, individual places) which have been personal favourites. The emphasis is on 'real' steam railways, i.e. non-heritage, non-museum operations. That's because the original reason for travelling had been to see as much as possible of the world's workaday steam before it was gone for good. However, I've a soft spot for the French preservation scene and it will become obvious where my sympathies are at home.

My first two books were published in the early 1990s. They've long been out of print. Some photographs from them make a reappearance here by virtue of the subject interest or accompanying story. Apart from a few other pictures which have been used in magazines, all of the remaining images have hitherto been unpublished.

The text attempts to convey something of my impressions and experiences, though descriptive prose does not come easily to an ex-bureaucrat. As in previously published works of mine, I have given some technical details about the locomotives (e.g. when built and by whom) where they may be of interest to the enthusiast. Having been fortunate to enjoy forty years of world steam, I hope this book will convey a measure of that enjoyment to the reader, whether a hard-core steam fan or an armchair traveller. For, as Flanders and Swann put it: 'if God had intended us to fly He would never have given us the railways.'

Keith Strickland
Great Hinton
Wiltshire
2015

1. Prelude

Let's start with the no. 1. In my train-spotting days the lowest-numbered British Railways steam locomotive was no. 7 on the Welsh narrow-gauge Vale of Rheidol line, so it's been fun to find locomotives carrying no. 1 in other parts of the world. A visit to Zimbabwe in July 1989 included the private railway system at Wankie colliery. Its no. 1 was a 4-8-2 built by the North British Locomotive Company, Glasgow, in 1955.

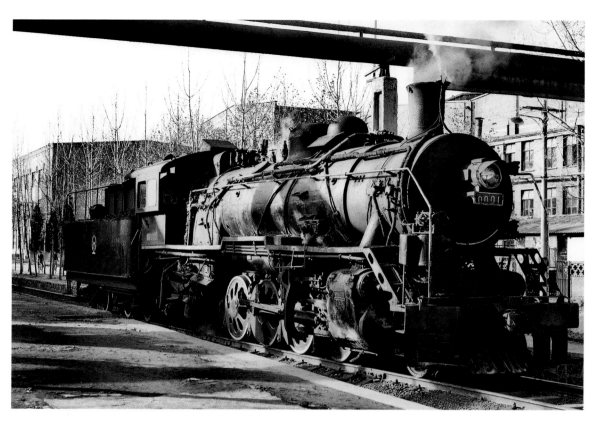

No. 0001 (above) was photographed in an industrial setting at Taiyuan, China, in November 1982. She was a 2-8-2 of the SY class, of which some 1,800 locos were built from the 1960s right up to the end of the twentieth century. In complete contrast, metre-gauge no. 1 (below) of 1906 vintage departed from St Valery in July 1998 with a train on the Chemin de Fer de la Baie de Somme in northern France.

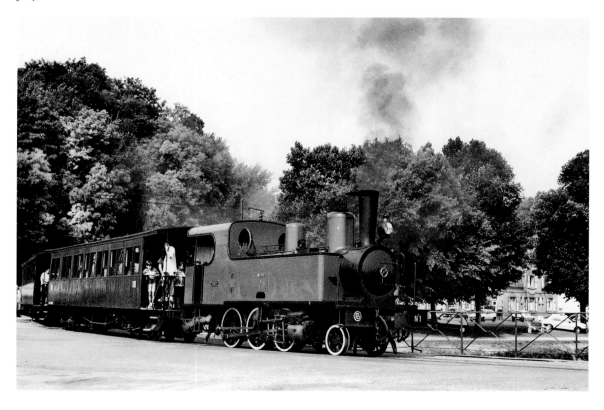

2. Home and Abroad

My first trip overseas to experience the thrill of steam on workaday railways was in February 1974. At the time I wasn't convinced that foreign steam would be much of a turn-on. It was hard to see how black locos with untidy exposed ironmongery could match the appeal of a Castle, a Duchess or even a Bulleid Pacific. That first trip was therefore something of a taster. 'Just once, to see what it's like,' I said to my wife.

It's often said that beauty is in the eye of the beholder; and so it proved to be. There's a ruggedness about continental steam which has an attraction all of its own. Moreover, it was all too easy to succumb once more to the sights, sounds and smells of steam. Add the frisson of a foreign setting and I was well and truly hooked.

What of that first trip? Based in Vienna for a long weekend, we started with an evening commuter train. To ride on the open balcony of the carriages as the mighty 4-6-2 tank loco thundered away from station stops, flinging sparks into the darkness, was a thrilling introduction. I kept the ticket as a memento.

```
01.02.74
Personenzug
Erm. Rückfahrkarte
Praterstern (1)

Von Süßenbrunn nach
Gänserndorf

H Gültig 4 Tage R

2KI S ≡ 25,00
          25,00
ER 1914
19 km   Praterstern 1
". Süßenbr. n. Gänserndf.
      2200
```

28 b ... 322

28 b Garsten—Klaus — Schmalspurbahn

Alle Züge 2. Klasse

3661	3663	3665	3667	3669	3671	3673	3675	km	ÖBBDion Linz	3660	3662	3664	3666	3668	3670	3672
5.37	-6.10	7.52	10.58	13.15	14.57	17.13	18.21	0	ab Garsten 28a an	5.56	7.42	9.53	13.05	16.14	17.57	20.17
5.41	6.14	7.56	11.02	13.19	15.01	17.17	18.25	1	Sarning Hu	5.52	7.38	9.49	13.01	16.11	17.54	20.14
5.47	6.19	8.01	11.07	13.24	15.06	17.22	18.30	2	Steyr Lokalb	5.48	7.34	9.45	12.57	16.06	17.49	20.09
5.50	6.23	8.05	11.11	13.27	15.10	17.26	18.34	2	Unterhimmel-Christkindl Hu	5.39	7.29	9.40	12.53	16.02	17.45	20.05
5.55	6.27	8.09	11.15	13.31	15.14	17.30	18.38	3	Schloß Rosenegg Hu	5.34	7.25	9.36	12.48	15.53	17.40	20.00
5.59	6.32	8.14	11.20	13.35	15.19	17.35	18.43	5	Pergern Hu	5.29	7.21	9.31	12.44	15.53	17.36	19.56
6.06	6.38	8.21	11.27	13.42	15.26	17.41	18.50	7	Neuzeug Hu	5.23	7.14	9.25	12.37	15.46	17.25	19.49
6.10	6.42	8.24	11.30	13.45	15.29	17.45	18.53	10	Letten Hu	5.19	7.10	9.20	12.33	15.42	17.21	19.45
6.14	6.46	8.28	11.35	13.50	15.39	17.49	18.59	11	Aschach a d Steyr Hu [2] ...	5.14	7.06	9.16	12.29	15.38	17.10	19.41
6.20	an	8.34	11.40	13.55	15.44	17.55	19.04	13	Sommerhubermühle Hu	5.08	6.54	9.09	12.23	15.31	17.10	19.34
6.29		8.43	11.49	14.04	15.53	18.03	19.13	15	Waldneukirchen Hu [2]	5.00	6.46	9.00	12.15	15.23	17.02	19.26
6.33		8.47	11.53	14.07	15.56	18.07	19.18	19	an Grünburg ab	4.56	6.42	8.56	12.11	15.19	16.58	19.22
								20								

3661		3665	3667					km		3662	3680	3664	3666				
6.40	...	8.55	12.15	14.08	15.57	18.08	19.24	20	ab Grünburg an	4.55	6.35	7.20	8.50	12.08	15.19	16.58	19.22
6.45		9.00	12.20	14.15	16.04	18.16	19.32	23	Unterhaus Hu	4.48	6.30	7.15	8.45	12.03	15.12	16.51	19.15
6.47		9.02	12.22	14.18	16.07	18.19	19.35	24	Haunoldmühle Hu	4.45	6.28	7.13	8.43	12.01	15.09	16.48	19.12
6.53		9.10	12.30	14.30	16.18	18.31	19.48	29	Leonstein Hu	4.33	6.18	7.05	8.35	11.53	14.57	16.37	19.00
6.57		9.14	12.34	14.35	16.23	18.36	19.53	31	an Molln [2] ab	4.28	6.12	7.00	8.31	11.49	14.52	16.32	18.55

		3669	3671	3673				km				3668	3670	3672		
...	...	9.22	14.55	16.30	18.43	...		31	ab Molln an	...	6.03	8.23	11.41	14.49	16.03	18.38
...	...	9.26	14.59	16.34	18.47	...		33	Agonitz Hu	...	5.59	8.19	11.37	14.45	15.59	18.34
...	...	9.30	15.03	16.38	18.51	...		36	Steyrdurchbruch Hu	...	5.55	8.15	11.33	14.41	15.55	18.30
...	...	9.34	15.07	16.42	18.55	...		38	Frauenstein Hu	...	5.51	8.11	11.29	14.37	15.51	18.26
...	...	9.40	15.13	16.48	19.01	...		41	an Klaus ab	...	5.45	8.05	11.23	14.31	15.45	18.20
...	...	11.22	14.29	15.35	...	19.09	...		ab Klaus 29 an	...	5.11	7.05	10.20	13.47	...	18.06
...	...	12.28	15.38	16.40	...	20.04	...		an Selzthal 29 ab	...	3.50	6.00	9.28	12.42	...	17.03
...	...	10.21	13.50	16.16	18.07	19.50	...		ab Klaus 29 an	...	5.37	8.00	11.20	14.26	15.34	...
...	...	11.36	15.34	17.27	19.50	21.31	...		an Linz Hbf 29 ab	...	3.23	6.11	9.44	12.37	14.20	...

Autobus hält in Obergrünburg PA. Hannoldmühle Konsum, Leonstein Gh Pfaffeneder, Agonitz Gh Schoißengeier, Steyrdurchbruch Gh Waghubinger Abzw nach Frauenstein.

Die Kurse 3665, 3667, 3662, 3664 und 3666 halten auch in Molln Postamt

Weitere Haltestellen: Grünburg Gh Plursch, Leonstein Gh Schlader, Agonitz B Engelstorfer

Next day was spent on the Steyrtalbahn, a 760mm gauge railway south of Linz. Opened in the late nineteenth century, it originally comprised a mainline of 25 miles and a branch of 10. By 1974 the branch had gone and the timetable showed that buses were sometimes substituted for trains on sections of the line. However, the mainline connected with standard-gauge routes at both termini and freight trains ran over its full length, timber being the principal cargo.

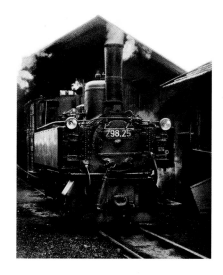

Before taking the 13.15 train from Garsten to Molln there was time to watch the loco being prepared at the sheds and take my very first photograph of overseas steam (left). Built in 1902, no. 298.25 was a 0-6-2 tank. Designated Class U, this was a type commonly found on the Austrian narrow gauge in steam days.

Following complete closure by the Austrian State railways in 1982, a 12-mile section of the mainline was rescued by preservationists and now operates as a heritage railway (see pages 157 and 158). For much of the way, it follows the River Steyr through pleasant countryside. Back in 1974 I hadn't a clue about the art of taking photographs of trains in the landscape and in any case we had no means of getting to the lineside. Moreover, my camera only took snaps. Even with today's digital technology, there's only so much one can do to improve a duff original. I hope it's not immodest to say that, with the right equipment and a good deal of practice, the results have got better over the years, though

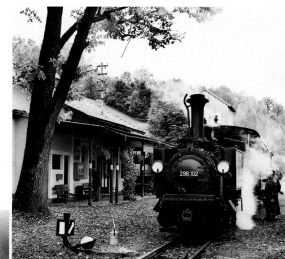

the dank autumnal weather in October 2004 wasn't ideal when sister loco no. 298.53 arrived at Sommerhubermühle with a special train from Steyr to Grünburg (below). On that occasion there were two locos in steam, the other being 0-6-2 no. 298.102 seen at Grünburg (right). Constructed in Linz by Krauss in 1888, she was one of the locos supplied for the opening of the railway.

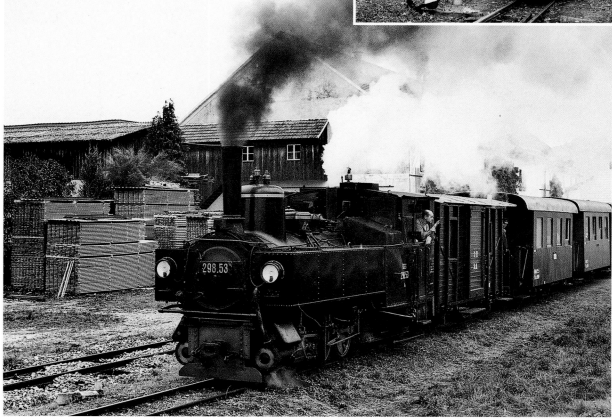

Until its closure in the late 1970s, the star attraction for Austrian steam on the standard gauge was the Erzbergbahn, known to 'gricers' (as railway enthusiasts are known) as the Iron Mountain rack railway. The purpose of this line was to convey iron ore from extensive quarry workings on an open mountainside. From the valley floor at Vordernberg, the limit of the electrified mainline, trains of empty wagons climbed at 1 in 14, with the aid of the rack, to the summit at Präbichl before briefly descending to the mine at Erzberg. With the exception of a railbus and an occasional diesel, the line was 100 per cent steam, the motive power being sturdy 0-6-2 tanks and one massive 0-12-0 tank. As most trains were banked, the sight and sound of trains ascending the rack drew many enthusiasts to what was otherwise an unremarkable Alpine valley. One author has commented that, with the delights of steam and snow, Vordernberg in winter was a place where a careless photographer could fall over, accidentally press the camera's shutter button and still get a great shot. Perhaps, but this assumed the trains were running. The group's 1974 visit was on a Sunday. Two mineral trains came down the rack, one with the 0-12-0 tank in charge, but none went up. We had to console ourselves with a ride on a steam passenger train from Vordernberg to Präbichl. But what a ride! Being the weekend of a local festival, the coaches were packed with families, many in local costume, and skiers going to the summit. After three-quarters of an hour being deafened and exhilarated by the noise of the two tank locos – one at the front, one at the rear – blasting up the hill, we arrived at the top. What an experience. It was definitely worth travelling the best part of 1,000 miles to see.

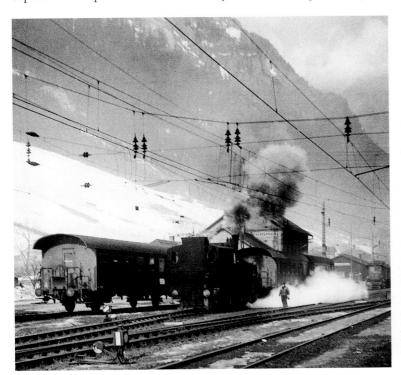 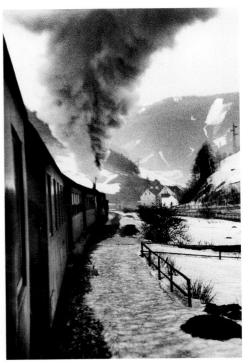

These two photographs were taken with my snap-shot camera and are included here for sentimental reasons, not for artistic merit. On the left, one of the tank locos was marshalling the coaches at Vordernberg for the 12.39 to Präbichl in February 1974. I'd like to say that the shot was deliberately composed so that the figure on the ground was framed by the steam, but I had no such arty aspirations in those days. The picture on the right was taken from the train, at the start of the climb. Already the loco at the front is working flat out. A word about photography from moving trains. Why do it? 99 times out of 100, the results are useless in terms of seeing the loco at the front. The train has to be going around a very sharp curve for any chance of a pleasing shot. That said, a lone and (for me) rare success appears in a later chapter.

There's a postscript to our visit to the Erzbergbahn. The return to Vienna included dinner on an express whose passengers seemed to be well-heeled city dwellers returning from a weekend in the countryside. Imagine their surprise at finding the restaurant car full of less-than-elegant-looking steam buffs and that there were no free tables. The tour guide had had the foresight to book the whole carriage for us. Now that's what I call leadership.

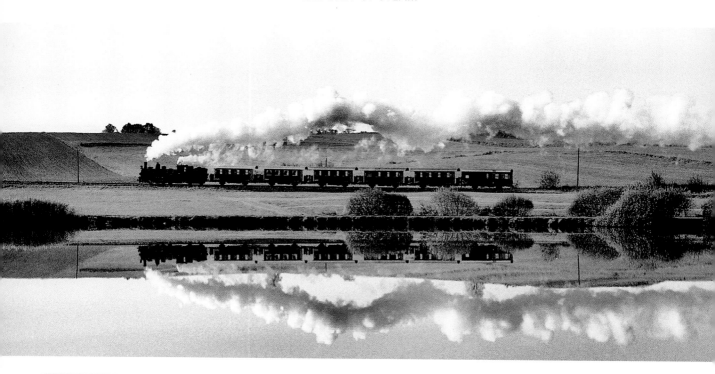

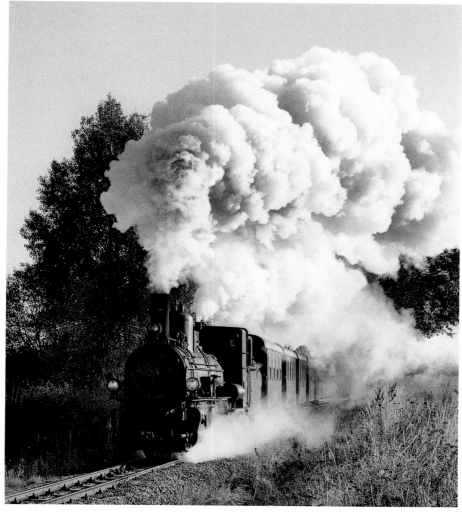

Another Austrian favourite was the Waldivertalbahn, a 760mm gauge system in the north, close to the Czech border with a total route of some 50 miles. Though closed not long after celebrating its centenary in 2000, it was – and perhaps still is – possible to charter steam trains in order to recreate the authentic look of the past. One such train ran in October 2004 and was seen en route from Gmünd to Weitra with no. 399.04 in charge (above and left). A crisp, windless, autumn morning made for pleasing steam effects.

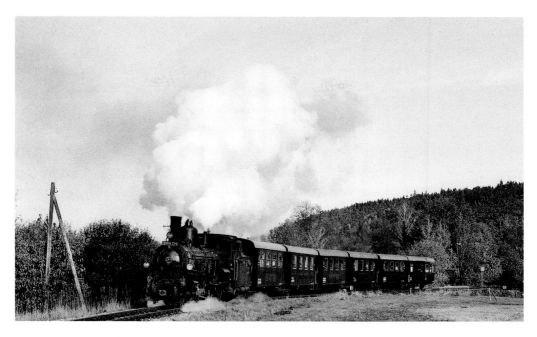

No. 399.04 again. She was about to start the long, twisting climb from Alt Weitra to Weitra.

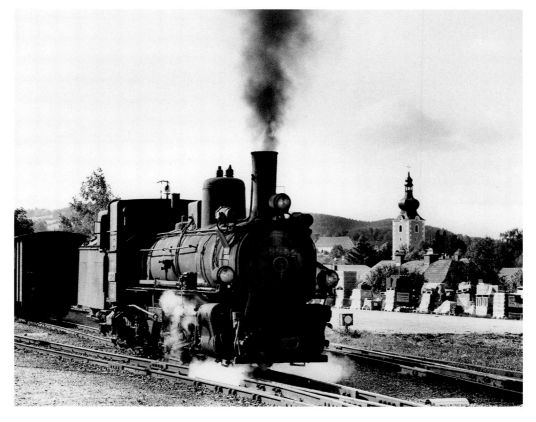

One doesn't often bother to photograph station manoeuvres, but the tower of the local church added interest to the scene as no. 399.02 started to run round its train at the terminus of Groß Gerungs in September 1995. Like no. 399.04, she was built by the Austrian firm of Krauss in the 1900s, and was an 0-8+4 of the Engerth type in which the tender is articulated with the main locomotive frame, thus improving adhesion by the transfer of some of the rear weight on to the driving wheels. This journey was memorable for the coach party which rode some of the way, complete with Oompah band. That there seemed to be a supply of beer on board was no doubt purely coincidental.

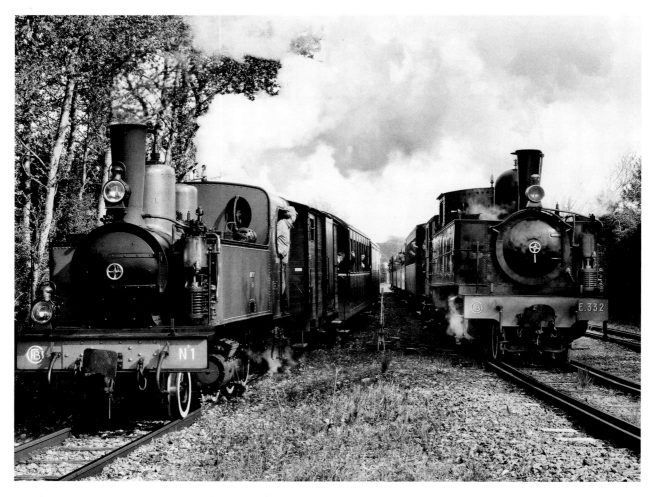

Until passenger services were scrapped on part of the Waldviertelbahn in 1986, it was possible to photograph simultaneous parallel steam departures from the junction at Alt Nagelberg. Sadly I never made it there in time. One place where this side-by-side spectacle can still be seen is in France, which leads me on to two of my favourite heritage railways on the other side of the Channel. Both are remnants of former extensive metre-gauge systems. As its name implies, the Chemin de Fer de la Baie de Somme (CFBS) links towns on either side of the estuary of the River Somme. From Noyelles, where the CFBS meets the State railway's mainline from Boulogne to Amiens, one arm of the CFBS follows the northern side of the estuary to Le Crotoy. Another takes the opposite side to St Valery before striking out across country to the seaside town of Cayeux. Trains from Noyelles are often scheduled to leave at the same time, but during a number of visits, only once have I witnessed a parallel departure with both locomotives working chimney first. In May 2010 trains for Le Crotoy and St Valery – on the left and right respectively – were captured on camera at the point where the two routes diverge. No. 1 is a 2-6-0 tank built by the firm Corpet-Louvet in 1906 and is named *Aisne* after the French *département* in which she originally worked. 4-6-0 tank no. E.332 was constructed three years later by Fives-Lille for the network of metre-gauge lines in Brittany, now sadly long gone, known as the Réseau Breton.

Sharp-eyed readers will note that the tracks on the right are dual-gauge. From Noyelles standard-gauge rails straddle those of the metre gauge as far as the quay at St Valery. In days gone by, this enabled mainline freight wagons to be worked to and from St Valery, thus avoiding the need for goods to be transhipped at Noyelles.

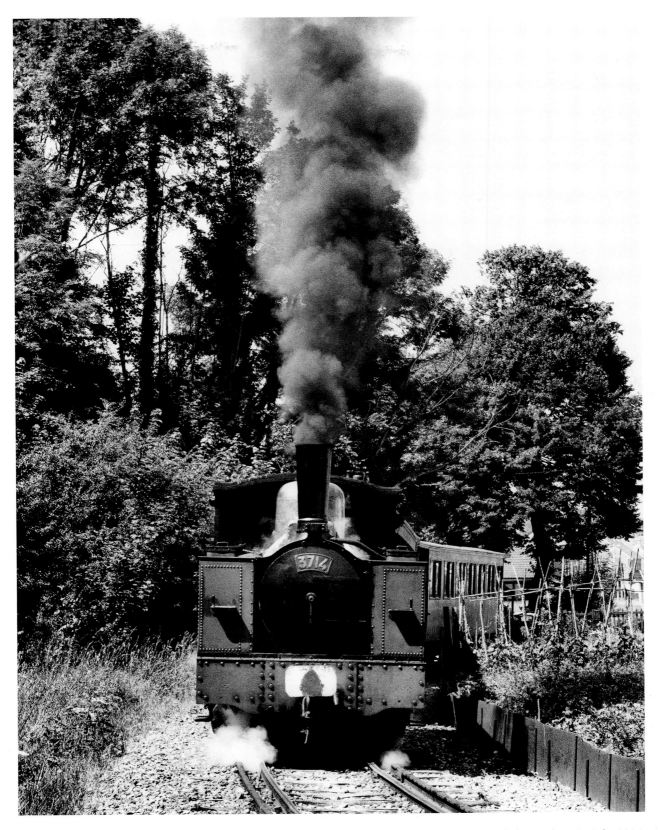

The dual-gauge track is very evident in this photograph of the first train of the day as it left St Valery in July 1984. No. 3714 carried the name *Beton-Bazoches*. She was built by the firm of Buffaud & Robatel in 1909 for a light railway in the *département* of Seine-et-Marne.

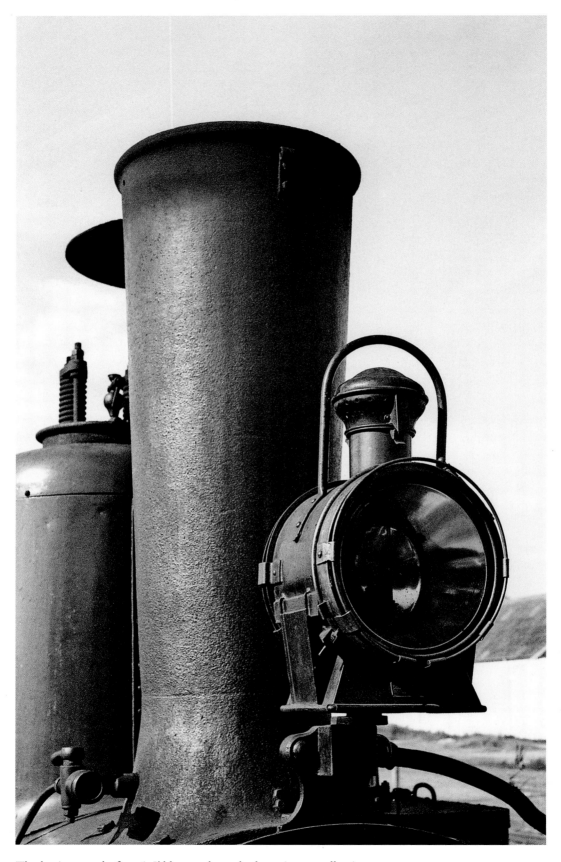

The business end of no. 1. I'd love to have the lamp in my collection.

At the opposite end of France is the Chemin de Fer du Vivarais (CFV), which climbs from the Rhone valley at Tournon through the rugged hilly countryside of the Ardèche to the small town of Lamastre. Part of a once extensive, busy, metre-gauge system which ceased operations in 1968, the CFV became a popular attraction for tourists as well as enthusiasts. However, in the past few years it has had a troubled life and ceased operations for a time. Trains started running again in 2013, though from a new terminus outside Tournon. Access to and from the former station was over a section of mixed-gauge track owned by the French State railways who seemed to resent the narrow-gauge presence and who allegedly charged an exorbitant fee for running rights. Unlike the gauntleted track of the CFBS, the two gauges at Tournon shared a common running rail to one side.

In July 1998, Mallet 0-6-6-0 tank no. 413 left Tournon with a heavy train and was about to enter the mixed-gauge section. Constructed for the Vivarais in 1932 by the Société Alsacienne, she was one of the last metre-gauge steam locos to be built in France.

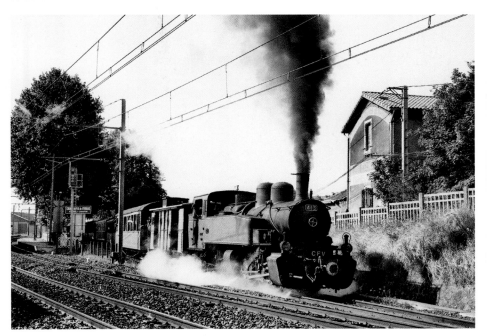

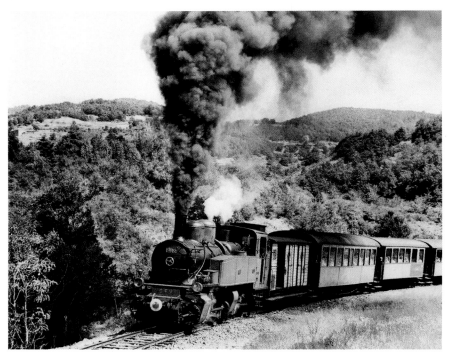

En route to Lamastre, this time in August 1990.

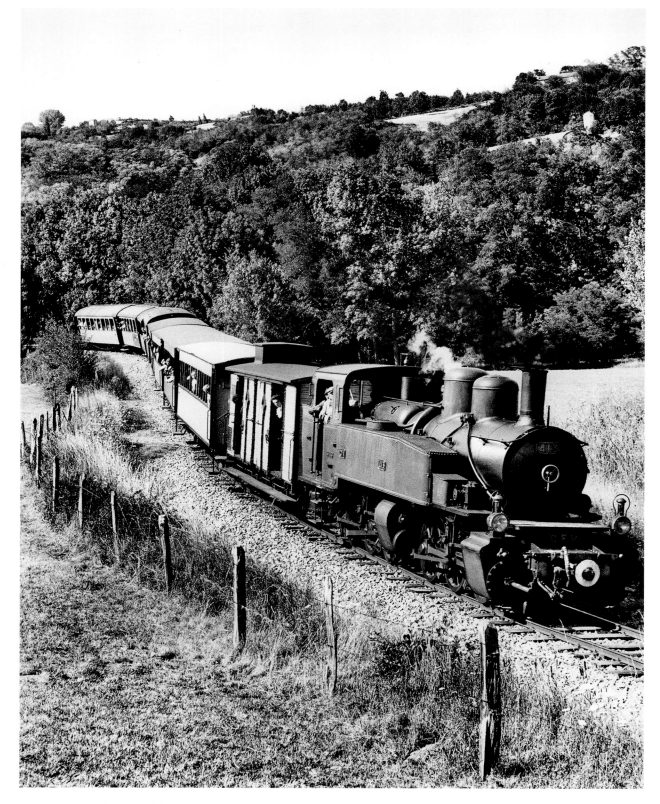

In August 1990 the timetable gave passengers four hours for lunch in Lamastre. In the late afternoon the temperature was still in the 90s (Fahrenheit) as no. 413 returned to Tournon with a well-fed and contented payload. A few days later, I had the pleasure of riding on this loco. During one of the station stops a fellow Brit, who turned out to be a journalist, asked if he could interview me for a holiday programme on BBC radio. Fame at last.

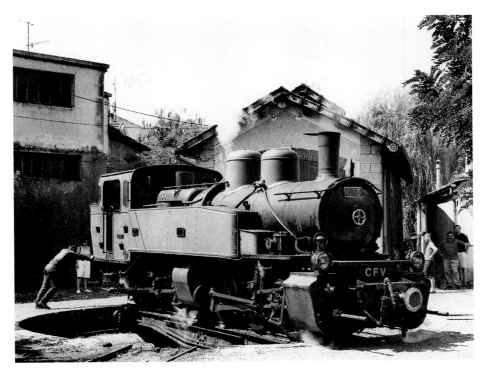

At Lamastre, locos were coaled and turned by hand ready for the return journey in the afternoon. On most days this attracted a few onlookers, as in July 1998.

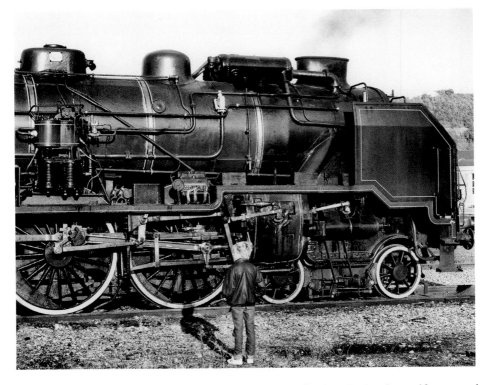

I must include a brief glimpse of the French mainline steam scene. By the time I stirred myself to cross the Channel, the State railways had almost dispensed with steam. Having missed out on the real thing, I made a number of trips in the 1980s for mainline specials – second best, perhaps, but thoroughly enjoyable nevertheless. The French have preserved in working order some magnificent machines, including Pacific no. 231-G-558 which was being serviced at Sotteville depot, Rouen, in October 1986 before returning to Paris.

Asked what drives the search for steam, some might say a subconscious wish to relive one's childhood. Perhaps there's some truth in this. Some of my earliest memories are of being taken by my father to watch trains and, like many boys of my generation, trainspotting was a favourite hobby. One of the joys of the preservation movement in the UK is the ability to conjure images which haven't changed that much since the 1950s and early 1960s. Because my family lived in former Great Western territory, the locomotives of that company's parentage have always been firm favourites and it is pleasing that a goodly number survive.

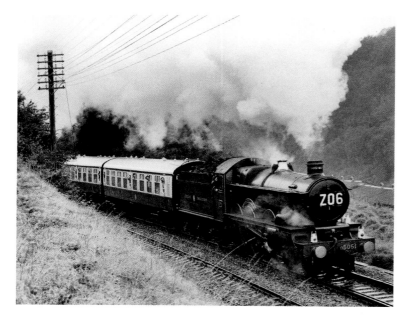

Castle class no. 5051 *Earl Bathurst*, here in the guise of *Dryslwyn Castle*, was making light work of the climb to Sapperton Tunnel with a Gloucester to Swindon train in August 1985, one of the events to mark the 150th anniversary of the GWR. The celebrations became muted when, in a public relations disaster of the first order, British Rail announced its intention to close Swindon Works, the spiritual home of the GW. Rain sweeping across the Cotswolds matched the mood many felt.

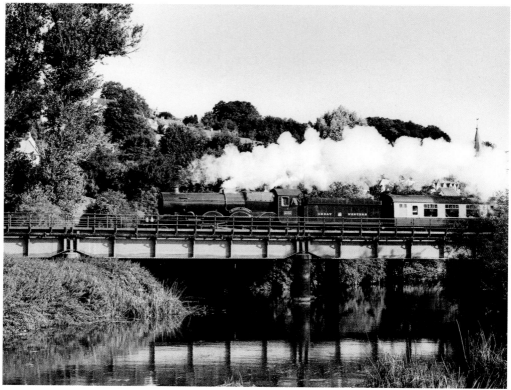

In happier circumstances and more clement weather, no. 5029 *Nunney Castle* was seen at Bradford on Avon in August 1996. White steam normally adds to the pictorial composition, but on this occasion there was too much. As a result, the photogenic buildings on the hillside in the background were mostly obscured. Some photographers are never satisfied.

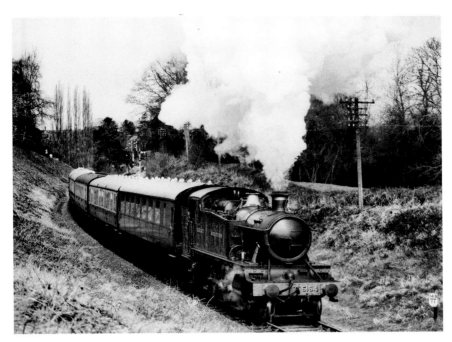

Most of my boyhood trainspotting was in and around Taunton. Being a major station where the mainline to the West Country connected with a number of branch lines, many types of ex-GW locos could been seen, from Kings and Castles at one end of the elegance stakes to humble tank engines at the other. No. 5164, a 2-6-2 tank, was seen leaving Bridgnorth in March 1983 with a train for Bewdley on the Severn Valley Railway. There isn't much evidence to show that this photograph was taken thirty-five years after the railways of Britain were nationalised. The scene has a thoroughly Great Western flavour – engine, coaches, signals and even the milepost.

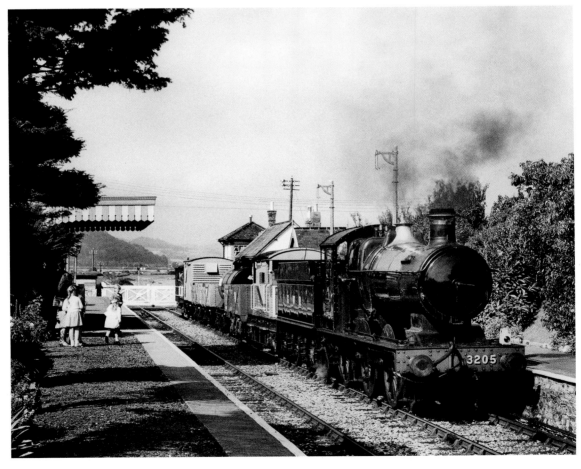

Pick-up goods trains, slowly clanking their way from station to station, collecting the odd wagon here and shedding another there, have completely disappeared from the modern railway. A recreation was photographed in September 1988 at Blue Anchor on the West Somerset Railway (WSR), though I don't recall many of Taunton's locos being in such pristine condition as 0-6-0 no. 3205. Mum and her family were waiting to catch a train to Minehead.

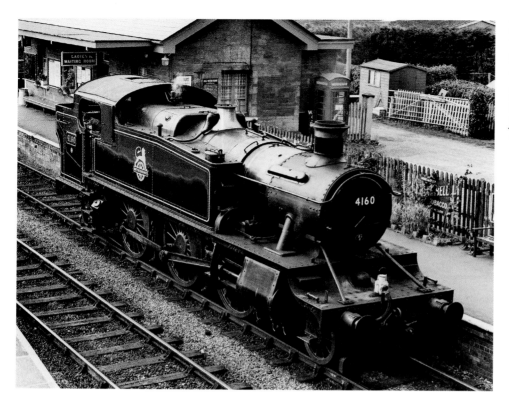

My favourite loco on the WSR, seen at Bishops Lydeard in September 1996. Though of GWR parentage, she was built at Swindon Works in 1948, just after Britain's railways were nationalised.

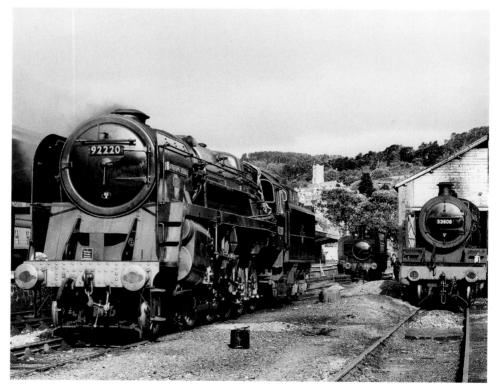

The scene at Minehead in August 1989 stirred more boyhood memories. I well remember a visit with my father to the sheds at Bath towards the end of the 1950s, courtesy of a helpful booking clerk at Green Park station who telephoned ahead to make sure we would have a friendly welcome. By the end of the day, there were lots of 'new' locos in my notebook. The depot was, of course, the principal home of the engines used on the Somerset & Dorset (S&D) line with which two of the locos in this photograph have a connection. No. 53808 (on the right) was one of a class of eleven 2-8-0s built specifically for the S&D. No. 92220 *Evening Star*, the last steam loco built for British Railways, hauled the final *Pines Express* over the S&D in September 1962. In between is no. 6412, a 0-6-0 pannier tank the likes of which could be found all over the former GWR network.

Because the S&D was a single-track line for much of its route, *Evening Star* looked the part as she left Stogumber with a train from Minehead to Bishops Lydeard, on the WSR in August 1989.

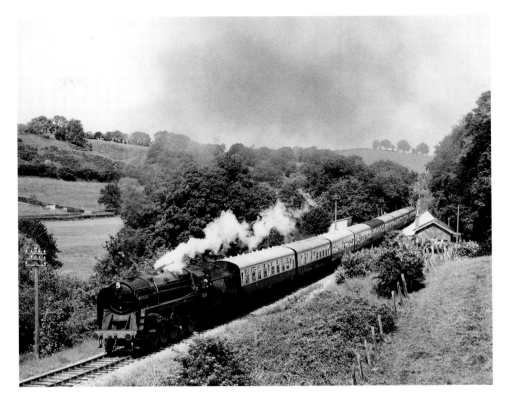

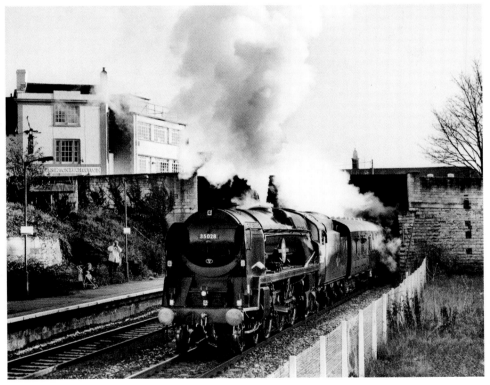

From a photographic point of view, there's nothing much to com -mend this picture. It's here because of two personal career-related connections. Taken at Trowbridge, the county town of Wiltshire, in December 1994, it shows Merchant Navy class no. 35028 *Clan Line* arriving with a train from London to Bristol via Westbury. Though in Great Western territory, this scene is a reminder that some boyhood trainspotting was on the Southern at places like Exeter and Yeovil. *Clan Line* was about to make an unscheduled stop in the station to take on an emergency supply of water courtesy of the Wiltshire Fire Brigade. At the time, I lived in Trowbridge and worked in the building with the clock tower in the far distance. Later, I became clerk (the equivalent of a company secretary) to the public authority responsible for Wiltshire's fire and rescue service.

Of the many narrow-gauge railways in North Wales, the Ffestiniog (FR) has been a favourite ever since a visit in 1962. Then it ran no further than the 7-and-a-bit miles from Porthmadog to Tanybwlch. Now it is the '40-mile railway', having not only built back to Blaenau Ffestiniog in 1982 but also having resurrected the Welsh Highland Railway (WHR) from Porthmadog to Caernarfon. On holiday in 1962, my brother, a friend and I walked the old WHR trackbed through the spectacular gorge known as the Aberglaslyn Pass. Had anyone told us that in fifty years' time trains would once again be running through the Pass, we would have thought them completely mad. As the adage has it, 'never say never'.

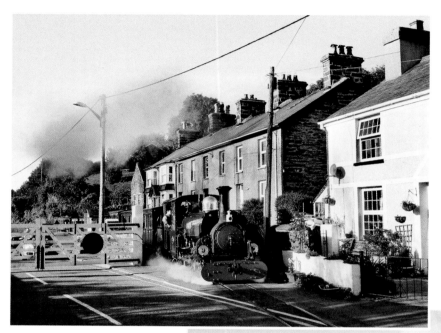

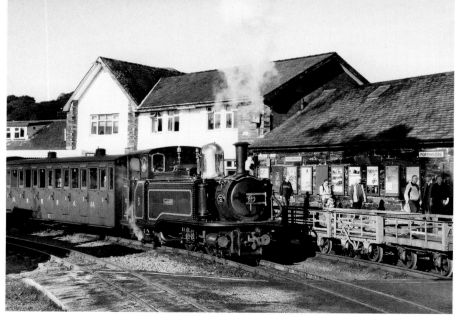

Blanche was photographed leaving Penrhyn (top) with the first train of the day in October 2012. On the same day, *Talesin* (bottom) was the station pilot at Porthmadog. This was a gala weekend on the Ffestiniog, held to commemorate the life of Alan Pegler. Best known to the general public as the man who saved the *Flying Scotsman* from the scrap merchants, his financial backing was the key to rescuing the FR from oblivion in the early 1950s.

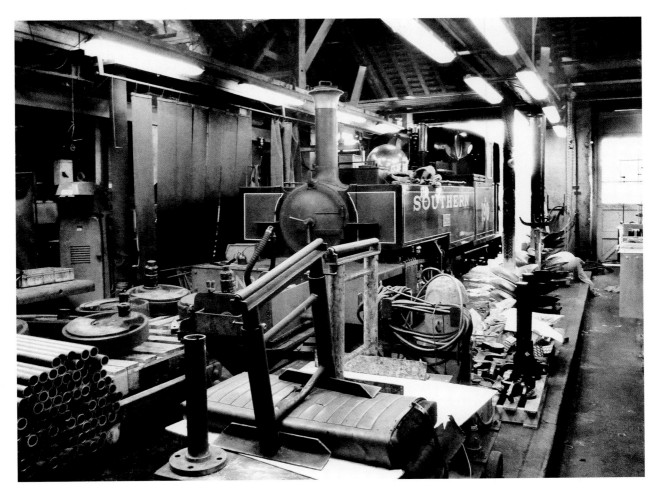

Hopefully, the Lynton & Barnstaple Railway (L&B) will prove to fall into the 'never say never' category. Closed by the Southern Railway in 1935, this would surely have been a dead certainty for preservation had it survived into the 1950s. As it is, something of the former atmosphere can be savoured at Woody Bay in Devon where one of the stations survives.

Moreover, in 2010 a loco built to the original designs emerged from the FR's Boston Lodge workshops. With a 2-6-2 wheel arrangement and named *Lyd*, she has visited Woody Bay where a determined band of volunteers are working to resurrect the L&B and where, of course, she looks just right.

Two workshop scenes at Boston Lodge. *Lyd* (top) in October 2012 and *Blanche* (right) in September 1983.

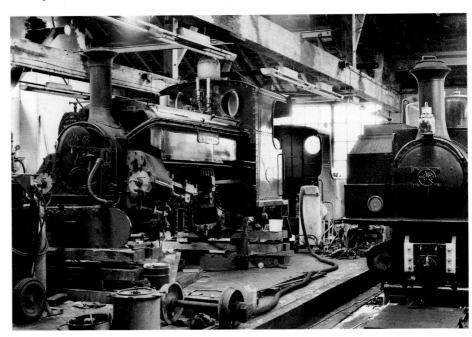

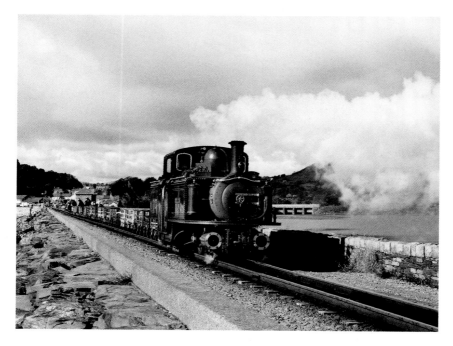

In today's management jargon, a unique selling point of FR galas is the gravity slate train. The route of the railway was originally laid out so that, in the days before steam traction was introduced, loaded trains of slate could descend by gravity from the quarries in the mountains around Blaenau Ffestiniog to the harbour at Porthmadog, horses being used to haul the empty wagons back uphill. In October 2012, *Merddin Emrys* set out from Porthmadog with a rake of empties bound for Dduallt from where they later returned by gravity – an amazing sight and sound.

The October 2012 gala weekend was blessed with glorious autumn sunshine, in contrast to the gloomy conditions which have often accompanied my visits to North Wales. A railway photographers' study course held at the Snowdonia National Park Study Centre in September 1983 saw typically wet and windy weather. It was only on the final afternoon that the rain relented, providing an opportunity to capture *Earl of Merioneth* on Gwyndy bank, bound for Blaenau Ffestiniog. Both these locos are 'Double-Fairlies' for which the FR is renowned. In layman's terms, they consist of two boilers with a central cab, on two articulated sets of wheels and cylinders. It all adds up to a most distinctive appearance, unlike that of any other UK locos.

An advantage of the study course was the ability to get to lineside locations which are normally inaccessible to the public. One such is Cei Mawr, an embankment built entirely of stone, where *Mountaineer* was seen with an up train. She has an interesting history. Built by the American Locomotive Company in 1917, she saw service in France, at first by the Allies in the First World War and then on a minor railway, before arriving on the FR in 1966. Sharp-eyed aficionados of the Ffestiniog may note that a telegraph pole part way along the embankment has been airbrushed out of the picture.

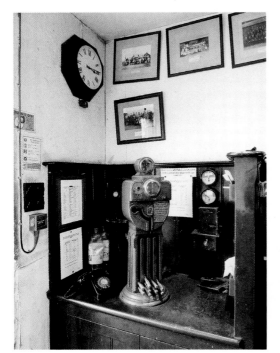

During a visit to Boston Lodge works in October 2013, the office (left) caught my eye, as did the example of naive art (below) on a gate at the entrance to the works.

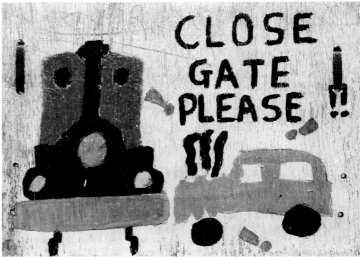

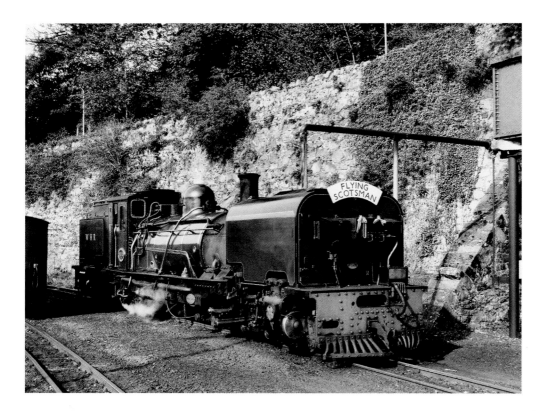

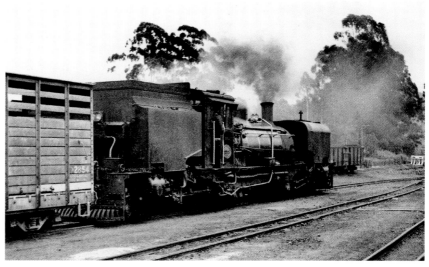

Let's return to the gala of October 2012. Tribute was paid to Alan Pegler in a number of ways including a memorial service, a photographic exhibition of his life, and a specially brewed local beer. The loco of Sunday's train on the WHR carried a *Flying Scotsman* headboard, seen at Caernarfon prior to the return journey to Porthmadog (top). This locomotive is not a native of North Wales. She was built in 1958 by the Manchester firm of Beyer Peacock for export to South Africa where she was numbered NG 143. Repatriated in 1997, she was overhauled and put to work on the WHR. Did I see her during one of my visits to South Africa? Fortunately my negatives are filed in date order so I had a rough idea of where to look. The answer was 'yes'. In fact, I found a number of photos of her hauling a freight train on the 2ft-gauge line from Port Shepstone (on the Indian Ocean coast south of Durban) to Harding in May 1979. We had been chasing the train under an overcast sky. With the weather closing in, we decided to give up at Highfields where the bottom photo was taken. On the way back, a small girl ran into the road in front of the coach carrying our group. Quick thinking by the driver prevented serious injury. Sadly the child, who in October 2012 went missing from her home in North Wales (an event marked by the ribbon tied to the front of no. 143 in the top photograph), was never found.

3. The Other Side of Europe

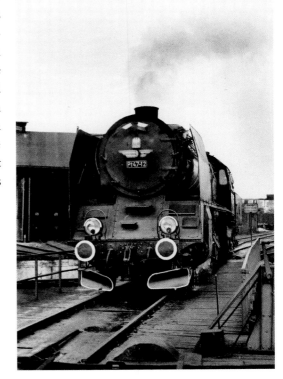

Before the fall of the Iron Curtain, I visited Poland once and the former East Germany twice. Poland was difficult photographic territory because railways were treated in the same way as military instal-lations. It's been an interesting experience to go back after the fall of communism and to view the changes brought about by liberalisation – changes of society, of economics and of attitudes. No better example can been given than at Wolsztyn where an ex-pat ran a commercial venture in co-operation with the railway authorities. This allowed enthusiasts to drive steam locomotives hauling real trains on the everyday railway. Such an arrangement would have been inconceivable in the past. Come to think of it, it wouldn't be allowed in the UK today. The card (below) given to me at the end of a week's driving in April 2000 confirms the routes involved. The mileage totalled more than 600. Amazing.

Odcinek linii kolejowej		Znajomość szlaku w/g danych z rubr. 5 poprzed. karty
od stacji	do stacji	
1	2	3
Wolsztyn	Poznan	12.04
Wolsztyn	Leszno	12.04
Wolsztyn	Zbaszynek	12.04
Wolsztyn	Konotop	12.04
Wolsztyn	Kargowa	12.04
Wolsztyn	Wschowa	12.04

The Pt47 2-8-2s were the last class of passenger steam locomotive to be constructed in Poland. In September 1975, no. Pt47-12 was seen on the turntable at Bialogard (above right). Never for a moment did one imagine that a member of the class would still be at work twenty-four years later, but here's the proof (right). No. Pt47-65 raised the rafters as she left Wolsztyn bound for Zbaszynek in April 2000 with a Brit in the driving seat.

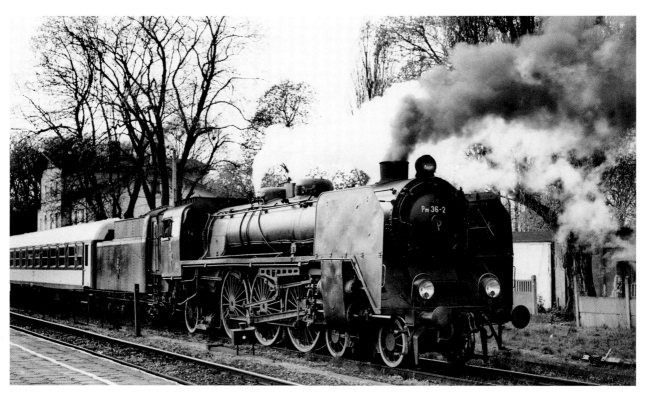

The pride of Wolsztyn shed was the Pm36 Pacific, one of only two built in the late 1930s. With driving wheels of 6ft 6in diameter, she was intended for express passenger work. To drive this beast at the metric equivalent of 60mph was a thrilling experience. In April 1999, she was about to leave Wschowa with a train for Leszno.

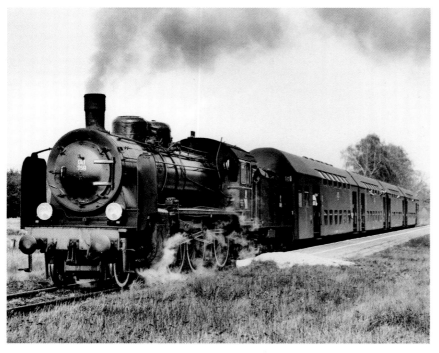

The oldest active loco at Wolsztyn was Ok1-359, a 4-6-0 built in Berlin in 1919. Of pre-First World War design, some of the class survived into the 1970s in parts of Europe which had been under German occupation during the Second World War, as well as in Germany itself where the class was popularly known as the P8. Photographed (left) leaving Rostarzewo in April 1994 with a train from Poznan to Wolsztyn, no. Ok1-359 was Poland's last working example of this class. Sadly I never got to drive her during my visits to Wolsztyn.

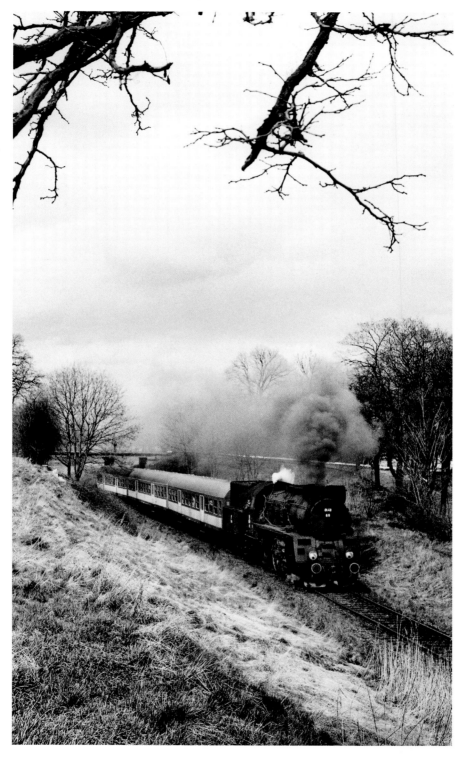

A favourite loco on a favourite line. The Class Ol49 2-6-2s were mixed-traffic locomotives used on secondary routes throughout Poland. A number ended up at Wolsztyn, including no. Ol49-69, which I have driven on many occasions. She was seen in full cry en route from Wolsztyn to Leszno in April 2000. An hour was allowed for this 30-mile journey. Not very fast, you may think. However, as trains called at all of the eleven intermediate stations, some nippy running was involved. There was no hanging about. For me when driving, the best part of the line was an uphill stretch with woods on both sides. Who could fail to be thrilled by the noise from the chimney reverberating through the forest? And who could resist blowing the whistle for the sheer pleasure of hearing its echo? Not me!

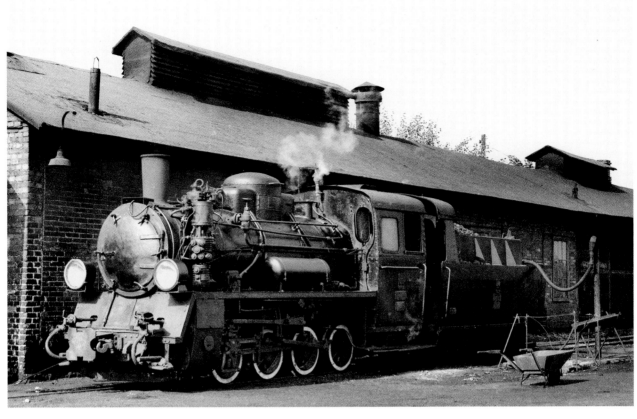

In the early 1970s Poland still had an extensive narrow-gauge network using a mixture of pre- and post-Second World War locos. The class Px48 0-8-0s were the most modern design, of which one was seen in September 1975 being prepared for her day's work at Włocławek. Photographs? No problem. Presumably narrow-gauge railways were viewed by the powers that be as having no strategic value.

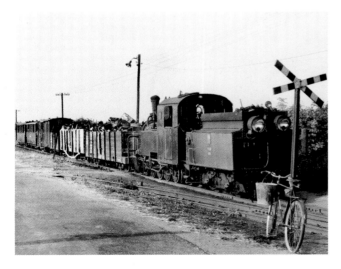

The enormous headlamps used on Polish railways looked out of proportion when applied to narrow-gauge locos. It's easy to imagine them as a pair of eyes. Perhaps they belong to Tomasz.

Though of poor quality, this photo is included to show a wayside scene once common throughout Poland. In September 1975, 600mm gauge 0-8-0 Px38-805 had just collected some wagons to add to her train en route from Wysoka to Białośliwie, a journey which took an hour and a half to cover 12 miles. No wonder we appeared to be the only passengers. This loco wasn't as old as she looked, being of 1938 vintage. Hurrying to take this picture, I managed to cut off the bottom of the bicycle wheel. Through the wonders of digital technology, it's been restored.

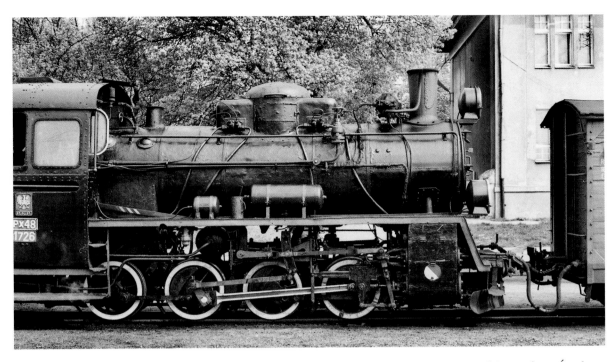

By 1994 only one of Poland's narrow-gauge lines still had a steam passenger service. This ran from Środa to Zaniemyśl. Px48-1726 was about to leave Środa with an afternoon train in April of that year. Looking at this 750mm gauge loco, the phrase 'small but perfectly formed' comes to mind.

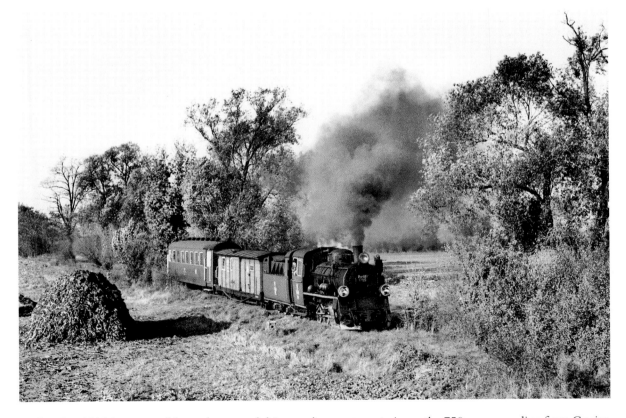

In October 2001 it was possible to charter and drive one's own steam train on the 750mm gauge line from Gneizo to Witkowo, whose regular traffic by then had been reduced to a weekly diesel-hauled freight train. Px48-1785 performed a vigorous run-past with the Strickland Special, seen from the top of a haystack.

When hunting steam abroad, I prefer to travel solo or with a like-minded friend or two – sometimes even with my wife. That said, group travel is unavoidable if one wants to enjoy the experience of specially chartered trains in places where the railway authorities are enlightened enough to allow specialist operators to recreate the steam scene of yesteryear. Getting the right locomotive with the right stock on the right route was one of the selling points of Steam Loco Safari Tours (SLST), run by David Rodgers. Here 'right' meant an engine that would have worked on the line concerned in the days of real steam, with carriages or freight wagons authentic for the period.

The SLST tour of Hungary in April and May 2001 remains one of my favourite group trips. In perfect spring weather the tour achieved 133 photographic run-pasts or false starts in only nine days. A number of photos have appeared in previous books and I make no apology for including more here.

Let's start with a machine designed for express passenger work in the last days of the Austro-Hungarian Empire. The Austrian Southern Railway, the *Sudbahn*, linked Vienna eastwards with Budapest and southwards with Trieste, the Empire's port. Between 1910 and 1917, fifty-four class 109 4-6-0s were built to work the principal trains on these routes. With the demise of the Empire at the end of the First World War, the class was divided between Austria, Italy, Yugoslavia and Hungary, where no. 109 survived to be restored in due course to working order. Painted apple green with red frame and wheels, she is an impressive machine.

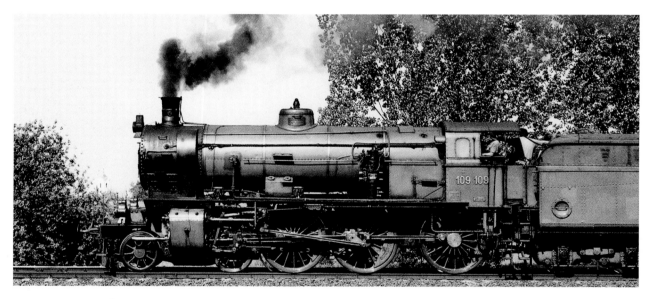

One of the tour highlights was the use for two nights of the coaches which form the *Royal Hungarian Express*, a luxury train aimed at wealthy tourists. The stock was that used by the country's president and senior party figures in the communist era. Elegance is not a word usually associated with the Soviet era in Eastern Europe, but certainly applied to these carriages. The top brass knew how to travel in comfort. The sleeping compartments, not to mention the dining car and standard of catering, would not be out of place on today's *Orient Express*. A particular memory is of aperitifs (Hungarian wine, naturally) in the lounge car whilst admiring the views of Lake Balaton. For part of the way we were hauled by no. 109, seen here near Nemeskeresztur.

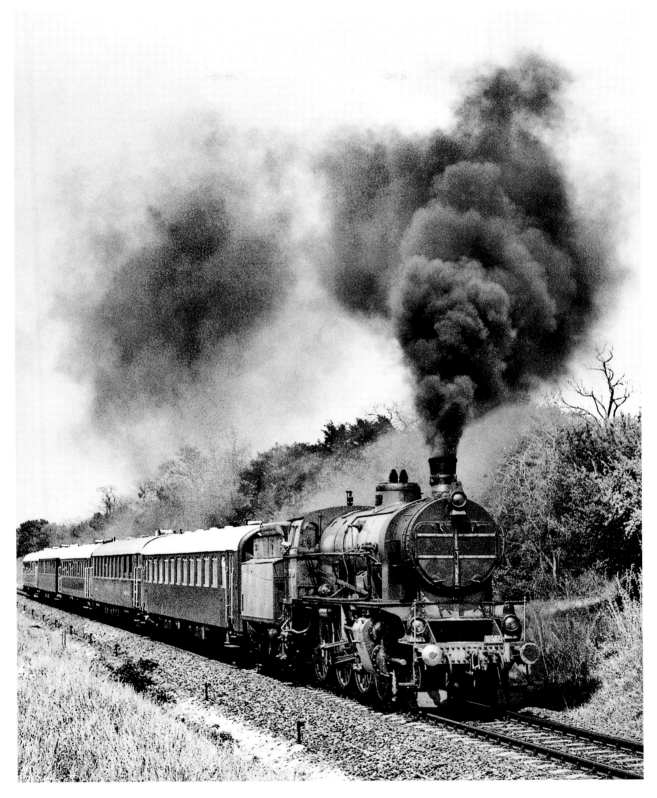

No. 109 with the president's train, near Sümeg. Though taken from an unimaginative angle – 'bog standard' one might say – this image conveys something of the power of an express locomotive in full flight.

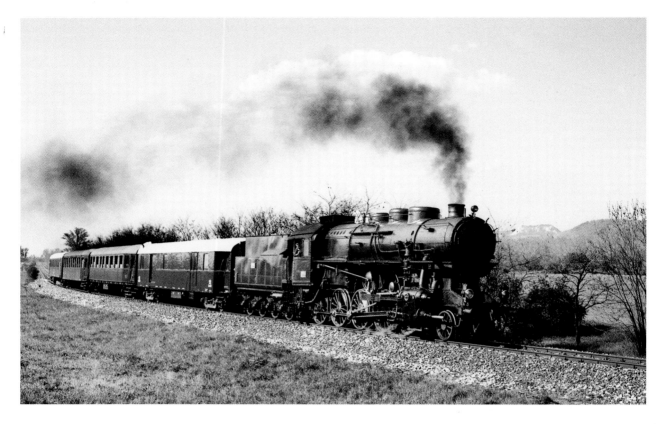

Despite appearances, the two locos on this page are of the same type: the 4-8-0 class 424. Described by the tour notes as Hungary's finest steam loco design, over 500 engines of this class were constructed between 1924 and 1958. No. 424.009 (above) was a coal-burner built in 1924. She was photographed en route from Dorog to Budapest. No. 424.247 (below) was nearing Hatavan with a freight train from Salgótarján Külsö. Built in 1955, she was an oil-burner, hence the smoke to order.

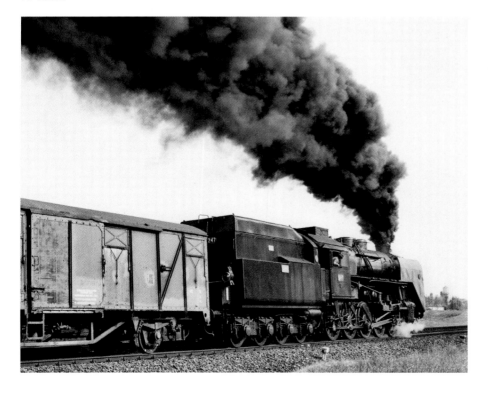

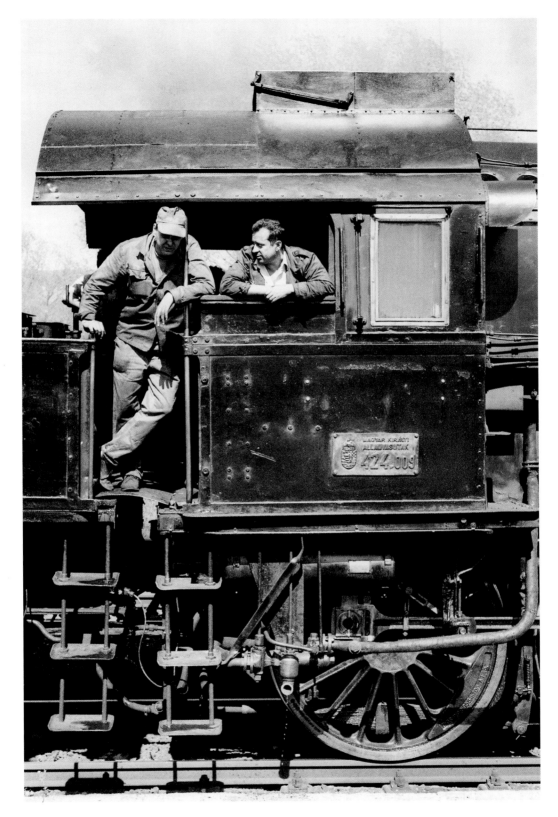

Run-pasts and false starts for the benefit of photographers have to be planned so as not to disrupt normal rail traffic. Moreover, their success depends on the willingness of the footplate crew to enter into the spirit of the occasion. Everyone wants smoke. When all goes to plan, a word of thanks doesn't go amiss. The crew of no. 424.009 did well notching up seventeen photo opportunities on the run from Dorog to Budapest.

In the good old days, when steam ruled the rails, we trainspotters didn't bother much about the humble branch line. How could the scruffy two-coach train to Chard compete with the glamour of the *Cornish Riviera* express? Unloved by most people at the time, with the honourable exception of John Betjeman, the country branch – or rather an idealised image of it – experienced a renaissance with the coming of the UK heritage scene. No such play acting was necessary in Hungary where at the turn of the millennium many parts of the country were still served by local lines. En route from Epleny to Veszprem, 2-6-2 tank loco no. 375.562 stopped at Bakonyszentiaszio. Over 700 engines of this class were built between 1907 and 1959, this one dating from 1923.

Next day, 2-6-0 no. 324.540, built in Budapest in 1915, was about to enter a tunnel near Zirc whilst working a freight train over the branch.

South of Budapest lies the town of Kecskemét, the starting point in 2001 of a 760mm gauge line to Kiskunmajsa. After working a photographic special, 0-8-0 tank no. 490.053 posed outside the sheds at Kecskemét. First introduced in 1905, this class became the standard design for the Hungarian narrow gauge. Seventy were eventually built, the last in 1950. No. 490.053 was constructed in 1942.

Hungary was able to provide an authentic nineteenth-century mixed train, seen here arriving at unpronounceable Nyergesújfalu behind 0-6-0 no. 269 of 1870 vintage. The historic rolling stock consisted of three passenger coaches, one postal wagon and one coal wagon. This station was on the secondary line from Dorog to Almásfüzitő, which in places paralleled the south bank of the Danube, though it was incredibly difficult to get train and river in the same photograph. Success was eventually achieved (see page 77 of *Worldwide Steam Railways*).

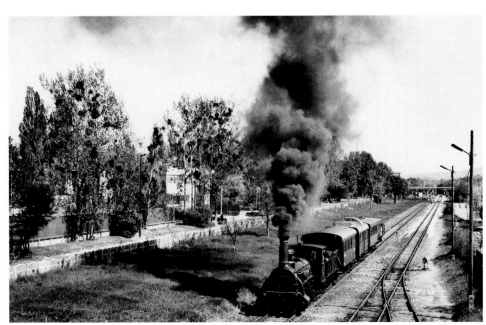

There isn't room here to include other Eastern European favourites such as the former East Germany, the Czech Republic and Ukraine, all of which have featured in previous books. In the last few years, a 'new' destination has been Bosnia-Herzegovina, where real steam can still be found at a handful of industrial locations. Don't let recent Balkan history put you off visiting; railwaymen seem eager to stress that religious differences have no part to play in the workplace and you're assured of a friendly welcome. However, do go through the official channels to get formal permission for visits. Turning up unannounced at a coalmine is not a recipe for success.

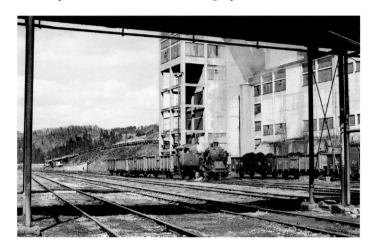

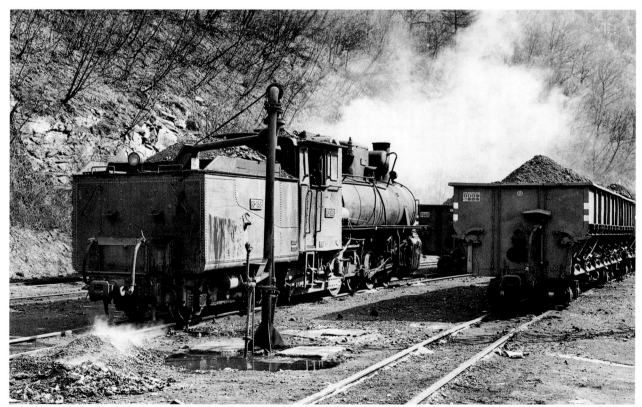

The coal industry at Banovici has steam on two gauges – standard and 760 mm. Coal is brought by narrow gauge from mines west of the town to the washery at Oskova where in April 2013 0-6-2 tank no. 19-12, built by Skoda in 1949, was shunting the standard gauge exchange sidings (top). On most days, steam on the 760 mm lines was confined to shunting at or near the washery, as in April 2012 when the resident shunter was 0-8-2 no. 83-159 (bottom). She was running with the tender from sister loco 83-158, having damaged her own in an accident the previous day.

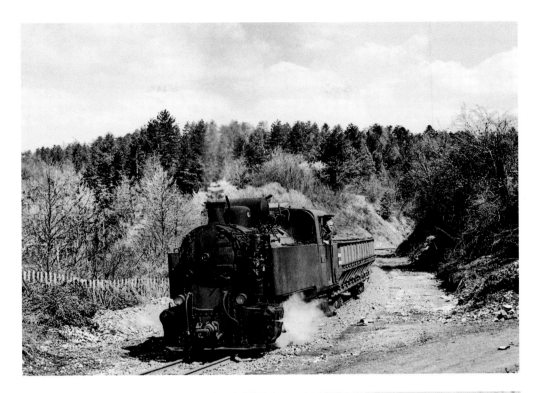

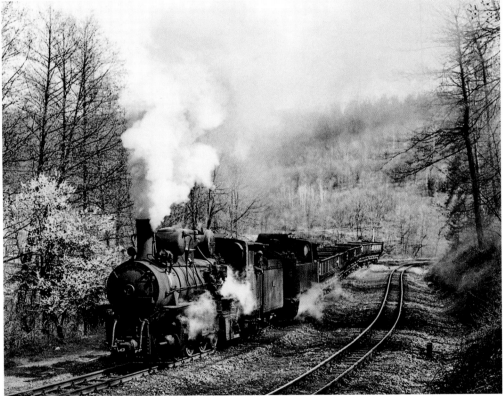

In April 2013, two of the narrow-gauge locos were in steam, no. 83-159 (this time with her proper tender) and 0-6-0 tank no. 25-30. Both were post-war locos, having been built in 1948 and 1949 respectively. Once upon a time the class 83 0-8-2s were common throughout the former Yugoslavia on the country's extensive 760mm gauge network. No. 25-30 engaged in some light shunting (top) before the two engines double-headed a specially chartered train of empty wagons from the washery to the mines (bottom).

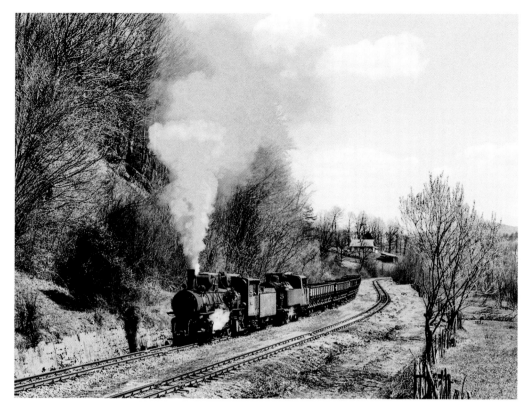

It seems to be a quirk of nature that coal mining is often carried on in what would otherwise be attractive countryside.

Riding the train necessitated perching on the open balconies at the ends of the wagons.

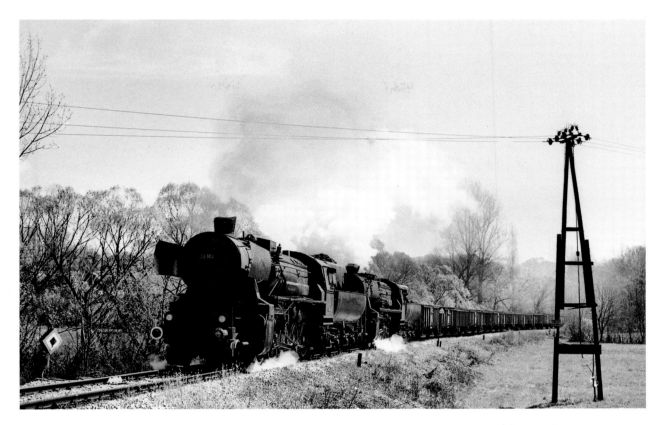

Dubrave is one of the coal mines which feed into the State railways in the vicinity of Tuzla, a large town towards the north-east of Bosnia. A small fleet of ex-German 2-10-0s is operated by the Kreka organisation to work coal traffic from this mine and that at Sikulje. In April 2013 nos 33-064 and 33-248 left Dubrave with a rake of loaded wagons bound for the mainline at Lukavac. It is sometimes possible to make a virtue out of an unsightly feature, in this case by using the pole and wires to frame the train. Both these engines were built in 1943 as part of the German war effort. Popularly referred to as *kreigsloks* (war locos), more than 6,000 were constructed between 1942 and 1945 and found their way to various parts of Europe. That one could enjoy the spectacle of double-headed *kreigsloks* in 2013 was almost unbelievable.

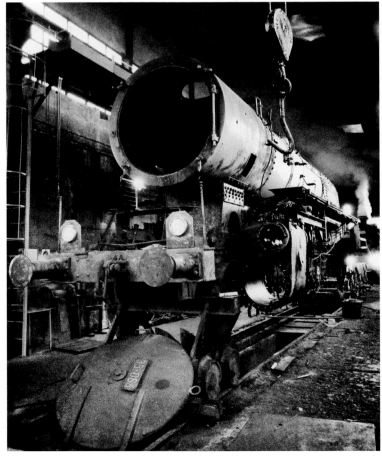

It was heartening to see that heavy overhauls were still being undertaken in the workshops at Bukinje in April 2012. No. 33-064 was the loco concerned. In the background, no. 33-504 was receiving minor attention.

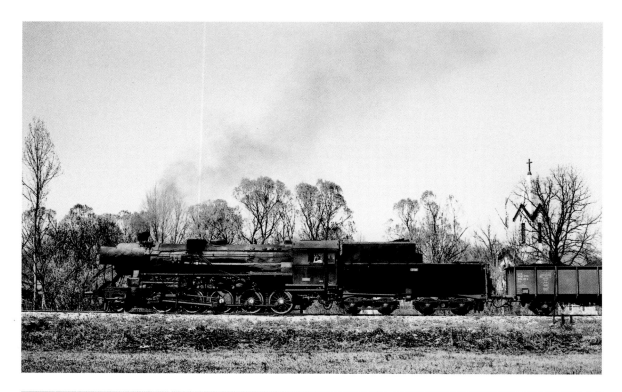

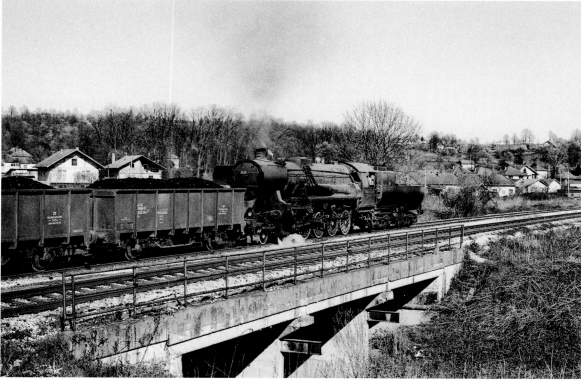

In April 2013, the engines of loaded trains from Dubrave mine worked chimney first (no. 33-064, top) whilst those from Sikulje were tender first (no. 33-503, bottom). The church seen in the top picture provides an excuse for a lovely anecdote recounted in the *Railway Magazine*. A well-known organist of his day, after finishing a particularly lively piece by Bach, was heard to remark: 'Well, we're through Westbury on time.' Moreover, he had a reputation for pulling out all the stops when playing hymns with numbers like 462. Being an amateur church organist, I've often wondered if there's a connection between railways and Church music. Now I have proof.

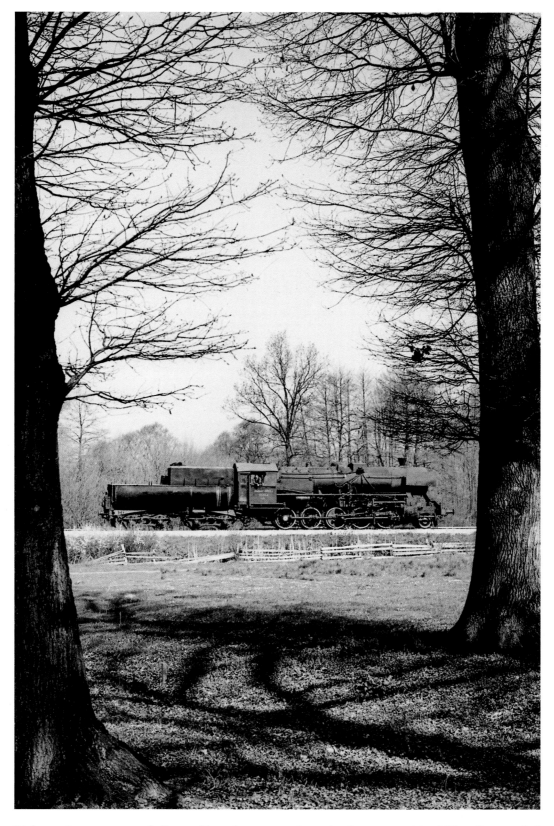

Light engines present a challenge. How does one make a pleasing composition? Have I succeeded here? In April 2013, one of Kreka's *kreigsloks* was photographed en route from the works–cum–sheds at Bukinje to take up her duties at Dubrave mine.

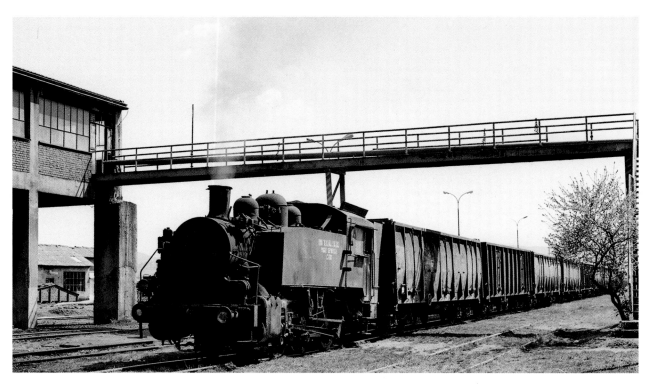

After the Second World War, the USA supplied steam locos to much of war-ravaged Europe. These included a class of chunky 0-6-0 tanks designed for shunting, or switching as the Americans would say. A few came to the UK. Known here, unsurprisingly, as the USA Class, they were mostly to be seen in the Southampton Docks area. Others were acquired by Yugoslavia where the authorities were so impressed with them that more were constructed locally in the 1950s. Built in 1943, no. 62-020 at Breza colliery was the last of the original American batch still active in April 2013.

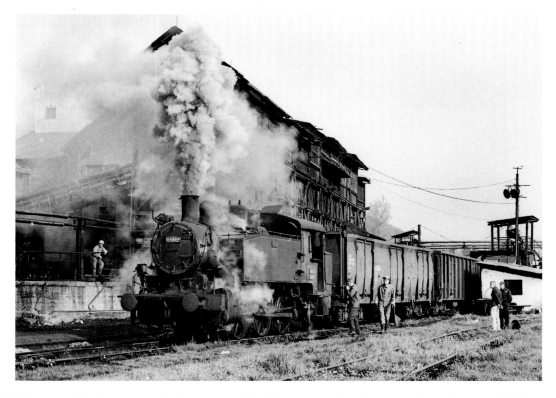

In April 2012, one of the Yugoslavian-built locos, no. 62-633, was at work at Zenica colliery. She was of 1955 vintage.

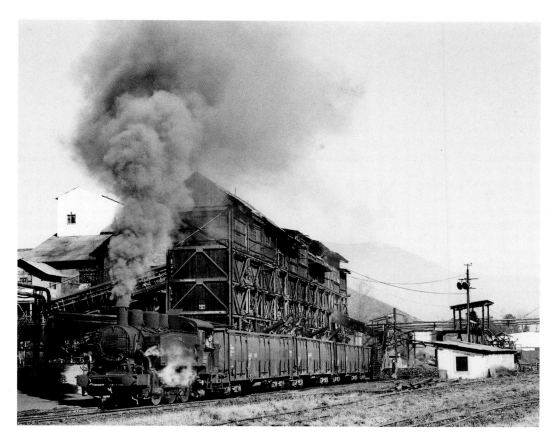

To return to the same location to repeat the same shot with the same locomotive is not very imaginative, but I can't resist an encore, if only for the sight of the antiquated wooden hoppers, an attraction in their own right. The date this time is April 2013.

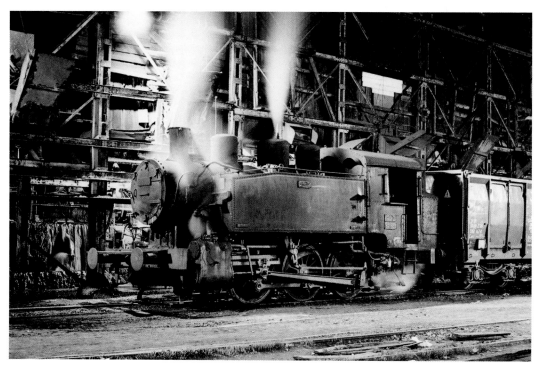

For a fee, the management agreed to pose the loco for some night-time photography.

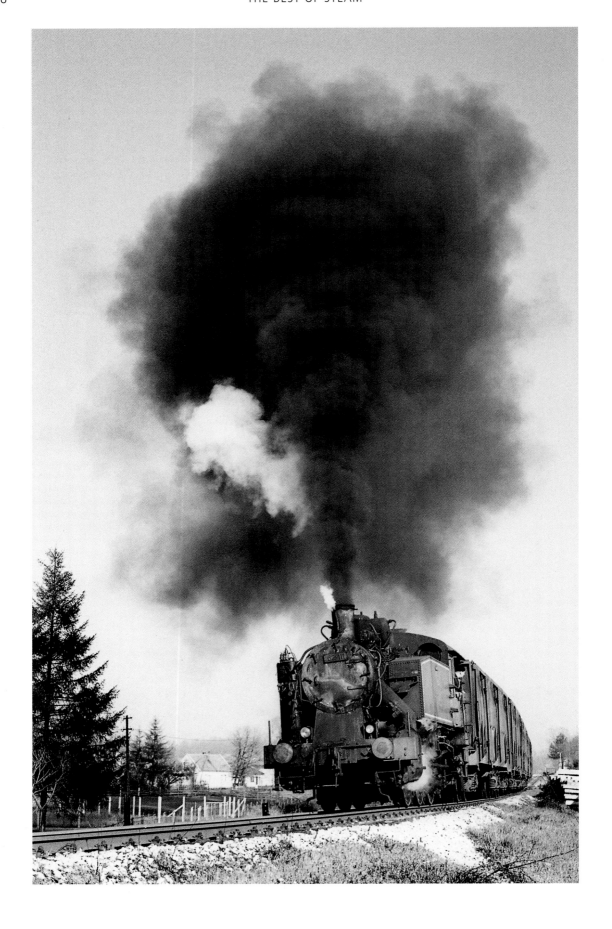

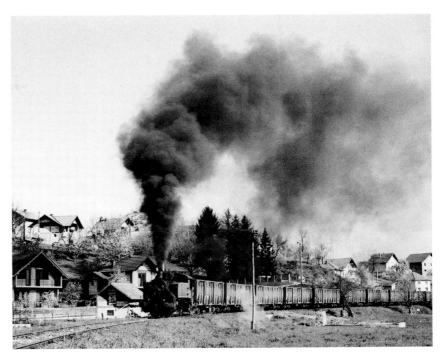

The route to Djurdjevik colliery wound through villages set in wooded countryside. A close examination of the scene below reveals a mosque in the far distance, evidence of the mix of Islam and Christianity in this part of the world.

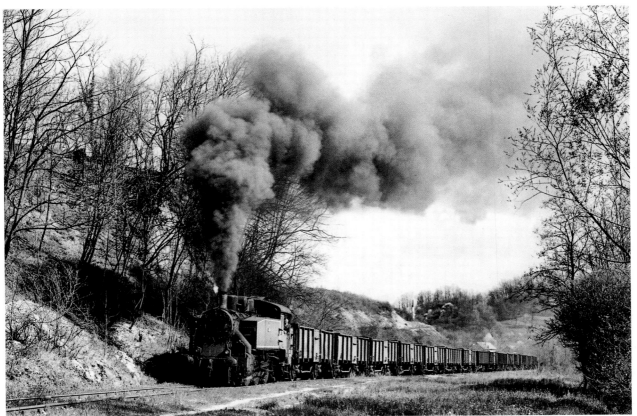

Opposite: In April 2013, coal was being exported by rail to Slovenia. From the exchange sidings at Zivenisa, the line to the colliery at Djurdjevik had some fearsome gradients as it twisted and turned along a valley to the coalmine. The incoming rake of empties presented too much of a challenge for the sole 0-6-0 to handle in one go. Half of the train was therefore taken to the colliery, the loco returning for the other part. Even so, maximum effort was required. No. 62-111 was another of the locally built 0-6-0 tanks, having been made in 1956.

4. China

Away from tourist hotspots, China is in some ways a hard country to cope with. It's not just the culture; it's the way life is lived in the provinces. Don't be fooled by the glitz of the modern cities. Economic prosperity seems not to have spread into much of the countryside, whilst towns with heavy industry and the concomitant pollution appear grim. The norms of etiquette and attitudes can also be very different to those to which one is accustomed. Spittoons are still sometimes found in restaurants – and used. Food can take some getting used to as well. Dog, snake, rat, donkey, anyone? Personally, I love the cuisine in China apart from breakfasts which, except in hotels designed for western tourists, often consist of rice gruel and cold vegetables, with not a drop of coffee in sight. The long distances involved in getting around the country mean travel can be wearisome too, despite the amazing expansion of domestic air travel, motorways and high-speed railways in recent years. Yet China has long been a favourite destination; endlessly fascinating and rewarding in experiences. With nine visits, the first in 1982 and the last in 2011, I could fill a whole book with images of Chinese steam.

It's difficult now to appreciate how few Western tourists had visited China before the 1980s and how little was known about the country. There were no direct flights from the UK and most people went in groups with itineraries rigidly controlled by the authorities. Much of the country was off limits to foreigners. In 1982, a visiting party of railway enthusiasts found that the opportunities to photograph steam were strictly rationed to ensure we had our quota of culture, not that there were many complaints. We felt privileged to be there. Of course, our interest in steam trains was beyond the authorities' comprehension. No wonder local guides were nervous about letting us wander at will around railway stations. It was incongruous, therefore, that one of the country's main locomotive workshops was an approved tourist attraction.

In 1982, Datong steam loco works employed 8,000 people of whom 2,000 were women. With five schools and a hospital providing free medical care, it was a vast enterprise. The planned output for that year was 233 steam locos, which meant one rolling off the production line every day and a half. To be allowed to roam where we liked almost defied belief. Some of the sights were awesome, especially that of a moving overhead crane with the carcass of a locomotive slung underneath. My diary simply says 'fantastic!' Had we known that new steam locos would continue to be built in China into the 1990s, we would have been even more amazed.

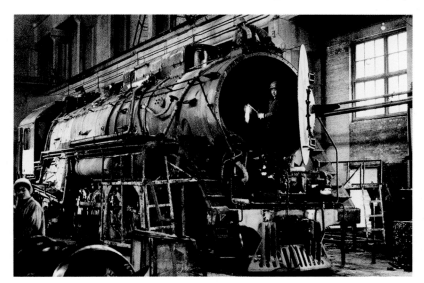

A corner of Datong works in November 1982. With no tripod to assist, this hand-held shot required a wide camera aperture and a slow shutter speed, hence the lack of sharpness. Nowadays, digital cameras seem able to cope with the most dismal lighting conditions.

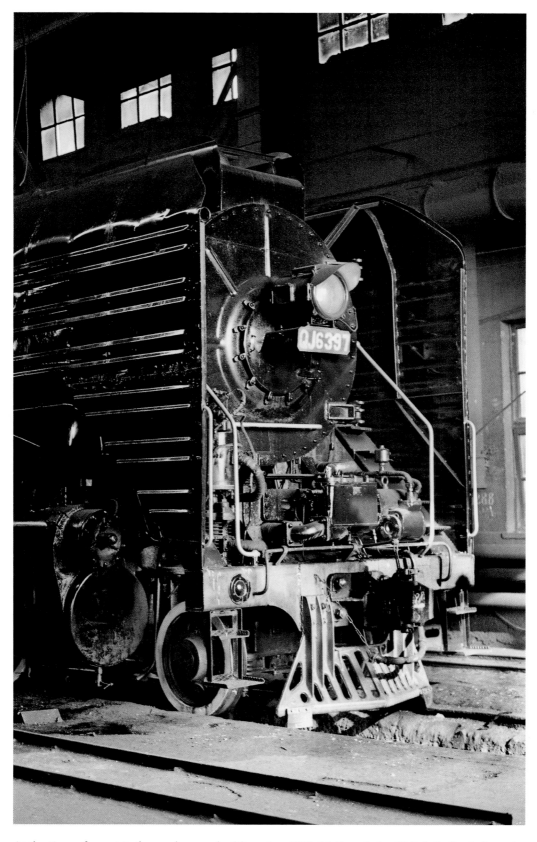

At the time of my visit, the works were building class QJ 2-10-2s and class JS 2-8-2s. Fresh from the paint shop, QJ no. 6397 was in the steam-testing plant.

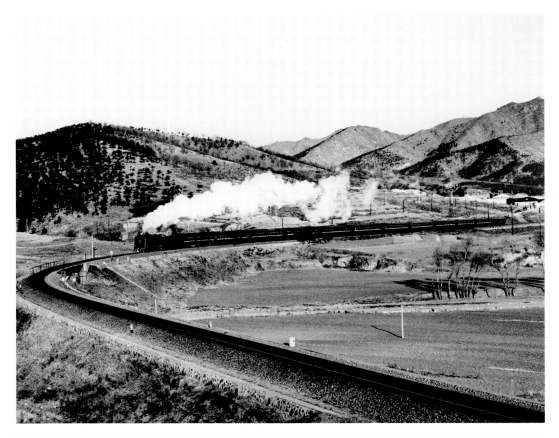

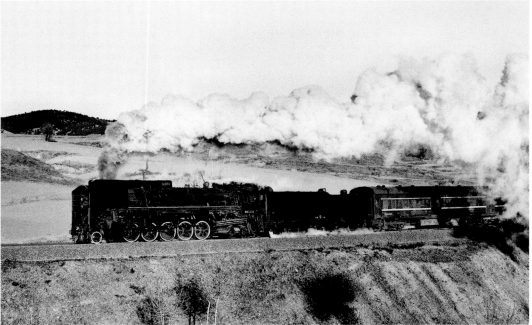

Though designed for freight traffic, QJs could be found on passenger duties, especially on heavily graded lines. Three railway routes converge on Yebaishou, a small town about 125 miles north-east of Beijing. Until dieselisation towards the end of the 1990s, the shed there had an allocation of about fifty steam locos but it was only in 1995 that foreigners were allowed to visit the area. One of the regular steam turns was the afternoon stopping train from Yebaishou to Chifeng, seen leaving Shina (top) in November 1996 with no. 3335 and next day on the climb to the summit at Shahai with the same loco (bottom).

From the north, the climb to the summit at Shahai needed maximum effort. The daytime express from Chifeng to Shenyang via Yebaishou and Fuxin was on the final stretch in November 1996.

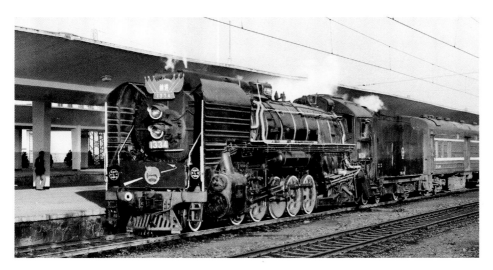

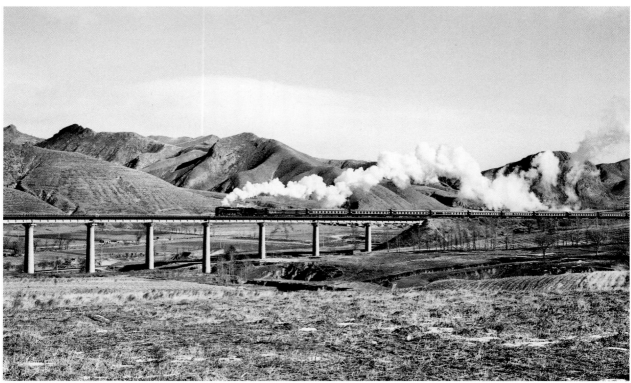

QJ no. 1334 (top) was about to depart from Taiyuan in November 1982. By then China had begun to electrify some of its main routes – hence the overhead wires in the photograph – even though the construction of steam locos was to continue throughout the decade. Students of Chinese steam will note that no. 1334 was coupled with a small eight-wheel tender in contrast to the larger twelve-wheel tender carried by no. 3335 on page 52.

Though a long-distance steam-hauled passenger train was a rare sight in 2004, China could boast of the last one in the world running to a daily timetable. This was on the famous JiTong railway which runs for some 600 miles across Inner Mongolia. Built in the 1990s as a brand new steam-worked mainline, it became the place where everyone wanted to go until steam was replaced by diesels in 2005. From a photographic point of view, the Jingpeng Pass was the highlight of the line – a 30-mile section with tunnels, horseshoe curves, spectacular viaducts and fierce gradients. Unfortunately for the camera fraternity, the steam passenger service was often timetabled to cross the Pass during the hours of darkness. However, the Jingpeng China Orient Express, chartered by the UK company GW Travel in March 2004, provided the chance to make good this deficiency as it crossed the curved viaduct at SiMingyi on the climb to the summit from the west (bottom).

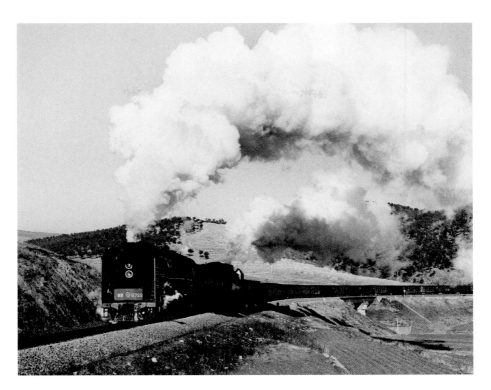

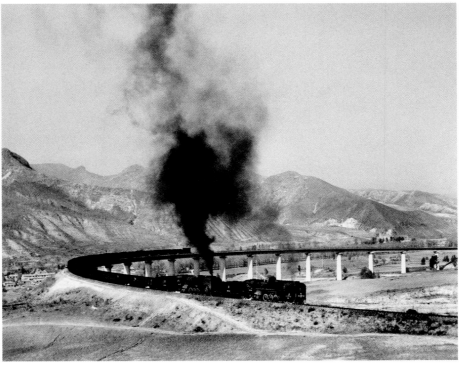

Freights out of Yebaishou were often double-headed with the locos coupled tender-to-tender. In November 1996, two QJs (top) headed a rake of empty coal wagons bound for Pingzhuang. Trains over the Jingpeng Pass were almost always double-headed, whether climbing from the east or the west. Against a mountainous backdrop, they made a magnificent spectacle. Winter was the favoured time of the year for photography because the cold produced splendid steam effects. However, not all was rosy. The cold could be too extreme for comfort when standing on an open hillside, and the effect of an unpredictable wind on the steam exhaust marred many a shot. In contrast, the weather during a visit in October 1997 was unseasonably warm. The firemen were hard at work as two QJs lifted an eastbound freight across SiMingyi viaduct (bottom).

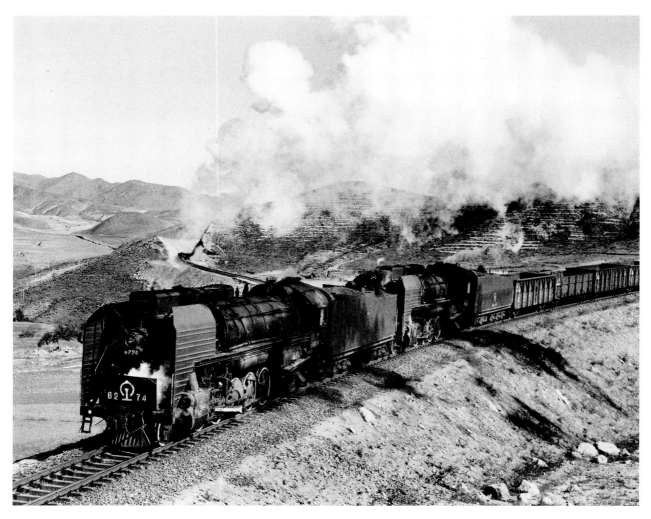

Because of its windy reputation and difficulty of access – hiking books were *de rigeur* – the eastern side of the Pass tended to attract fewer photographers than the western. However, for those who were prepared to walk, the views were tremendous. As the railway changed direction through a series of curves, it was possible to watch the progress of a train for a full forty-five minutes. In this photo, taken in October 1997, two QJs were on the highest of three levels, having looped 180 degrees around, behind and through the hill in the background. The second level can be glimpsed behind the first loco and the lowest level was way out of sight to the left. On a warm day with a swirling breeze, what steam there was, though clear of the train, cast shadows on the locos thus somewhat spoiling the composition.

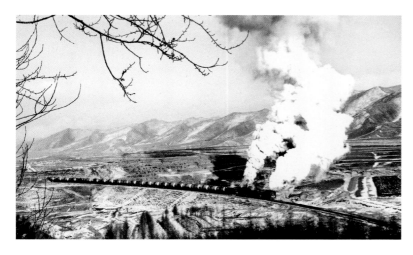

This time the wind direction favoured the photographer. These QJs were travelling at a walking pace as they approached the summit tunnel in March 2004.

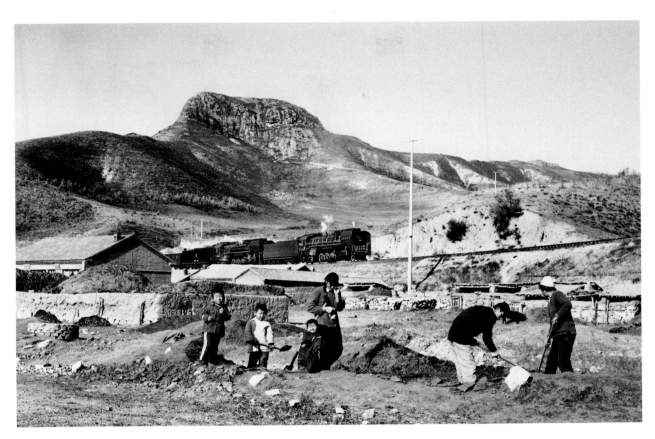

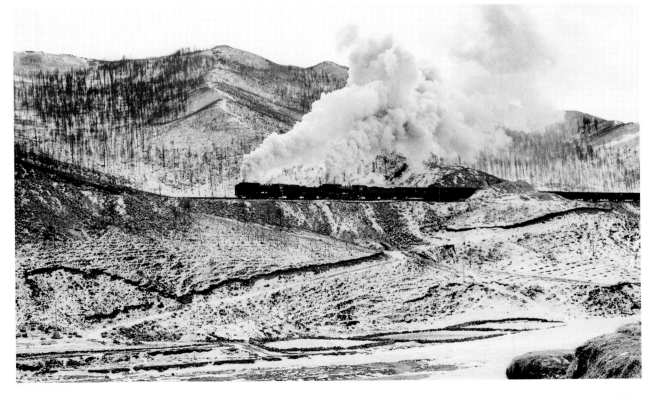

More seasonal contrasts, this time on the west side of the Pass. Though the railway had arrived only a year or so earlier, by October 1997 villagers (top) were already oblivious to the succession of trains passing their back doors. The final few metres of the climb presented a bleak scene (bottom) in March 2004.

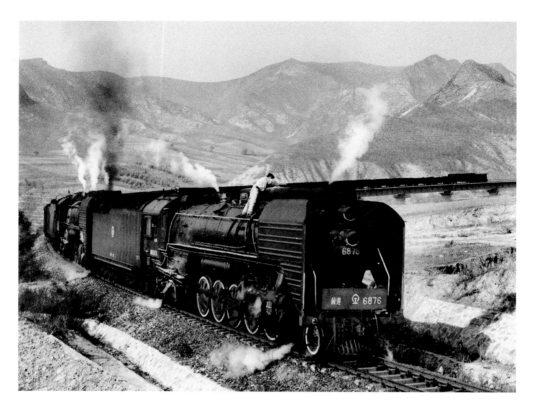

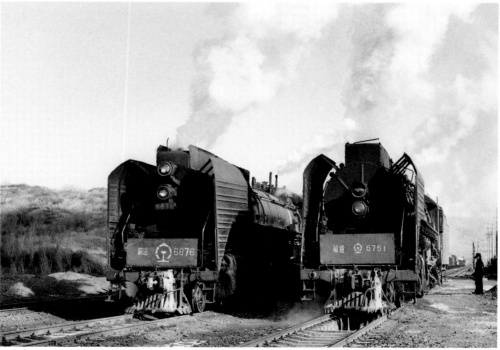

A last look at the Jingpeng Pass. It seems there was a problem with the sanding gear on QJ no. 6876 (top) in October 1997. Whilst the train was still on the move, one of the crew was doing something to the sandbox atop the boiler. The driver would not want to risk stalling in one of the four tunnels on the way to the top of the climb. From a footplate ride on this stretch in 2004, I can vouch that though the tunnels were short, two locos working flat out in such confined spaces made for a hellish experience. No wonder the crews were looking forward to the coming of the diesels. In March 2004, no. 6876 was the leading engine (bottom) of a westbound freight which had stopped to take water in Jingpeng station, at the foot of the Pass, whilst no. 6751 was engaged in some shunting.

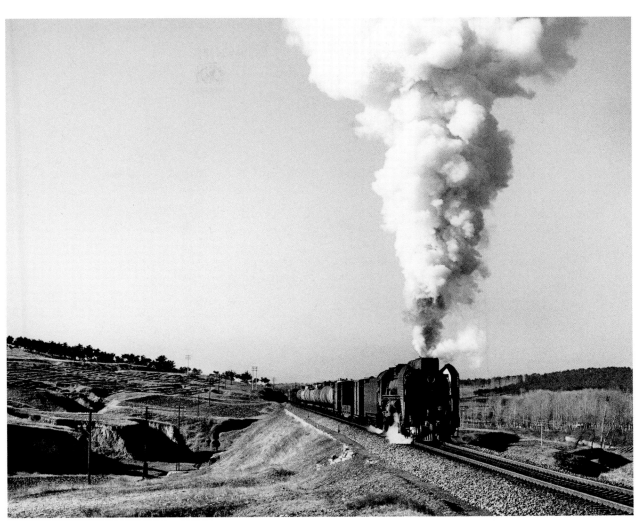

The line from Chengde to Yebaishou reached a summit at Hetanggou. In November 1996, an unidentified QJ made a stirring sight and sound as she climbed towards the top with a short freight train.

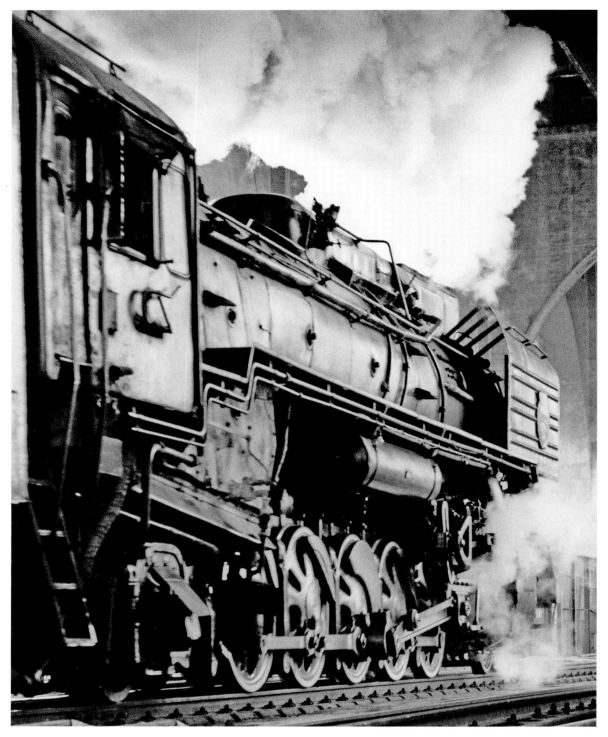

The bridge over the River Yangtze at Wuhan is a double-decker – rail below, road above. Three-quarters of a mile long, it was the pride and joy of Chinese engineering when built in the mid-1950s. In many Communist countries, bridges were regarded in the same light as military installations. It was therefore no surprise we were prevented by an armed guard from taking pictures of the structure from the outside. Contrariwise, after taking tea with the bridge manager as required by Chinese etiquette, we were allowed a brief visit to the rail deck. As a QJ-hauled freight came thundering across, there was little time to compose a photograph. Turning as the train passed by, I twiddled some bits on the camera, pressed the shutter and hoped for the best. The result won't win any competitions but does, I hope, convey something of the tunnel-like atmosphere.

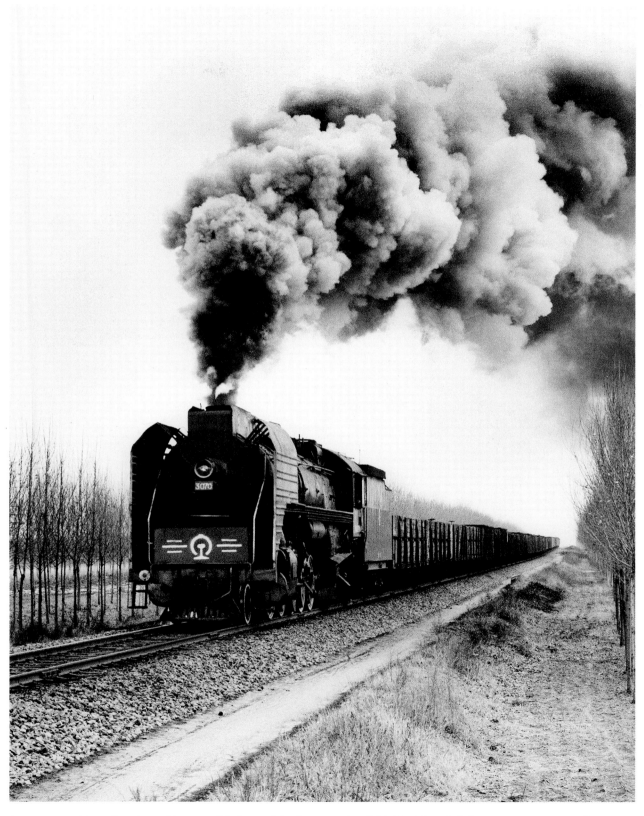

As a composition, there's nothing special about this photograph of QJ 3070 headed for Datong in November 1982. It's here because for me it says a lot about the bleakness of a grey winter's day in northern China. Nearby, the torso of an infant in a roadside ditch provided less palatable evidence of the harshness of rural life.

The next four photographs are for the steam connoisseur. Taken in November and December 1982, they depict classes of locomotive which were later to become extinct. At the beginning of the 1980s, there were estimated to be 10,000 active steam locos in China. That number dramatically reduced through the 1990s as steam came to be regarded as old technology which didn't fit the country's self-image as a modern economy.

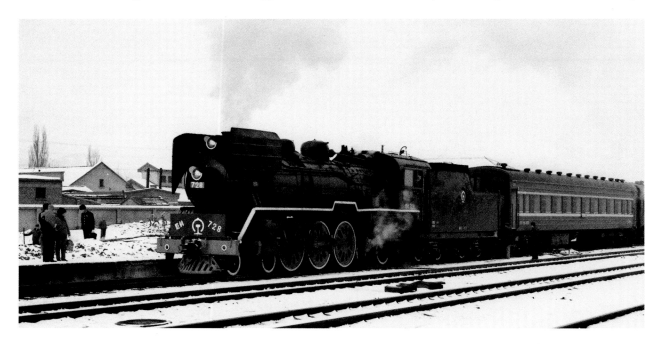

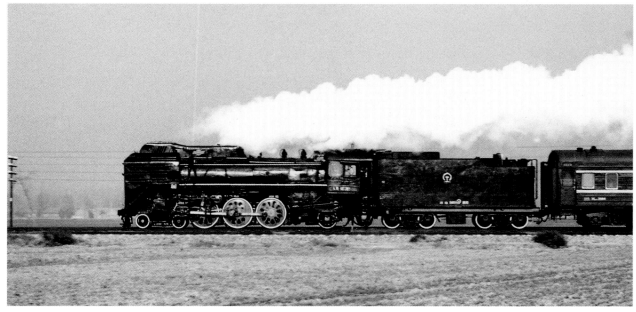

At the beginning of the 1980s China Rail possessed two classes of Pacific – SL6 and RM. The former was a design from the 1930s when that part of China known at the time as Manchuria was occupied by Japan. The RM Pacifics date from the late 1950s. SL6 no. 728 (top) had just arrived at Datong and was being uncoupled from her train. The double-track mainline into Xian, home of the Terracotta Army, saw around 100 trains a day in 1982, all of them steam hauled. In the countryside to the east, an unidentified RM (bottom) was caught at speed bound for the city.

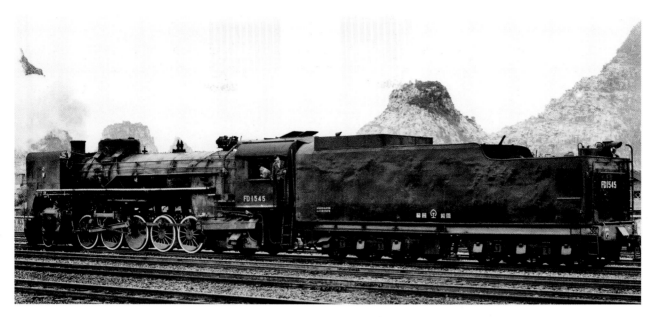

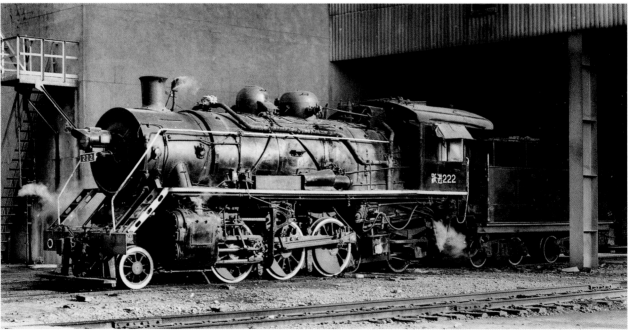

The class FD 2-10-2s were built in the Soviet Union between 1931 and 1942. About 1,250 were sold to China in the late 1950s and early 1960s where they were rebuilt to standard gauge from the Russian gauge of 5ft. No. 1545 (top) was seen during an afternoon's photography at Guilin. This was abruptly terminated when we unwittingly photographed a train carrying military equipment. Threatened with confiscation of our films, we were quarantined in the bus which had taken us to the station. When darkness prevented any further activity we were allowed to return to our hotel with films intact. Both sides had avoided losing face.

Wuhan steelworks had its own rail network of some 140 miles with a fleet of fifty steam locomotives, including this YJ class 2-6-2 (bottom).

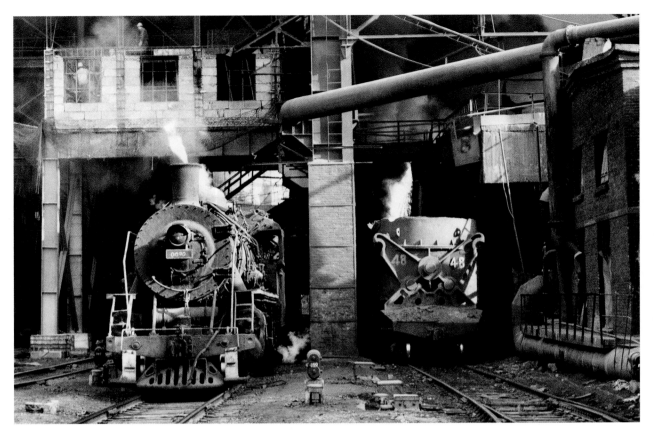

The steelworks at Anshan, in what used to be Manchuria, was another location which, surprisingly, was open to visitors – after payment of a few dollars in exchange for a hard hat. The complex was on a vast scale. A writer in the mid-1980s claimed that over 250,000 workers were employed. Figures quoted by another in 2005 showed that the output of iron and steel was half as much again as that for the whole of the UK. What is undeniable is that a visit was an amazing experience. Something of the atmosphere is, I hope, captured in the photos on this page and the next, taken during visits in December 1996 and October 1997. Here, molten slag is seen being poured from the furnaces into huge side-tipping wagons to be taken, by steam, to the slag tips on the outskirts of the complex.

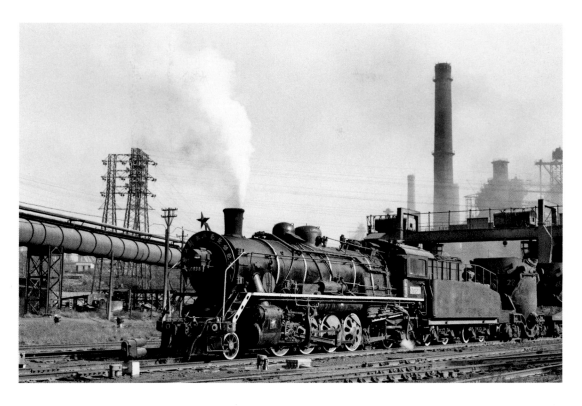

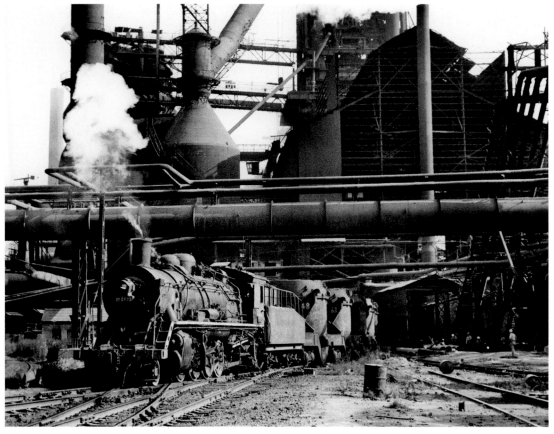

These locos are class SY 2-8-2s, a type much used in heavy industry, as demonstrated on the next ten pages. The occasional brand new SY was still being built at the end of the twentieth century and at the time of writing a few remain active in China.

Jalainur open-cast coal pit was in the far north of China, not far from the Russian border. In October 2007, thirty-five active SYs were seen in two-and-a-half days' photography. Some idea of the scale of operations can be gauged from the photograph below in which, when enlarged, it is possible to pinpoint twelve locos in steam.

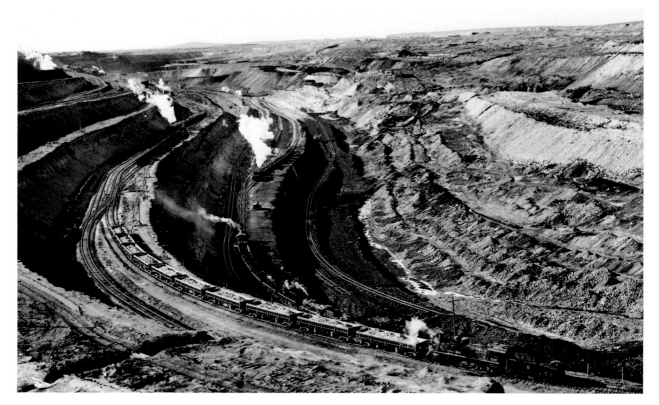

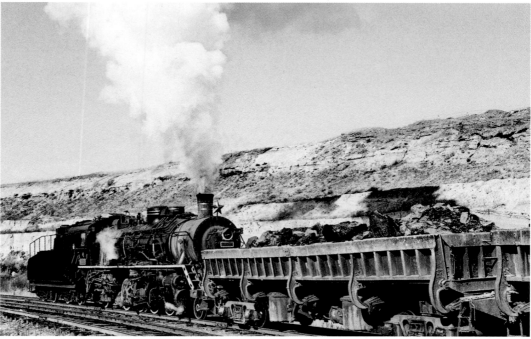

Trains zigzagged down into and up out of the pit all day and night. The SY above, sporting a red star in front of its chimney, was propelling a rake of side-tipping wagons up one of the zigs, or zags. Readers can find out more about Jalainur in my previous book, *In Search of Steam*.

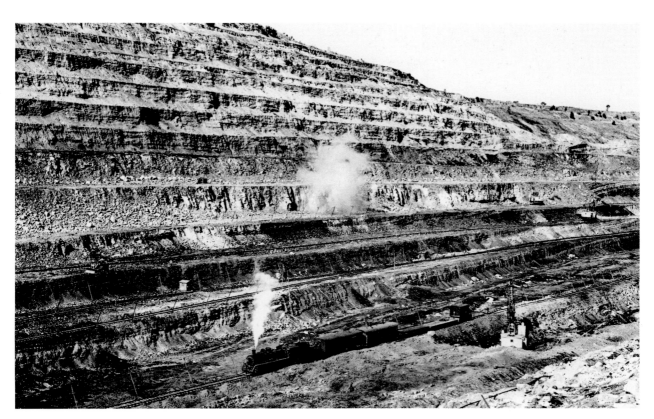

Another open-cast pit could be found at Pingzhuang. In October 2007, activity there was much less than at Jalainur. Indeed, the only signs of life were two permanent way trains. In the context of open-cast mining, 'permanent' is something of a misnomer. Much of the track gets lifted and relaid elsewhere as the pit gets deeper and/or wider. Encouraged by friendly waves from the track gangs, we were able to walk to the very bottom without being challenged. That wouldn't have happened in 1982. The view above was taken about halfway down and shows the extent to which earth and rock has had to be removed to find the dark coal-bearing seams.

SY no. 1025 was at the head of a workers' train in another part of the pit, though some of the gang had clearly got there by independent means.

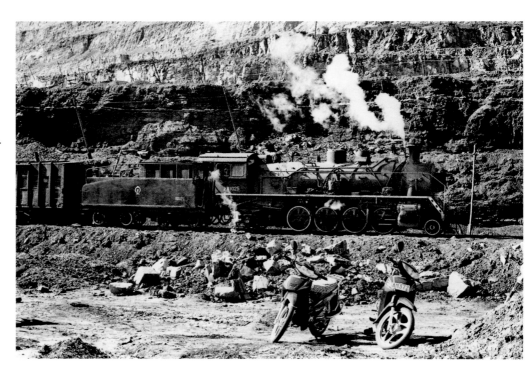

Most of the coal produced at Pingzhuang came from deep mines. In October 2007, SY no. 1052 (top) left the washery with a full load, bound for the exchange sidings with China Rail. The slogan on the headboard reads 'harmony and safety'.

At the time of writing, the network of coal lines at Fuxin remains a steamy place though some diesels have appeared on the scene. Between 8 and 9 o'clock each morning, the loco crews change shift. In October 2011, six SYs were present at the changeover (bottom) – the sixth was out of sight behind a building to the left of the picture.

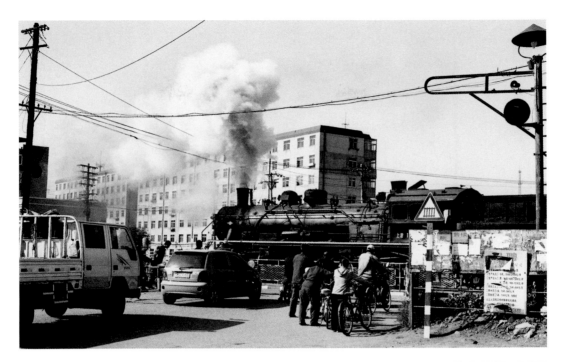

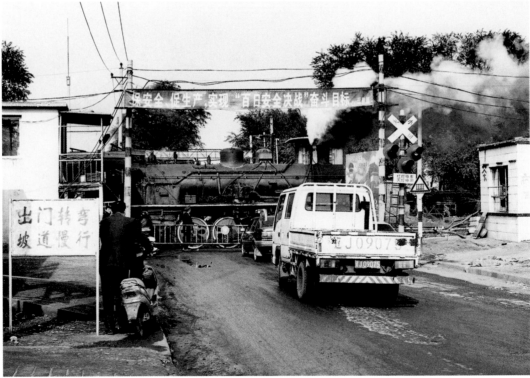

Level crossings are fascinating places. Chinese road-users appear to be just as impatient as people the world over when it comes to having their way blocked, however temporarily. When the obstruction is removed, the rule of the road seems to be to head for the biggest gap between vehicles, no matter in which direction they are facing. (Never to be forgotten was a taxi ride in Beijing when the driver in the fast lane of a dual carriageway exited by cutting across the four inside lanes all of which had nose-to-tail traffic.) The first of these two photos interrupted a delicious lunch of meat-filled dumplings and beer, partaken in a roadside 'restaurant' in Fuxin. The second features the entrance to Wulong colliery at Fuxin. The crossing keeper was a grumpy so-and-so. He didn't like me standing on his equipment. Perhaps the slogan on the banner was something to do with safety.

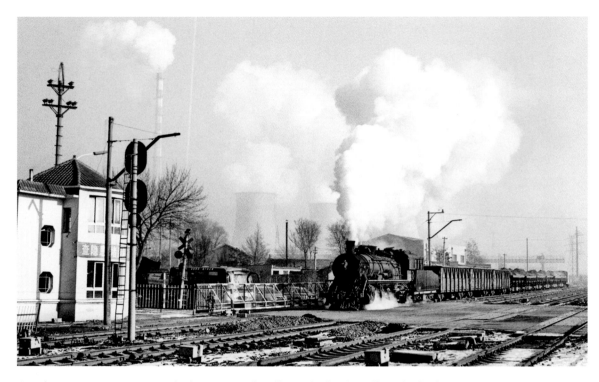

Another crossing at Fuxin with three rows of traffic ready for the off. In the background is the power station which consumes much of the coal produced in the area.

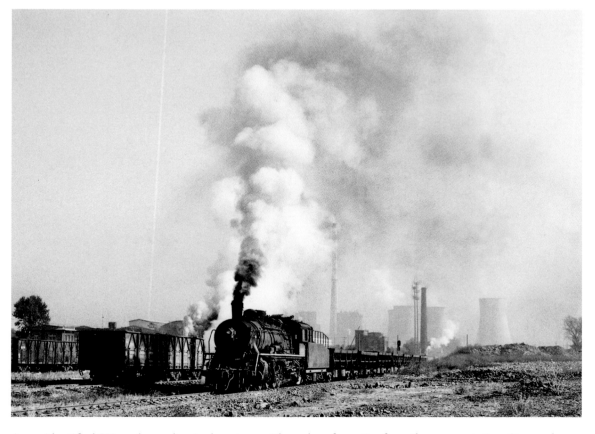

An unidentified SY made a volcanic departure with a rake of empties from the power station. Steam plumes show that there were two more locos at work in the vicinity.

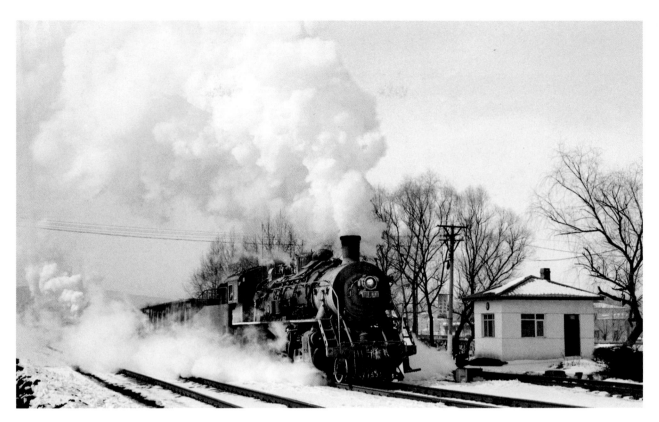

The coal mining area centred on Jixi, east of Harbin and close to the Russian border, has featured in previous books of mine. A number of separate railway systems connected the area's coal mines with the national network. Such was the attraction of Jixi from a steam point of view that my good friend and fellow photographer Richard Turkington and I paid two visits in the same year – March and November 2009. We wanted steam effects but hadn't bargained for the severity of the climate. On our second visit, the often-polluted air plus daytime temperatures of –10°C made for very trying conditions. But when the sun shone, the spectacle of 'real' steam hard at work more than made up for all the discomforts. Above, a rake of empties was leaving the exchange sidings at Hengshan at the start of the climb to the local mine. Such was the severity of the gradient that a second loco was required to bank the train. Its exhaust can be seen in the distance. At Pinggang colliery (right), SY no. 1118 departed with fully laden wagons bound for the national railway at Lishu.

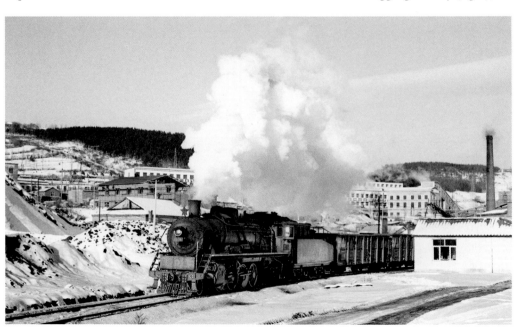

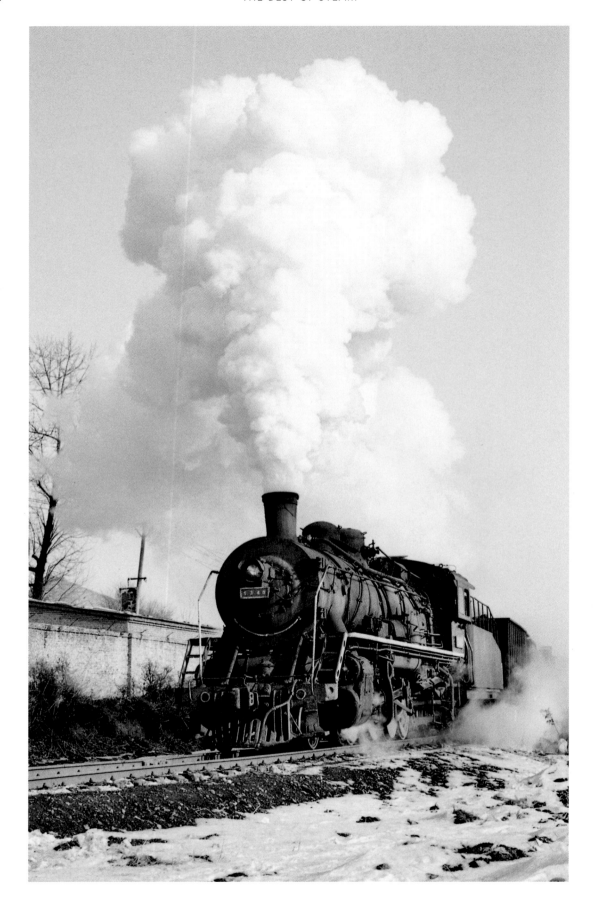

One of the highlights of the Jixi area was the steeply graded curved line from Dongchang mine to Beichang washery. Though this section of track wasn't very long, the locos of loaded trains heading for the washery had to work flat out. Unlike SY no. 1340 (opposite), they didn't always make it at the first attempt.

The loco sheds at Fushan steelworks, east of the city of Shenyang, took some finding. In October 2011 all we and our guide knew was that they were near a pair of wooden cooling towers. Dirt tracks took the van in which we were travelling to the back of beyond. Cooling towers? Yes, but the wrong ones. After a phone call, the driver's nephew appeared from nowhere to point us in the direction of the correct dirt road. Even then we weren't sure if we would be allowed in as we had no official permit. Sweet talking and an exchange of cigarettes between our guide and the man on the gate smoothed the way. We found three SYs in light steam and a fourth shunting the yard. In no way could the environment be described as scenically attractive, even though the sun was shining. This was industrial steam in the raw.

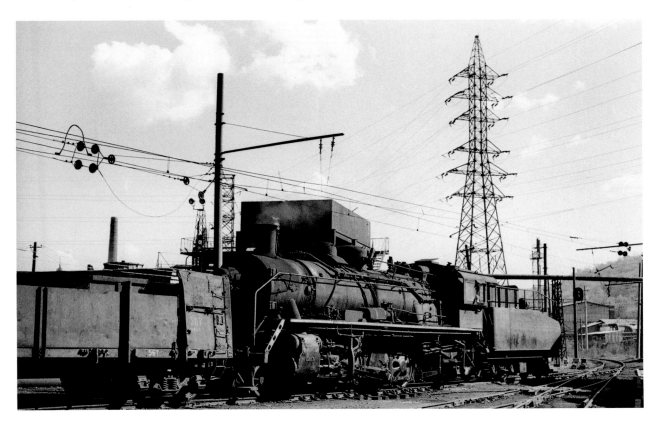

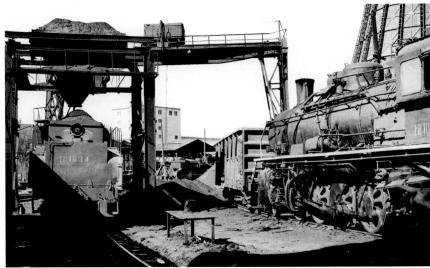

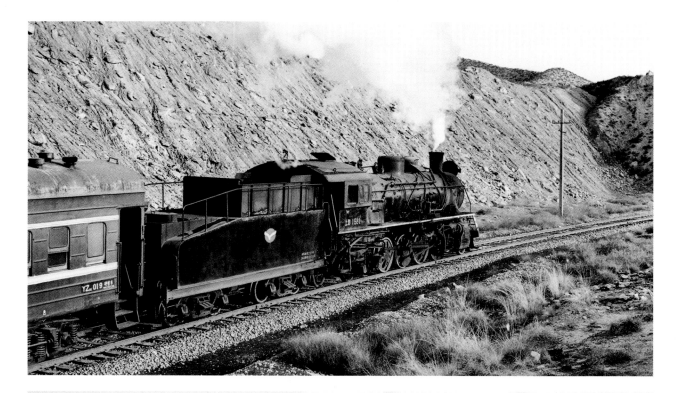

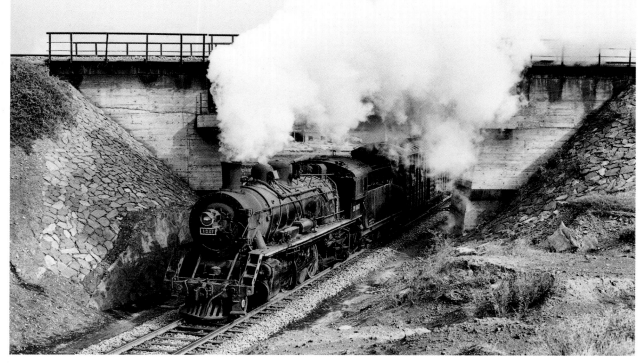

Baiyin lies to the north of the city of Lanzhou in Gansu Province. It has a private railway run by the Baiyin Non-Ferrous Metals Company linking mines with factories where copper, lead and zinc are smelted. Though diesels have taken over much of the traffic, at the time of writing steam has been retained to work the winter passenger trains. SY no. 1581 (top) was climbing into the hills, heading for the mines at Shenbutong with the morning workers' train in March 2009. In October 2011, no. 1047 emerged with a short rake of wagons from one of the smelting works (bottom).

Before saying goodbye to the SY class, I can't resist including this photo, taken in the sheds at Jalainur in October 2007. The aroma is almost tangible.

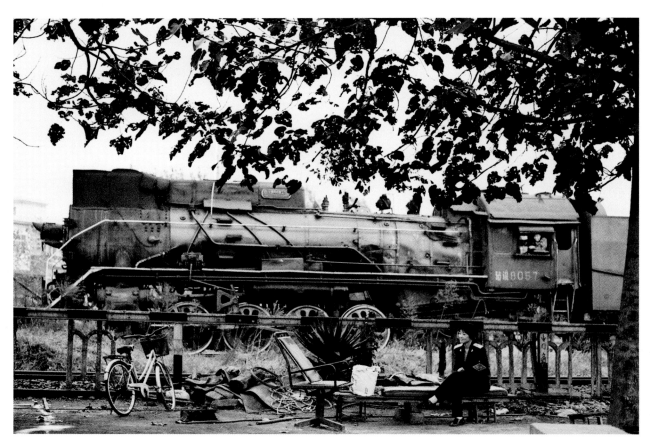

The class JS 2-8-2s were built in China at roughly the same time as the QJs. Latterly they could chiefly be found at two industrial locations – the coal-mining areas of Pingdingshan in central China and Sandaoling in the far north-west. Steam has now finished at the former but was very much alive and kicking in October 2007. A level crossing near the spur to the loco sheds was a great place to watch the constant activity – passenger as well as coal trains. We too became an attraction for a local press reporter – or was he from the authorities? Photography was tricky because of the heavy pollution; coal dust even found its way into our hotel rooms via the air conditioning. During one of the less hazy periods, JS no. 8057 (top) passed the lady crossing-keeper's garden.

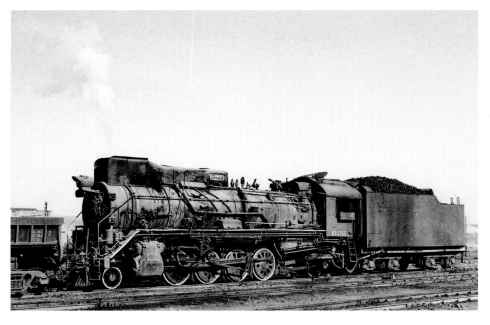

At the time of writing, steam is still active at Sandaoling on a network of lines serving deep mines as well as an open-cast pit. The crew of no. 8368 (left) were waiting for instructions at Xibolizhan in March 2009. Beautiful? That's a matter of opinion.

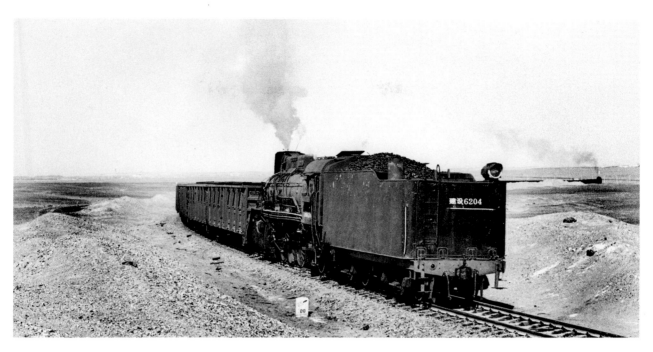

Sandaoling is linked to the national rail network at Liushuquan by a single-track line which traverses a bleak arid landscape. The gradient favours loaded trains which means there's a stiff uphill climb for the returning empties. In March 2009, trains from the exchange sidings, often with as many as sixty wagons, were worked by a pair of JSs, one at the front, one at the back. With such a long train, it was surprisingly difficult to compose a shot which included both locos. In the photograph above, JS no. 6204 was the banker. The leading engine can just be seen in the far distance.

Sandaoling had its own workshops where, in October 2011, heavy overhauls were still taking place.

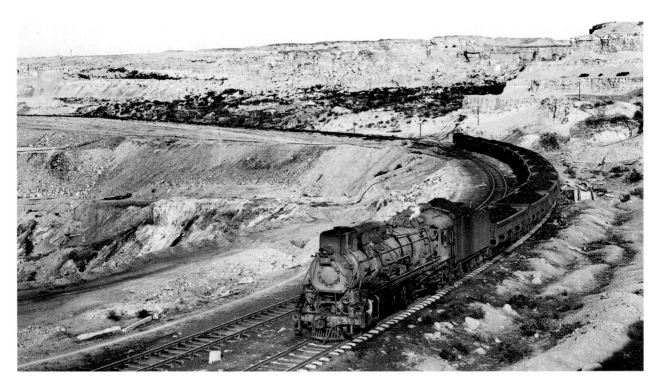

By October 2011 diesels had taken over the trains to and from the exchange sidings. Most of the steam action was then centred on the eastern side of the open-cast pit. From a loading point at the bottom, a double-track line gradually ascended to the top. Such was the volume of coal being moved that at times there was a train every twenty minutes or so. Cue a vantage point to enjoy what must be the last great steam show in the world. For Richard and me, this was the culmination of our fourth trip to China together, during which we visited six industrial locations; and it was at this very spot that we bagged our fiftieth active steam loco of the trip. It was time to celebrate. Having despatched our ever-willing guide, Alan Wang, to procure some beer, the hills resounded to a song specially composed for the occasion, to the tune of *Robin Hood*: 'Sandaoling, Sandaoling / home of the JS / Sandaoling, Sandaoling / JS is the best / JS to the left / JS to the right / Sandaoling, Sandaoling, Sandaoling!' I'll spare you the lyrics of the other verses. Should anyone be interested, the locos above and below were nos 8140 and 8194 respectively.

Opposite: Until a few years ago, it was possible to see real steam within an hour's drive of the centre of Beijing. The Dahuichang narrow-gauge railway was only about a mile or so long. Its purpose was to take stone from a quarry to a crushing plant from where it was transferred to the standard gauge. The difficulty was finding it. In 2000, my wife and I succeeded only

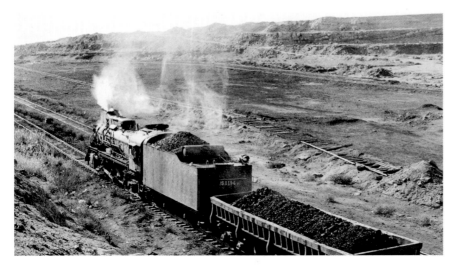

through the persistence of our local guide. The taxi driver had never been there and didn't want to lose face by admitting he was lost. However, once we'd arrived he was as fascinated as we were. As a bonus, there was steam on the standard gauge, too. All should have been well in 2004 with an organised group but no one had thought to make sure the railway was running. 'Come back tomorrow, please.' It's as well that we did because the line closed the following year. In March 2004, a loaded train (top) approached the crushing plant, and a train of empties (bottom) left for the quarry.

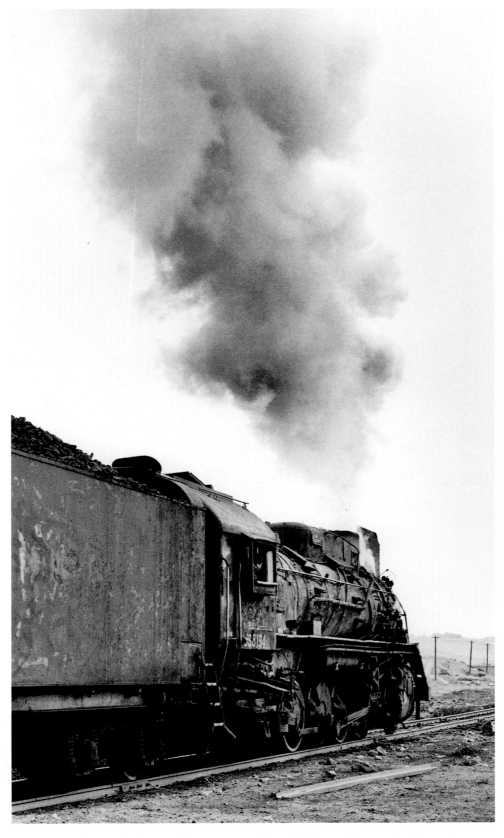

To return to the standard gauge for a moment, JS no. 8194 was photographed storming away
from the loading point in Sandaoling's open-cast pit in October 2011.

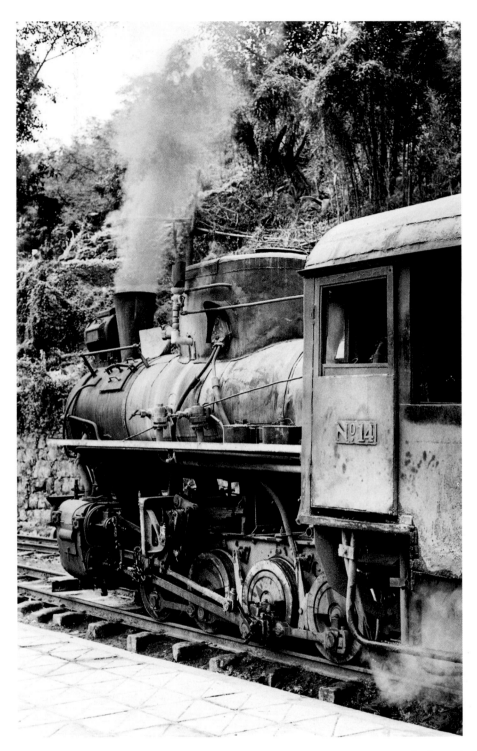

The province of Sichuan, with its lush vegetation and paddy fields, is a world away from Sandaoling. There are, however, pockets of industry which explain how a narrow-gauge (762mm) railway came to be built in 1959 from Shibanxi to mines some 12 miles away. The line carried everything needed by the remote communities it served – materials, people, animals – as well as coal from the mines. In recent years it has been promoted as a tourist attraction. To quote a local guidebook, 'small train runs among high mountains along which terrace displays the unique and beautiful rural landscape.' However, the railway's claim to be 'the only narrow-rail small steam passenger train in the world' is way off the mark. In October 2007, one of the 0-8-0 locos which work the line paused at Ba Jiao Gou with the afternoon passenger train from Sibanxi. What tiny wheels.

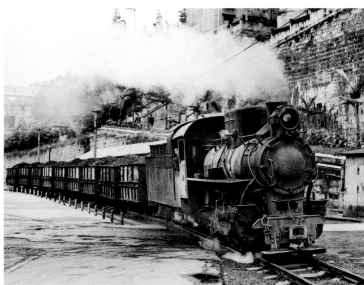

When not much seems to be happening, railway photography requires a deal of patience. Whilst waiting for action on the Yankuang Coal Railway – one of the last QJ haunts – in October 2007, Richard caught up on his notes (left). What would we Brits do without our elevenses?

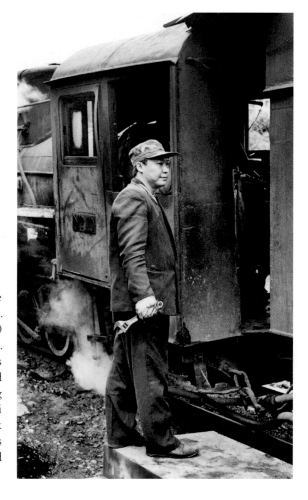

In October 2007, a coal train (top right) from the mines at the far end of the Shibanxi railway rattled through Yue Jin Qiao. Like steam crews the world over, the driver of Shibanxi no. 10 had a selection of tools to hand (right). They were often needed. During our visit, one of the steam locos failed out in the sticks and had to be rescued, resulting in the sight of a double-headed passenger train. As already mentioned, this railway was beginning to be promoted as a tourist attraction – witness the 'pub' at Mi Feng Yan (above). Whilst waiting for our train there we partook of a beer or two. Next door some sort of construction work was going on. With no vehicular access, bricks were being delivered on the backs of donkeys. All part of the China experience.

How much longer will industrial steam survive in China? By the time this book is published, it is expected that the water cranes (top) at Xibolizhan on the Sandaoling system will see no further use. At the Yankuang Coal Railway, vegetation was already gradually smothering the remains of QJs in 1997 (bottom).

5. The Indian Sub-Continent

What can one say about the experience of India which hasn't already been said? With its extremes of grace and wretchedness, of life for the urban elite and the rural poor, of five-star luxury hotels and city slums, of nuclear technology and bullock carts, and so on, is it possible to come to terms with the country in a rational way? I can only repeat a comment from *Steam Railways Around the World*: if there is an answer to this question it probably lies in not judging India by Western values and through Western eyes. By taking this approach the visitor can begin to relax, despite the poverty, the heat and dust, the crowds and their inquisitiveness, the bureaucracy, the power cuts, the mosquitoes and the stomach bugs. Mark Twain wrote that India was 'the one land that all men desire to see, and having seen it once by even a glimpse, would not give that glimpse for the shows of all the rest of the globe combined'. Whilst that's a bit over-the-top, there's no denying that India exerts a fascination and a hold on many Westerners.

To see and experience the real India away from the main tourist hotspots there is no better way than to take a long train journey – and I don't mean one of the luxury hotels-on-wheels aimed at rich tourists. The stations themselves often reflect the whole kaleidoscope of life, from business commuters to the homeless.

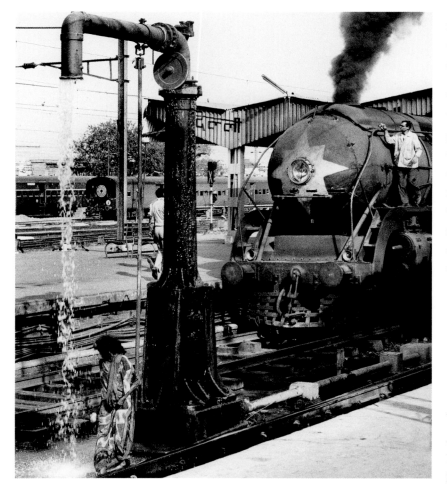

Sadly the latter include children, for it has been estimated that every five minutes a child arrives at a station somewhere in India. It's a place they can scrape a living by selling refilled water bottles or by begging. But it's also a magnet for pimps and drug-pushers which is why the charity Railway Children is working with the railway police, the Indian authorities and local charities to make stations safer places, by reaching children before those who prey on their vulnerability do.

At Delhi Junction in November 1985. One of the station dwellers was taking a wash whilst a class WP Pacific waited to depart with a local passenger train.

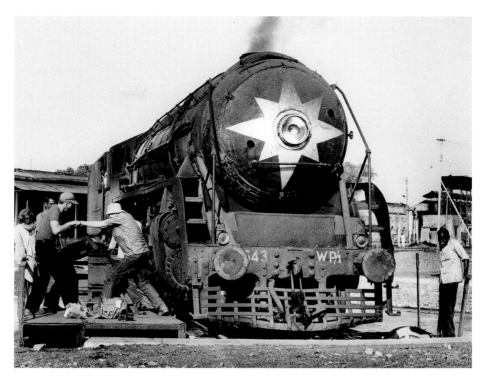

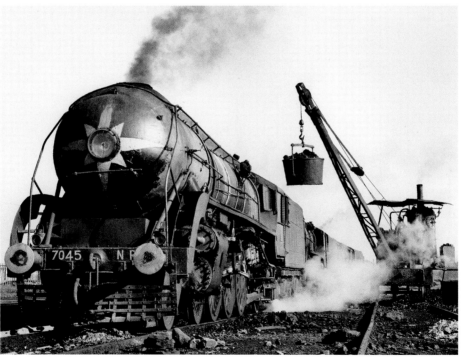

India had steam on four gauges – broad (5ft 6in), metre, 2ft 6in and 2ft. On the broad, the WP Pacifics were the most distinctive class of steam locomotive. The prototype was built in the USA in 1947. Twenty years and 754 locos later, the last was constructed at India's own workshops at Chittaranjan, West Bengal. Much to the amusement of the local staff, Brits helped turn no. 7643 on the hand-operated turntable at Agra (top). Of 1965 vintage, she was built at Chittaranjan. The coaling of steam locos in India was often by primitive means – sometimes, it was from baskets carried on the heads of men. At Lucknow broad-gauge sheds, matters were at least partly mechanised with the help of a steam-operated crane. No. 7045 (bottom) was built in 1957 by the Austrian firm Wiener Lokomotivfabrik. Both of these photos were taken in November 1985.

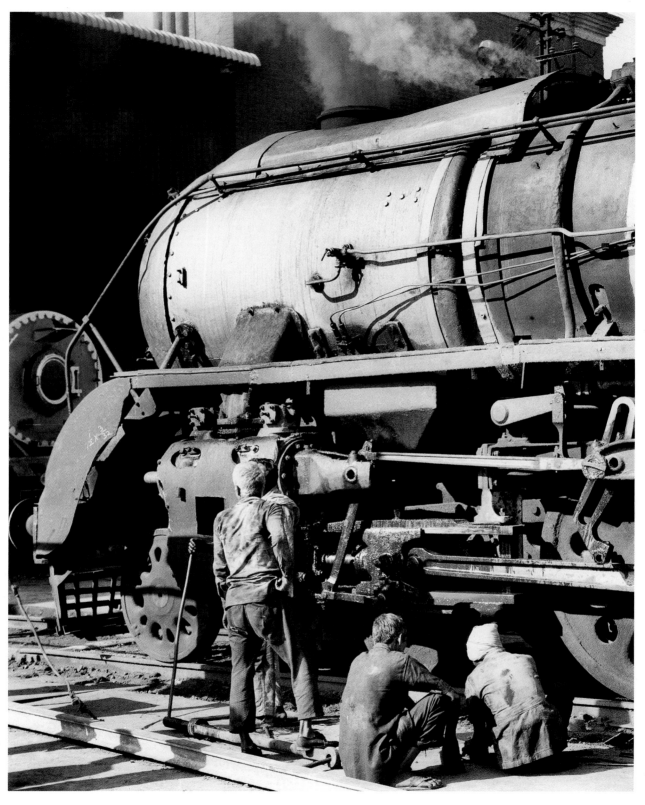

In the mid-1980s, Lucknow was a very steamy place with busy sheds on both broad and metre gauges. An unidentified WP receives some attention in November 1985. The sheer size of a steam loco is best appreciated from ground level, especially when contrasted with the human form.

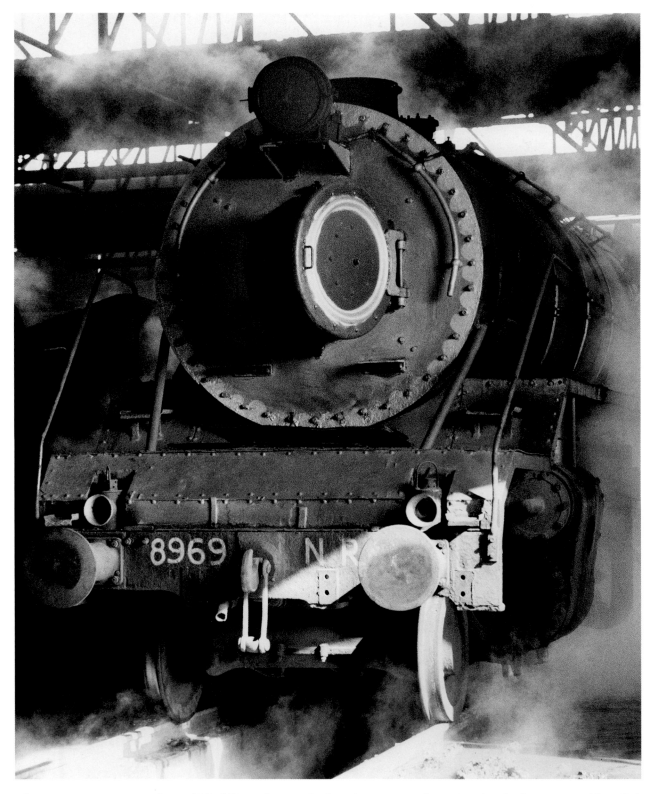

The most numerous post–Second World War class on the broad gauge was the WG 2-8-2, built to cope with India's expanding freight traffic. One source states that 2,450 engines of this type were put into service, making it the largest single-class of steam locomotive on any railway within the British Commonwealth. The majority were constructed in India's own workshops but a number came from British and Continental builders. Photographed at Lucknow in November 1985, a very grubby no. 8969 was one of a batch of sixty built in Austria in 1954.

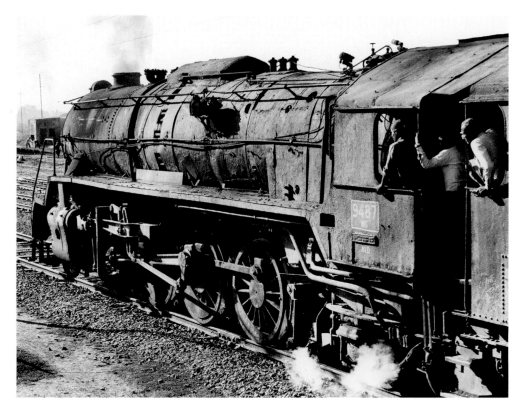

In November 1985 the Toofan Express was timetabled to take thirty-four hours for the 900 miles from Calcutta to Delhi. This meant an average speed of just over 26mph. Some express! Since the word 'toofan' is a variant of 'typhoon', whoever named this train must have had a sense of humour. WG no. 9487 was hauling the train when seen at Idgah Junction near Agra. The letters ALD on the cabside indicate that the loco's home shed was Allahabad. Shovelling coal in the confines of the footplate can be hard work at the best of times, and India's climate must have made conditions very unpleasant. Hence, steam locos often had more than one fireman, though the gentleman with the clean shirt can't have been one of them. No. 9487 was built in India in 1957.

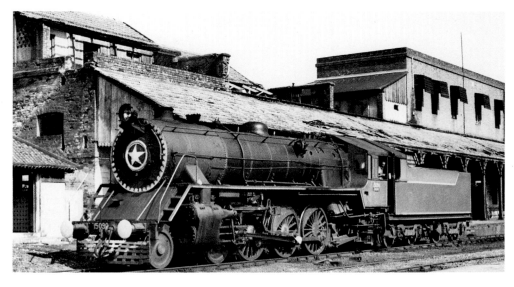

The class WL was a light Pacific of which ninety-four were constructed. No. 15090 was photographed at Erode, southern India, in November 1977. She too was a home product, having rolled off the production line in 1968.

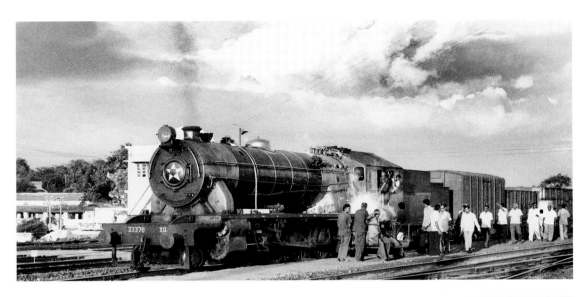

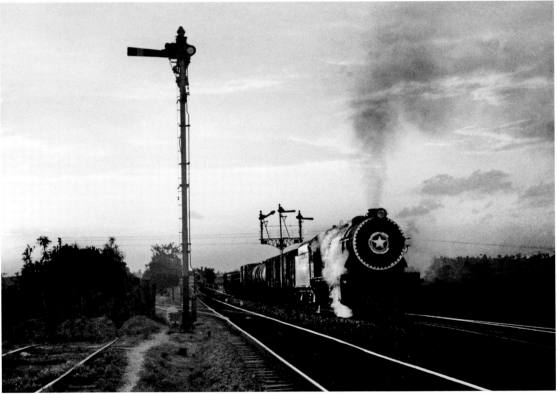

At the beginning of the twentieth century there was a multiplicity of railway companies in India, each with its own preference in locomotives and its own views on dimensions, etc. Since the majority of locos were British built, the UK manufacturers felt their work would be easier if the various railways adopted common types instead of the plethora of individual designs. From this came the British Engineering Standards Association's (BESA) standard classes, followed in the 1920s by Indian Railway Standard (IRS) designs of which the classes XD and XE 2-8-2s were two. In the late afternoon, under a dramatic sky, XD no. 22370 (top), built in Glasgow by the North British Locomotive Company in 1946, was approaching Secunderabad with a freight train in November 1977. It's evident that railway tracks in India are often used as footpaths. In the same month, XE no. 22578 (bottom) crossed the River Cauvery in southern India with a short freight. She was built in 1945 at the Vulcan Foundry, Newton-le-Willows, Lancashire. I'm not sure about the artistic merits of this composition and will leave the reader to form a view. Glint shots are like Marmite: you either love them or hate them.

During and after the Second World War there was a huge increase in traffic on India's railways. The urgent need for extra motive power was met by an influx of locos from American and Canadian builders. On the broad gauge, the majority of these were 2-8-2s, those from the USA being classed AWD and those from Canada CWD. No. 12649 was a product of the Baldwin Locomotive Works, Philadelphia from 1944. Resting outside the sheds at Bamy, a part of Bombay (now Mumbai), in November 1977, she was the first loco I photographed in India – hence her inclusion here. Getting to the sheds involved travelling on Bombay's crowded suburban trains where the crush and the heat were almost overwhelming.

The equivalent class on the metre gauge was designated MAWD (or WD for short), all having come from a variety of USA firms. In November 1985, no. 1572 was station pilot at Jaipur. Of 1948 vintage, she was also built by Baldwin. The attractive signals are a feature of this scene and a reminder that the infrastructure of India's railways was much influenced by British practice. Despite the approach of the train, people were still using the level crossing in the background – an everyday hazard for the local signalmen.

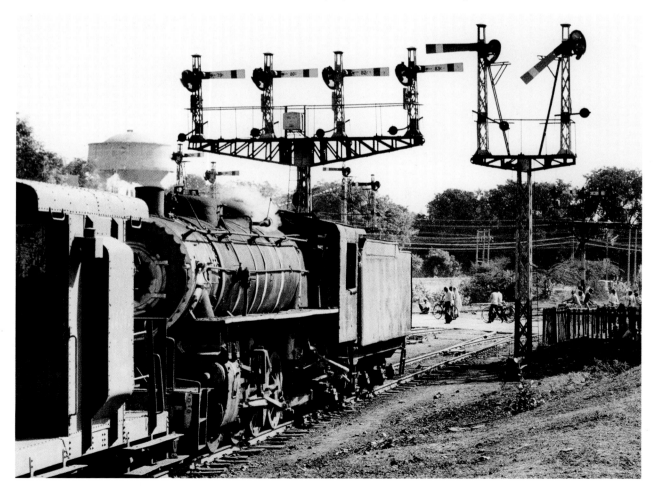

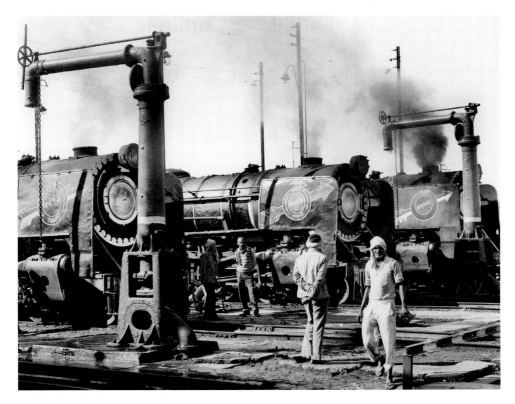

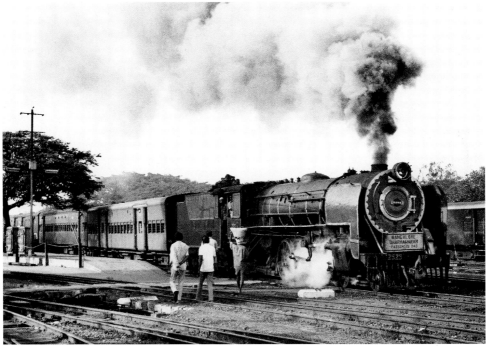

The post–Second World War class YP Pacifics and class YG 2-8-2s for the metre gauge were scaled down versions of the broad gauge WPs and WGs. Three YPs were awaiting their next duties at Varanasi sheds in November 1985 (top). Of course, Varanasi is best known for the burning ghats on the banks of the Ganges – an unforgettable sight – but had other attractions for steam buffs. Mind, finding the sheds was a bit of a problem for the bus driver. At one point we found ourselves stuck on a dirt road in a cul-de-sac on the approach to the local slums. Of such are memories made. Eight years earlier, YP no. 2525 (bottom) made a vigorous departure from Bangalore with a train for Dharmavaram. She was constructed by the Indian firm of Tata in 1963.

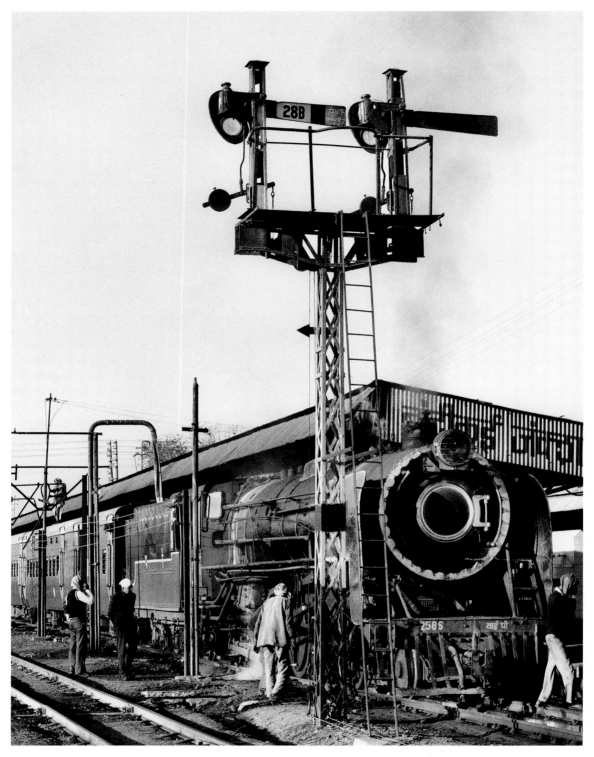

In November 1985, train 22 left Jaipur at 5.45 a.m. and arrived in Agra at 11 a.m. This was a marvellous journey. As dawn broke, the vastness of the Indian countryside became clear. India's cities might be teeming, but the rural scene is often one of apparent remoteness. At one point we crossed a dried-up river bed in the middle of a plain. Down below was a lone camel-driver and his mount and nothing else as far as the eye could see. On arrival at Agra, there was steam activity on both broad and metre gauges to enjoy; and next day the Taj Mahal was visited at dawn under a totally clear sky. There's much of railway interest in this scene of Bandikui whilst YP no. 2586 and the train's carriages were being watered. The loco was built by Tata in 1952.

Let's move on to the narrow gauge, regarded by many as the jewel in the crown of Indian railways. Indeed, there were some real steam gems. For example, who would expect to find Pacifics on a gauge of 2ft? Yet the system centred on Gwalior had half a dozen built by the English firm of Bagnall in 1931. In November 1985, Class NM no. 763 was captured on the outskirts of Gwalior with a morning train for Bhind. The driver was proud of his loco and keen to be photographed. Like many narrow-gauge systems in the sub-continent, the Gwalior railways were a substantial undertaking. Promoted by the local maharajah, who was something of a railway enthusiast, they originally comprised three routes totalling 250 miles, though by 1985 one line had closed.

The town of Dhaulpur, on the broad-gauge mainline from Agra to Gwalior, was the starting point for a 2ft 6in gauge line originally built to serve quarries. There's a story attached to this picture, taken at Garhl Sandra in November 1985. The group I was with had reached here on a passenger train from Dhaulpur behind class D 4-8-0 no. 707 built in Hannover, Germany in 1925. This train was due to cross one coming in the opposite direction on which we were supposed to travel back to our starting point. Due to a misunderstanding, six of the group failed to make the connection. Stranded seemingly in the middle of nowhere and with the next train in seven hours' time, they decided to walk the 12 miles back to Dhaulpur, unaware that this was dacoit country – allegedly. They made it.

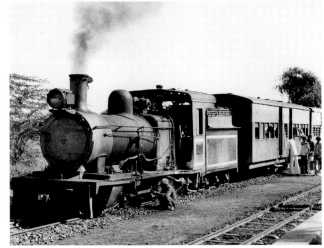

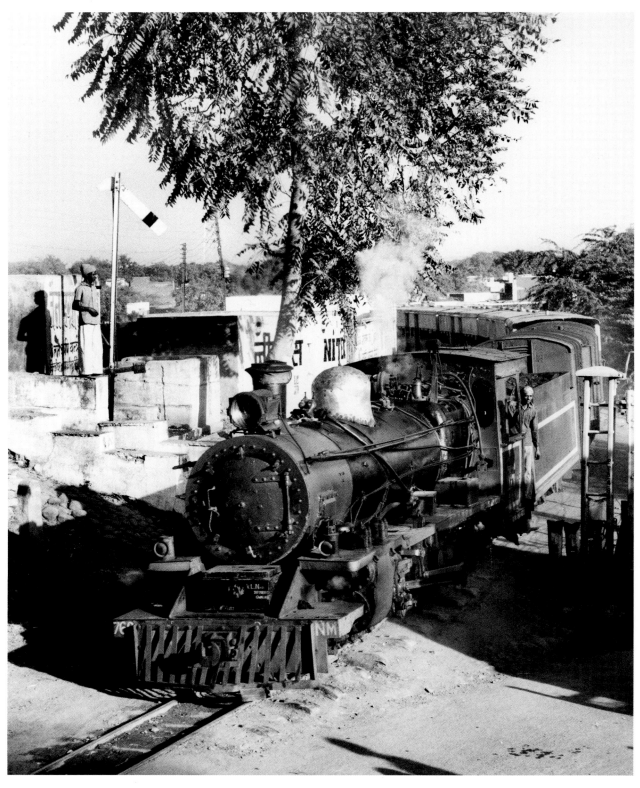

A favourite photograph. Another Pacific, no. 760, heads out of Gwalior with an afternoon train for Sheopur Kalan. The gentleman standing by the signal looked after a level crossing and kindly allowed me to sit in the shade offered by his hut. The train was late. For two hours I waited. And then I contrived to make the tree grow out of the chimney – a basic error in railway photography. Nevertheless, this scene epitomises the charm of the Indian narrow gauge. No. 760 was a class NM 4-6-2 constructed by W.G. Bagnall Ltd of Stafford in 1931.

Whole books have been written about the Darjeeling Himalayan Railway (DHR), such is the interest in what some regard as one of the railway engineering wonders of the world. Indeed, in 1997 a society was set up in the UK with the aim of making the Indian authorities aware of the line's uniqueness, for by then the railway was rundown and its future far from secure. So successful have been the efforts of the society and of influential individuals in India that the DHR is now a World Heritage Site and actively marketed as an attraction for both Indian and overseas visitors. Unfortunately, in recent years the line has suffered badly from the effects of the annual monsoons with sections being completely washed away or blocked by landslides. It's to the credit of the railway administration that there has been a determination to restore the complete railway, no matter how long it takes to do so.

Getting to Darjeeling in December 1985 took something of a personal effort. Three days previously the group I was with had been in Nepal. 'Were there steam railways in Nepal?' I hear you ask. Yes, there was a 2ft 6in gauge line which at that time had a motley collection of locos including a 1947 vintage Garratt, which makes an appearance on page 101. Nepal's railway connected with India's at Jaynagar, a back-of-beyond place at the end of a metre-gauge branch. Returning to Jaynagar we had somehow acquired a crate of beer. Railway photography can be thirsty work, but remembering that alcohol aids dehydration, I stuck to the contents of my water bottle, with added purification tablets of course. A long footbridge linked the Nepalese and Indian stations at the border. Crossing it, my legs felt wobbly. A few minutes later, but with just enough time to make sure my camera bag was unharmed, I crumpled in a heap on the platform. Later I found myself being laid on a table in the stationmaster's office. What I needed was liquid, and fast. Someone intending to be helpful filled my water bottle from a standpipe. Cue a revolting stomach and an overnight train journey. Not nice. To add insult to injury, when I and the rest of my group reached the DHR we found that the railway wasn't running. Back home my GP diagnosed giardia, an organism against which purification tablets don't work. 'You must have drunk water contaminated by human sewage,' he said, and I knew exactly where. 'In future, stick to beer,' he advised. So I have, ever since.

Kurseong sheds provided proof of the absence of trains. Neither loco was in steam.

The 1985 visit wasn't really a disaster. How could it be? Darjeeling has more to offer than just the railway – tea plantations, Buddhist monasteries, a museum of mountaineering, snooker at the Darjeeling Club, and the panoramic views (especially that of Kanchenjunga at dawn, the third highest Himalayan mountain) to name but a few. Moreover, a member of the group who worked for the railways back home persuaded the DHR management not only to allow us to visit the workshops at Tindharia but to lay on a special train for the group, albeit for only a short distance. In this photograph, the train was leaving the workshops complex and was about to join the mainline. Out of sight, hidden by the loco, a notice board proclaimed 'Photo Graphy Totally Prohibited'.

Places like India are a photographer's delight. The vibrant atmosphere and colours are irresistible. Whilst travelling, I usually have a second camera in my kitbag. After all, it's pictures of places and people which many folks back home want to see. These days a compact digital is used for colour but in the past I've taken transparencies and colour prints. Perhaps these few pages will whet the reader's appetite.

Railway stations in the major towns and cities of the Indian sub-continent teem with life – and not just of the human variety. Shortly after these scenes were taken at Lucknow, India, in November 1985, a cow nonchalantly wandered across the tracks between the platforms. In the top photo, a vendor is serving snacks. No doubt there was a kettle on the go – *chai* is served strong yet sweet. The tea, milk and sugar all go into the kettle.

Refreshment trolleys being trundled along platforms have disappeared from the UK scene. Station stops are no longer long enough. Not so on the sub-continent where long-distance trains often make lengthy halts at the main stations en route, especially if they happen to be junctions. The vendor and friends (left) were at Samasata Junction, on the mainline from Karachi to the north of Pakistan, in February 1988.

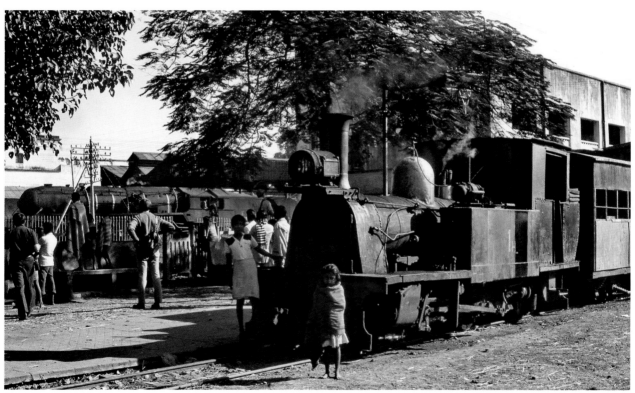

I've commented elsewhere about the opportunities which existed in a number of locations around the globe to capture locomotives of different gauges in the same photograph. In years gone by it was theoretically possible in India to get steam locos of three gauges in the one picture, a rare feat but one achieved by the doyen of Indian steam photography, Lawrence Marshall. Futwa, a station on the mainline from Patna to Calcutta, was the terminus of a narrow-gauge line to Islampur visited in November 1985. The two girls by the loco were keen to have their picture taken. Only when setting up the shot did I notice the broad-gauge WP Pacific in the background.

Because railway stations are places where people obviously gather, there's often a local market nearby, giving endless photographic possibilities. A word of warning: always make sure, by sign language if necessary, that people have no objection to their picture being taken. Some do, possibly for spiritual reasons or because they perceive a loss of face. Seen in February 2007, the market is somewhere in Burma. My notes don't say where.

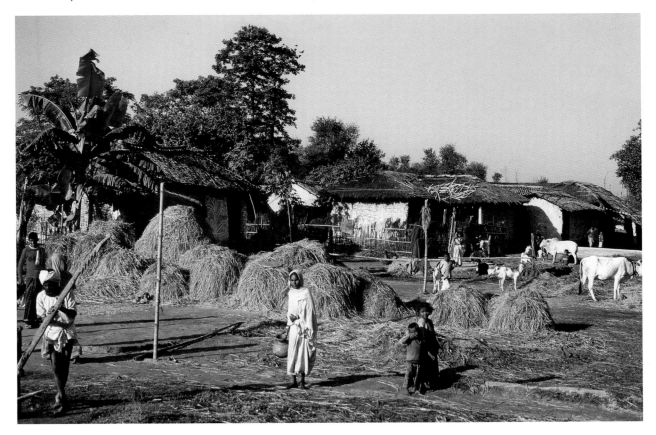

Of course such courtesy is not possible with photographs taken out of the window of a moving train. One hopes that no offence was taken by the villagers in the above scene snapped during the course of a journey on the line from Janakpur to Jaynagar, Nepal in November 1985.

Passengers are often curious to meet visitors from the West – and the less touristy the area, the more curious they are. This Burmese lady taking her wares to market in February 2007 was amused by the antics of the photographers in the train opposite hers.

This Chinese mum and daughter were happy to have their picture taken in the soft (i.e. first) class carriage of an overnight train from Lanzhou to Hami in October 2011.

The railways are not the only institutions in the Indian sub-continent where the influence of British practices and traditions are still evident. Think of the pomp attached to military ceremony. Think also of schools for the elite. Just as in my young days, these two lads didn't look very happy about having to wear their school caps when photographed at Rawalpindi Station in February 1988. One imagines that the education they received was for the privileged few.

More typical, one suspects, for most Pakistani boys was the school seen alongside the tracks just outside the station at Malakwal. A predominantly Muslim country, it's no surprise there was a mosque next door. More surprising was that there were no girls. The head teacher claimed that parents had no interest in having their daughters educated. That was over twenty-five years ago. One wonders how things may have since changed.

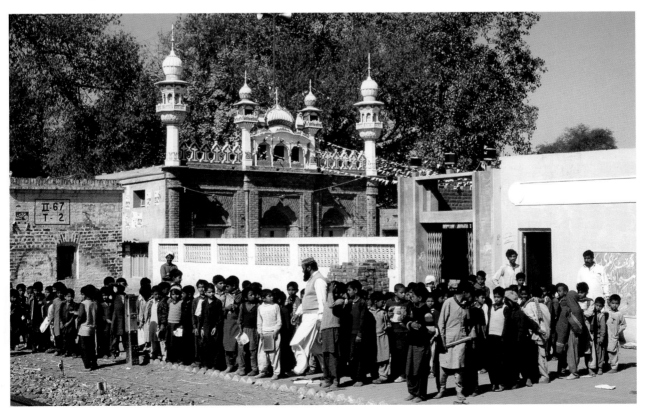

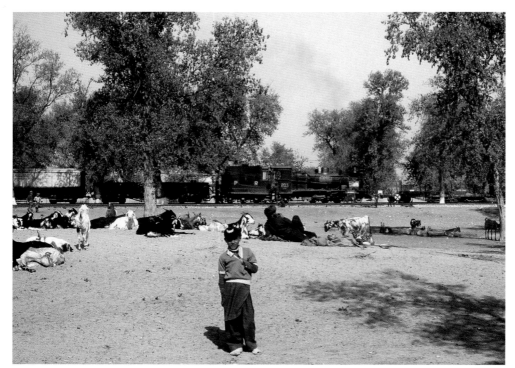

I wonder how old this boy was. Had he left school or had he never had the chance to go? He was helping a goatherd alongside the tracks at Laki Marwat Junction, Pakistan where the once-a-week train from Tank had just arrived in February 1988.

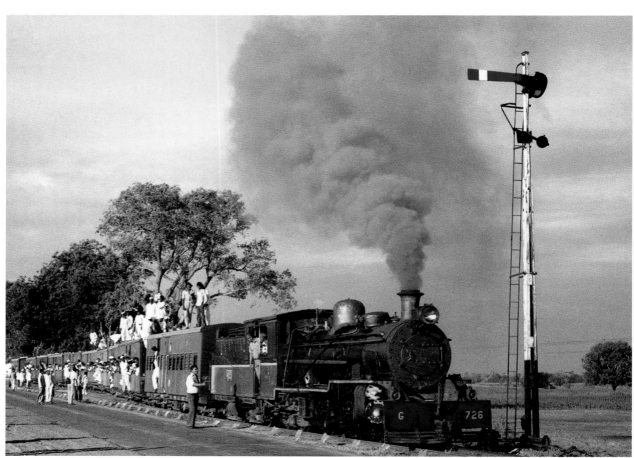

Roof-riding was common in India but still had the ability to shock Western sensibilities. However, it made for interesting photography. The early morning train from Kurduvadi to Latur was seen leaving Shendri in November 1977.

It may be infra dig to include one's partner in an album, but as this author's wife has shared some of his exploits, it's not inappropriate. In June 2014 we marked forty years of overseas steam photography by going back to Austria (see page 157).

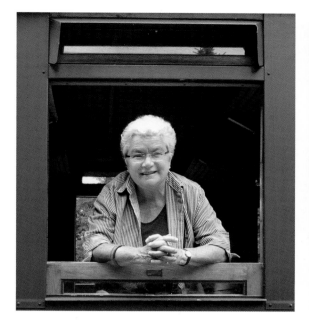

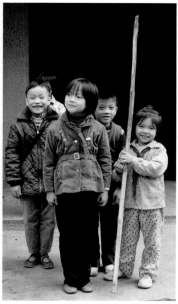

In 1982 Western tourists were something of a curiosity for Chinese children (far right).

Only an intrepid enthusiast would attempt to travel around the more remote parts of China without a guide. Aside from the language difficulties, one needs someone to navigate the local bureaucracy. During four visits Richard Turkington (left) and I have enjoyed the company of Alan Feng Wang (right) as our guide, one of whose essential tasks has been to translate food menus. Dinner in the diner on the overnight train from Lanzhou to Hami, October 2011.

A contrast in breakfasts. At Sandaoling, China (top), meat-filled steamed dumplings were a staple. Delicious. Just don't enquire about the source of the meat. Alan and our local taxi driver – sitting on the right – had no complaints. At Bukinje workshops, Bosnia (bottom), breakfast was taken in the mess room after the meat had been cooked on a locomotive shovel.

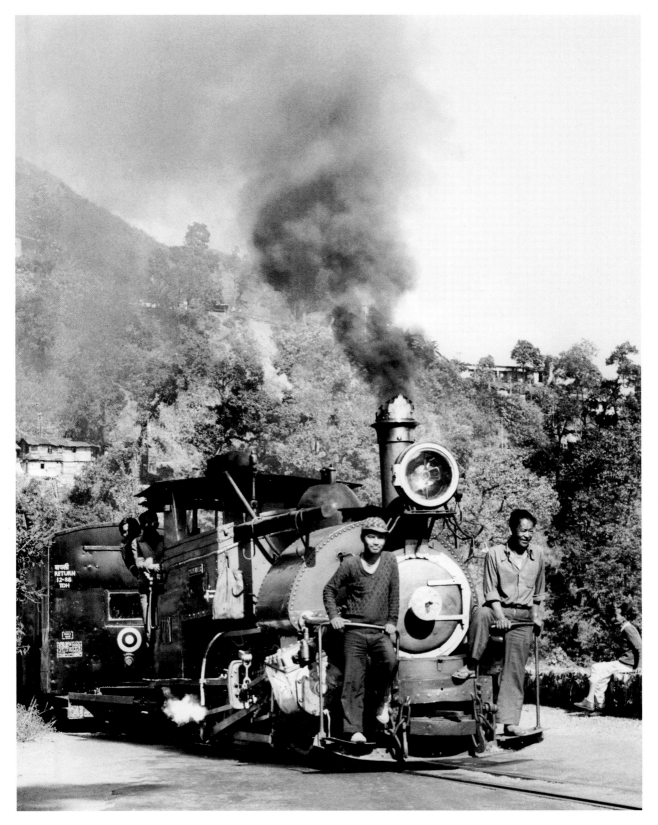

The special train referred to on page 96, en route from the workshops to Tindharia station. The loco was one of the famous class B 0-4-0 saddle-tanks. Assuming she was carrying the correct plates, she was no. 779, built in 1892 by the firm of Sharp Stewart, later to become one of the constituents of the North British Locomotive Company.

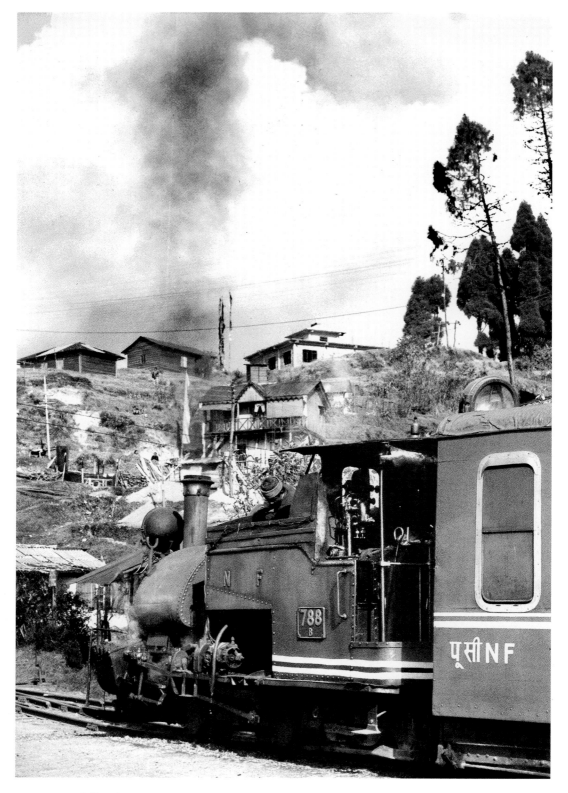

Trains were definitely running when my wife and I visited Darjeeling at the end of December 1998. The good news was that the line was still 100 per cent steam. (Since then, diesels have taken over some of the work.) The bad news was that because of a serious washout, trains were unable to operate over the whole route. On New Year's Eve we chased the morning train from Kurseong to Darjeeling with the help of local guide Nima and his jeep. Built by the North British Locomotive Co. in 1913, no. 788 paused at Rangbhul.

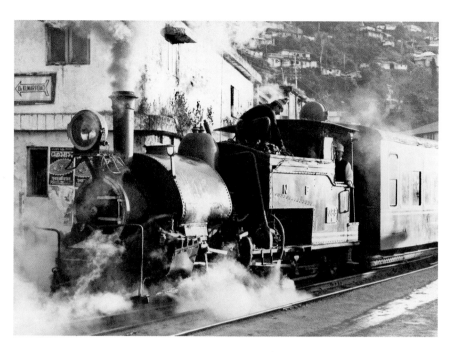

Two days later we did it all again. The first rays of the sun caught no. 788 and her train (above) as, having reversed out of Kurseong station, she started to head out of town through the main shopping street. My notes don't record the name of the spot where the photograph below was taken but on the evidence of the roadside milepost (in kilometres) it was somewhere between Tung and Sonada.

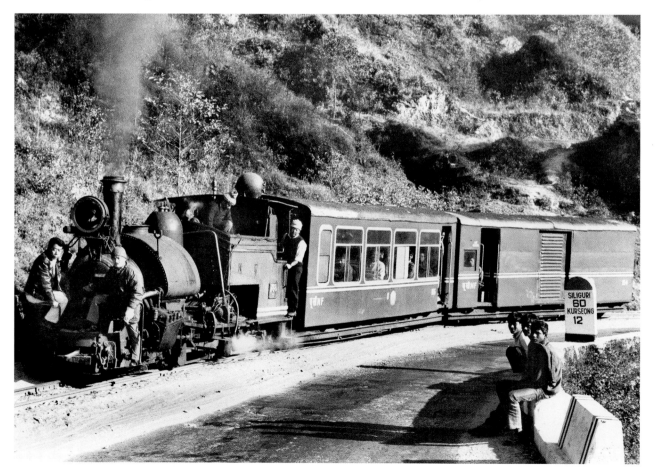

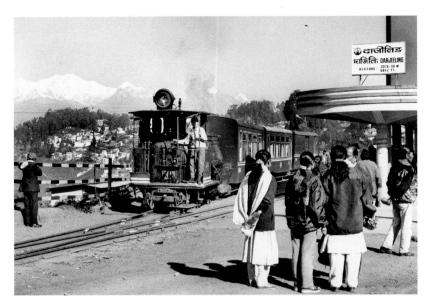

The comings and goings of a train at Darjeeling station always draw a crowd – and perhaps a vulture? '6812ft above sea level', said the sign. The reader who wants to know more about Darjeeling and its railway is recommended to visit the website of the Darjeeling Himalayan Railway Society: www.dhrs.org.

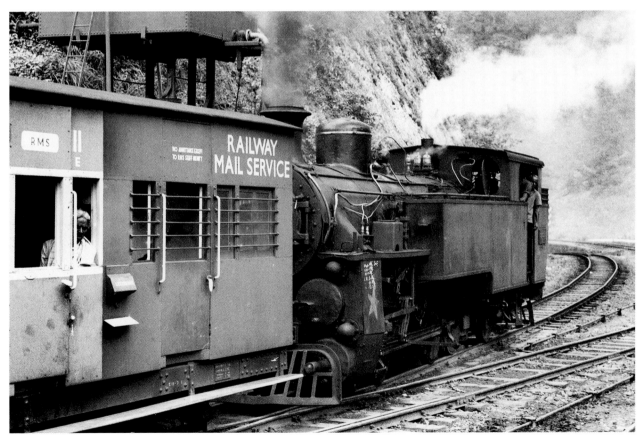

At the other end of India, down south, lies the town of Udhagamandalam. Formerly Ootacamund, and still affectionately called Ooty, like Darjeeling it was established by the British as a hill station, somewhere to escape the heat of the plains. Again like Darjeeling, it has its own railway; but with severe gradients necessitating rack assistance, the metre-gauge Ooty line is a more substantial affair than the 2ft DHR. However, this does not prevent it suffering from the effects of the annual monsoon, as in November 1977 when the line was closed by landslides. Fortunately for the visiting enthusiasts, the management put on a special train, seen here taking water at the station of Runnymede. The loco was Class X no. 37391, an 0-8-2 tank built in Switzerland in 1952. The reserved compartment for mail, with letterbox, is a reminder of how vital the railways once were to postal traffic.

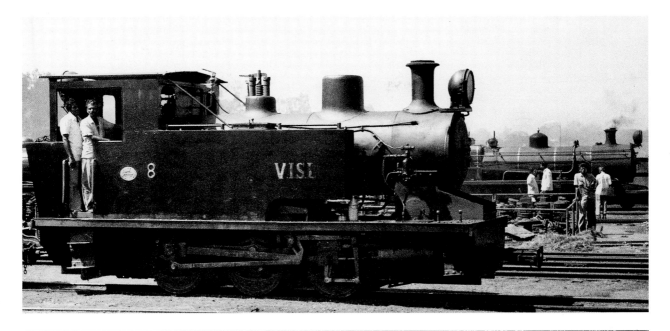

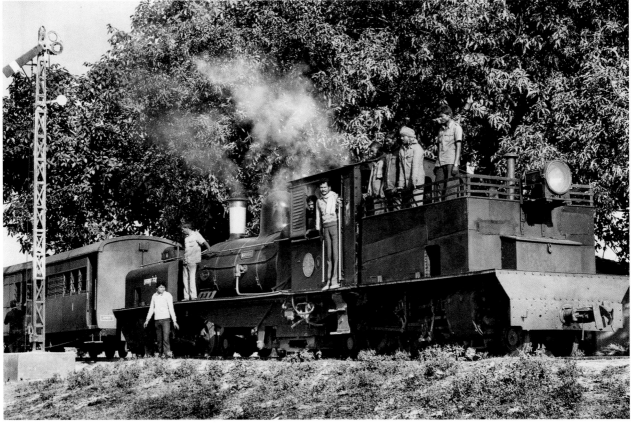

With no photographic pretentions, here are two locos for the cognoscente. As described in my previous book *In Search of Steam*, there was the opportunity in November 1977 to visit the Visvesvaraya (formerly Mysore) Iron and Steel Company's plant at Bhadravati with its large fleet of steam locomotives on two gauges. One of the metre gauge stars was this attractive 0-6-0 tank (top) built in Kilmarnock, Scotland, by Andrew Barclay Sons & Co. in 1951. In the background can be seen a 2ft gauge 2-8-2 supplied by Bagnall in the 1950s. Below is the Garratt loco seen in Nepal in November 1985 and referred to on page 95. She was built in Manchester in 1932. Not too many enthusiasts ventured to this remote outpost of steam, hence the curiosity of the crew plus local stationmaster.

Footplate crews took great delight in embellishing their steam locos for special occasions. YG no. 3438 was waiting to leave Delhi Cantonment in December 1998 with one of India's luxury hotels-on-wheels. She was built by Tata in 1962. As I believe it should always be made clear when and where a composition has been significantly altered using computer technology, it needs to be said that some careful editing has removed the station's footbridge, which appeared to protrude from either side of the loco.

Such adornments were not confined to India; Pakistan too kept alive the tradition. This was the cab of class YD 2-8-2 no. 734 which, in February 1988, worked a photographic charter from Mirpur Khas on the metre-gauge line to Pithoro Junction. The previous day, the loco had been specially cleaned and the numerals on the cabside hand-painted – literally, by fingers dipped into a paint pot. No. 734 was built by the Japanese firm Nippon in 1952.

Opposite top: In the 1980s Pakistan, like India, had steam on broad, metre and narrow gauges. When the subcontinent was partitioned at the end of the Raj, the assets of the railways were divided between the two countries. Some classes of steam loco, such as the broad-gauge CWDs, could therefore be found in both. No. 5590, built by the Montreal Locomotive Works in 1945, was photographed in February 1988 arriving at Shorkot with a train chartered by a UK enthusiasts' group. Once again the splendid signal gantry is a reminder of the British influence on the sub-continent's railways. Thirty or so hardened gricers lived on this train for ten days as we travelled in search of the country's remaining steam – we ate, slept and tried to wash on it. One comfort missing was alcohol.

Opposite bottom: After the end of the Raj, and in contrast to India, Pakistan had no facilities for building its own steam locos. Engines of some ageing classes were thus still at work after their last Indian counterparts had been scrapped. The class HGS 2-8-0s were a case in point. Built by the Vulcan Foundry in 1923, no. 2277 was shunting the goods yards at Samasata Junction in February 1988. The camel appeared to be more interested in the photographer than the loco which, except for the headlight in front of the chimney, wouldn't have looked out of place in England ninety years ago.

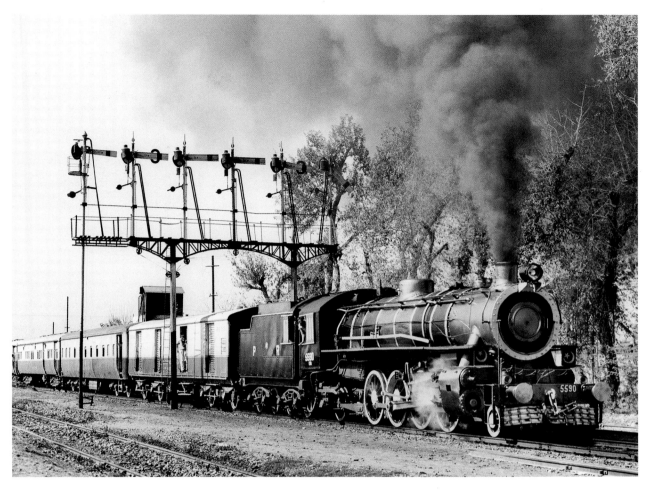

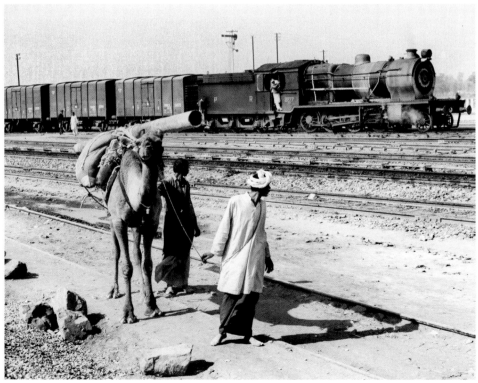

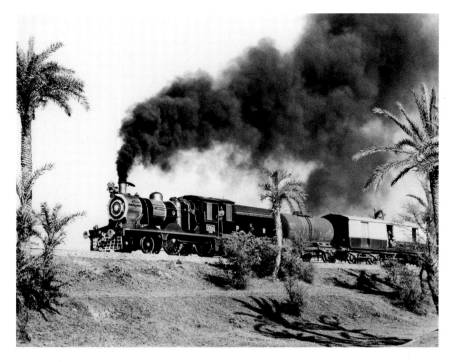

Of the steam locos to be found in Pakistan in the 1980s, the class SPS 4-4-0s were without doubt the doyen. Some enthusiasts visited Pakistan just to see these British-built locos. The Mecca of this pilgrimage and the home shed of the 4-4-0s was Malakwal on the secondary mainline from Lala Musa to Shorkot. No. 3005 was photographed en route from Shorkot to Malakwal. What a magnificent sight. Of 1917 vintage, she was built by the Vulcan Foundry in Lancashire.

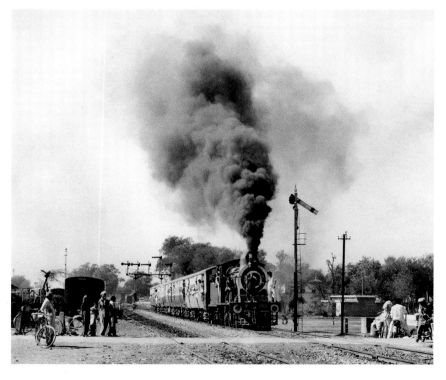

Sister loco no. 2969 was three years older. She was seen making a noisy departure from Malakwal with a late-running train to Lala Musa. This is a favourite photo because many of the elements which made up the atmosphere of steam on the sub-continent are present: heat, dust, passengers hanging on the outside of carriages and even riding on the engine, bystanders, bicycles, signals, a venerable loco and, of course, smoke.

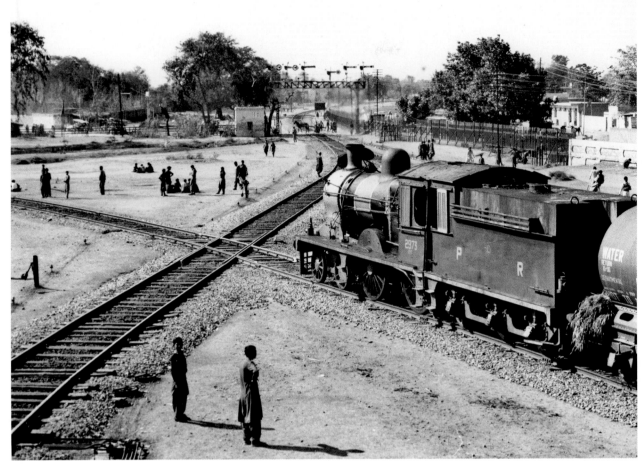

I can't resist one more shot of these wonderful machines. After school had finished for the day, the area around Malakwal station became a playground. Curious to meet Englishmen, boys would crowd around. They weren't interested in trains; cricket was their passion and was all they wanted to talk about. When the crush was such that photography became impossible, the signal box became a place of refuge – courtesy of a kind signalman – from where no. 2973 was seen (top)

departing with a train for Sarghoda Junction. From the same vantage point, Class SGS 0-6-0 no. 2410 (right) arrived with a train from Gharibwal. The 0-6-0 was another ubiquitous British design. How many locos of this wheel arrangement were built in the UK for home and abroad? Thousands, one imagines. No. 2410 was another Vulcan Foundry product, from a batch of nineteen built in 1916/17 of which four were lost at sea on their way to India.

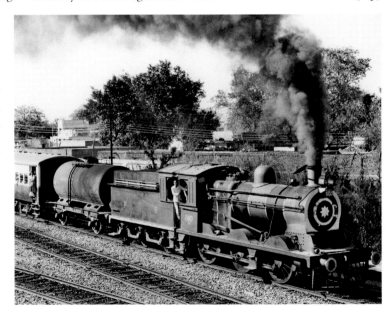

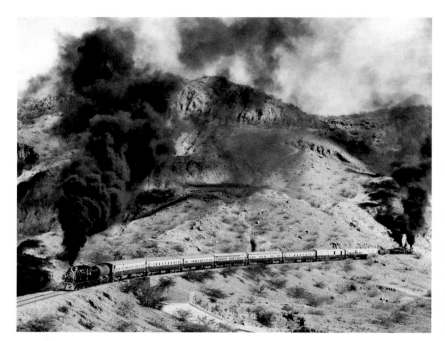

Two 0-6-0s were needed to enable the photographers' special to surmount the fierce gradients on the branch line from Malakwal to Dandot – a sight and sound never to be forgotten. The leading engine is on the left; the banker on the right. This was thought to be the first time a restaurant car had been worked to Dandot, which normally only saw one train a day. The meals served on the train were excellent. Every morning, the kitchen staff would disappear into a local market to find fresh meat and vegetables. The food wasn't responsible for the stomach upsets suffered by some, though luckily not by me this time; blame lay with the sanitary arrangements – about which the less said the better.

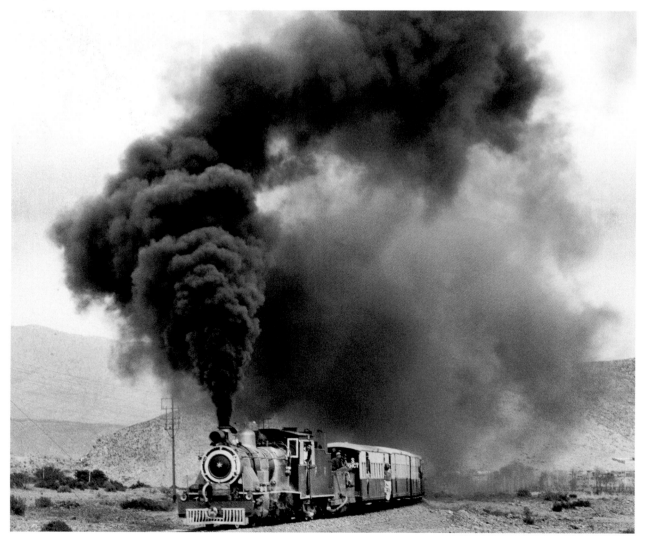

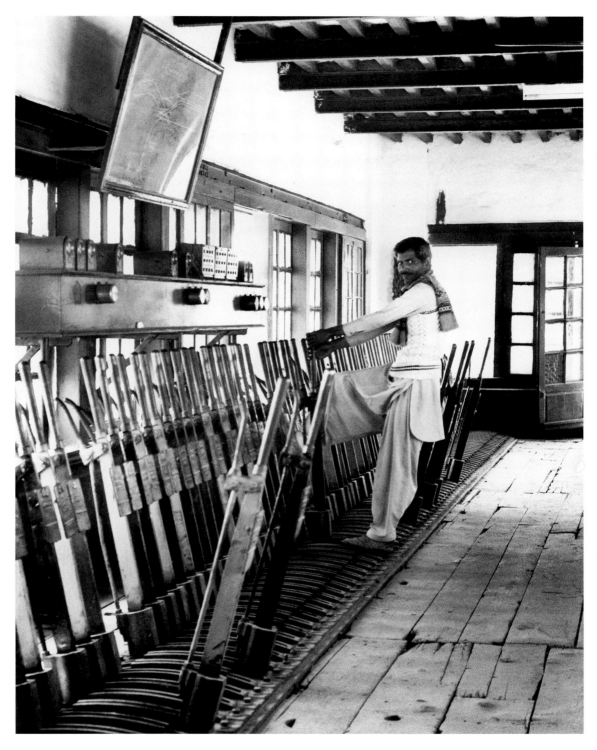

Visited in February 1988, the signal-box at Kotri Junction, Pakistan, had a British feel to it, though I'd never before been in a box where birds nested under the beams inside.

Opposite below: In 1988 a couple of the country's narrow-gauge lines were hanging on by a thread. One of these ran on a gauge of 2ft 6in for 62 miles from Kohat to Thal. In years gone by, the service on the line was such as to warrant sleeping cars; but by the time of my visit in February that year there was just one passenger train each way per week – out on Tuesdays, back on Thursdays. In bleak arid countryside, a photographers' special approached Hangu with smoke to order. The loco was class ZB 2-6-2 no. 211, built by Bagnall in 1933.

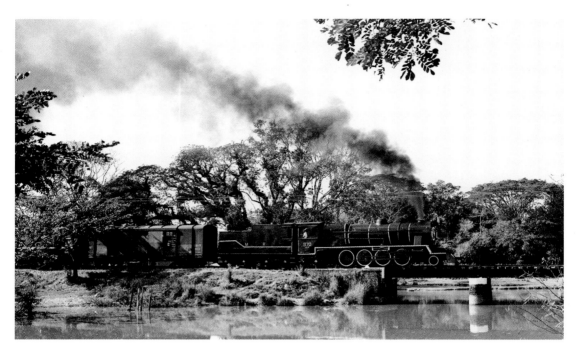

For a time, the British administered Burma as part of the Raj. It's therefore unsurprising that its railways reflected Indian practice and locomotive types. By 2007 only three steam classes remained active on the metre gauge system of the country now officially known as Myanmar – Class YB Pacifics, Class YC Pacifics, and Class YD 2-8-2s. All three were seen in action during a visit in January of that year. YD no. 970 performed a run-past en route from Bago to Kyaik with a special train organised by the UK-based Railway Touring Company. She was built in 1949 by the Vulcan Foundry.

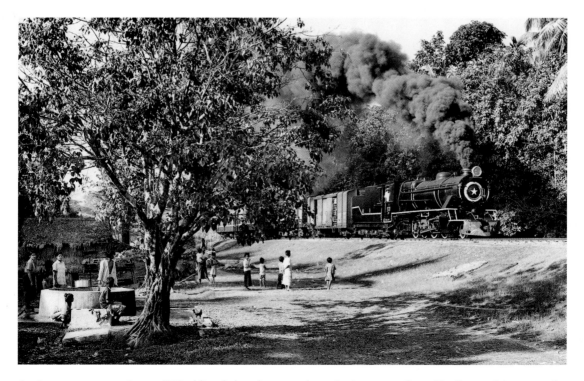

A picture to savour. As no. 970 obliged the photographers during a run from Kyaikto to Mottama, the villagers by the well and the children playing on the grass didn't know which was the more surprising – the antics of Westerners or a steam train.

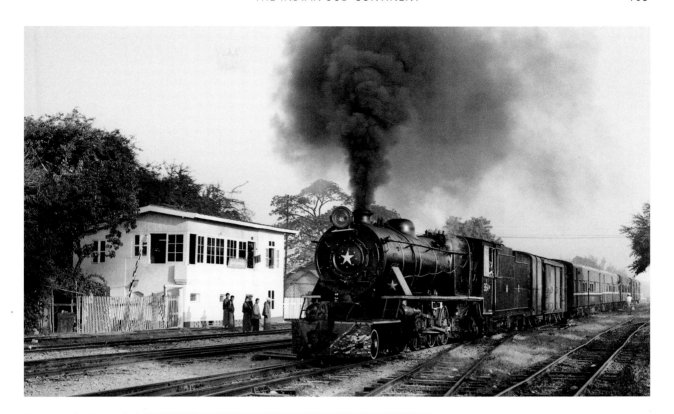

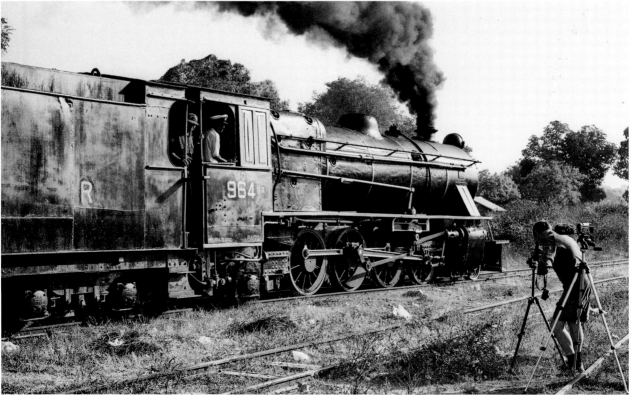

When new, YD no. 964 came from the same batch as no. 970. The sun had only moments before risen high enough in the early morning sky to illuminate her as she stormed past Myo Haung Junction signal box on the outskirts of Mandalay (top). Once more there was a good crowd of onlookers. Later she played to the gallery at Htonebo (bottom). Ah, shorts and socks – it can only be a Brit.

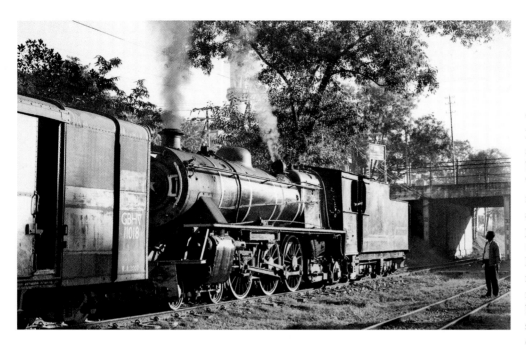

To my eye, the Burmese Pacifics had an air of grace and beauty about them. They were lovely machines to look at, especially in side profile. YB no. 534 (left) was leaving Rangoon with a train for Bago. She was running tender-first because the local shed's turntable was out of action. Against a background of pagodas, YC no. 629 (below) neared Kyaukpadaung with a train from Kyini. Readers who have been paying attention in this chapter won't be surprised to learn that these two locos were constructed by the Vulcan Foundry at Newton-le-Willows, Lancashire in 1947 and 1948 respectively.

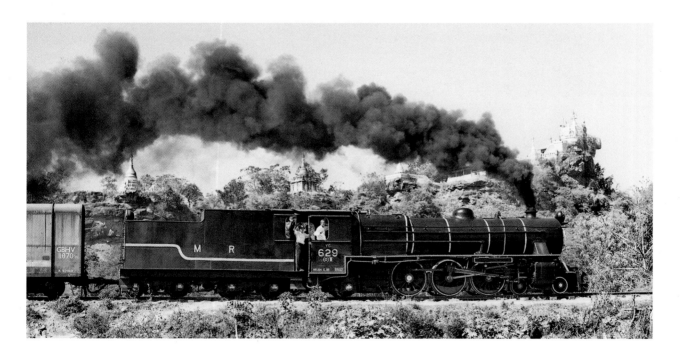

Burma was a wonderful country to visit, as much for the unspoilt scenery and the friendliness and charming nature of the people as for the steam. The 2007 trip was memorable for another reason: it was the last time I went with a group led by the well-known photographer Hugh Ballantyne, who sadly died in 2013. Not only was Hugh much respected and admired for his skills in the art of railway photography, he was jolly good company. I for one was always grateful for the encouragement and advice Hugh gave to those of us less experienced with the camera.

6. South Africa

In the 1970s, many steam enthusiasts were attracted to the Republic of South Africa. Though running on a gauge no wider than 3ft 6in, known as 'Cape Gauge', the State railways had some huge locomotives. Magnificent scenery and a pleasant climate made for a winning combination. Of course, apartheid was not something to be relished. The way non-white people were viewed and treated as second class made one feel very uncomfortable. Trains had separate carriages for *blanke* and *nie-blanke*. Stations had separate entrances, even separate footbridges, and visiting enthusiasts were expected to conform. And you'd better be careful about the sort of reading material you had with you. On arriving at airports, it was not unknown for suitcases to be checked for banned magazines. Perversely, apartheid indirectly prolonged the use of steam – on the national network (South African Railways – SAR) as well as on industrial systems – as a consequence of the UN embargo on oil to South Africa.

According to the official report of the tour, a group visit in May 1979 witnessed 826 steam locos, though it has to be said this number included some engines not in use at the time. The most numerous class on the SAR was the 15F 4-8-2s of which 255 were built. Some came from German workshops just before the Second World War; the remainder from British firms between 1939 and 1948. They were regarded as maids of all work, used on anything from express passenger to heavy shunting duties. A night-time ride on the footplate of no. 3147 en route from Breyten to Johannesburg was quite an experience. By that time, the 15Fs dominated the steam scene in the heavily industrialised area around Jo'burg. One of the main steam sheds in that part of the country was at Germiston (below). Constant twenty-four-hour activity there was a reminder of how it used to be at Britain's major depots. If only one could have bottled the atmosphere. The loco to the left of the picture is a class S1 0-8-0 used for shunting.

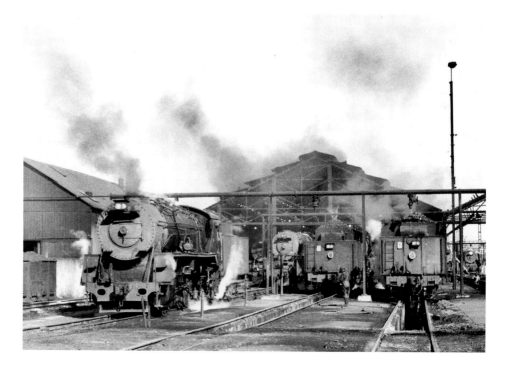

Seventy-three of the locos seen in May 1979 were in industrial use at collieries, gold mines and the like. Of these, fifty-three were ex-SAR engines. The remainder had been acquired brand new for industrial use, such as the 4-8-2 tank (top) supplied by the North British Locomotive Company (NBL) in 1952 and photographed in the Witbank coalfields. By contrast, the 4-8-0 (bottom), seen shunting at a cellulose-processing factory at Umkomaas, south-west of Durban, was formerly a member of SAR class 8DW. Delivered in 1903, she came from Neilson Reid, one of the constituent companies when NBL was formed that year. There's a hotel story attached to this picture. Arriving the previous evening at nearby Scottburgh, we were greeted with 'you weren't expected until next month'. The hotel's *Fawlty Towers* credentials were confirmed at dinner. 'What, no spuds?' became the cry as the kitchen ran out of them and almost everything else, whilst entertainment was provided by three waiters trying to evict a bat. To be fair, this experience wasn't typical of our stay in South Africa. The tour report claims that at another hotel, dinner extended to thirteen courses. This may not be hyperbole, as I seem to recall that on a fixed-price menu with choices for each course, the customer was entitled to order every one of the dishes on offer.

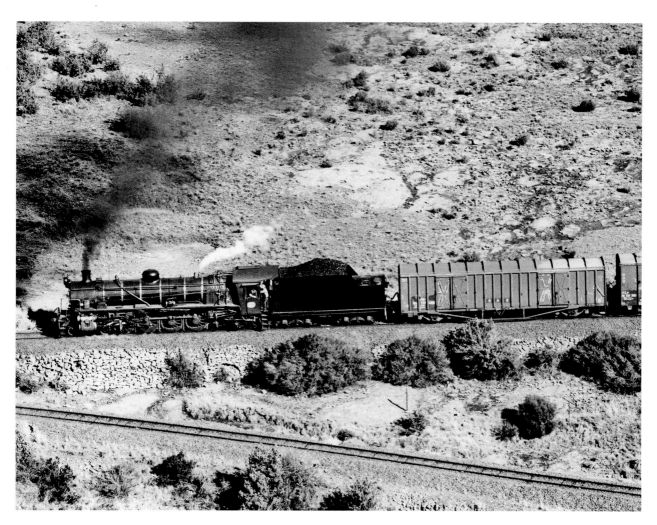

By the time of my second visit to South Africa, real steam had finished. However, the railway authorities were co-operative in allowing steam to be used on photo safaris. One such was the Drakensberg Farewell tour in July 1995. The concept here was similar to that experienced in Pakistan, i.e. a complete train on which thirty or so photographers lived, ate and slept. As this was South Africa, the standard of the on-board accommodation was first class. There were even showers. The food too was excellent, accompanied of course by the country's fine wines. The two weeks' itinerary, starting at Bulawayo and finishing at Cape Town, included some branch lines. On these, stock authentic to the 1960s and '70s for the route concerned was sometimes used in lieu of the charter train. The Barkly East branch was a

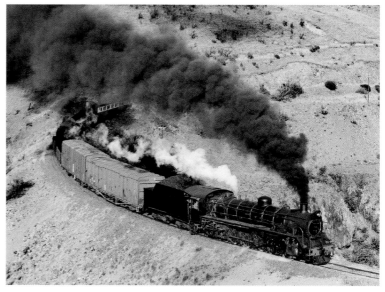

case in point. This line was famous for the zigzags ('reverses' in local railway parlance) by which it gained or lost height. Class 19D 4-8-2 no. 3323 was photographed descending the sixth reverse (top) and climbing away from the eighth reverse (bottom), the stub of which was in the rock cutting below the front of the loco.

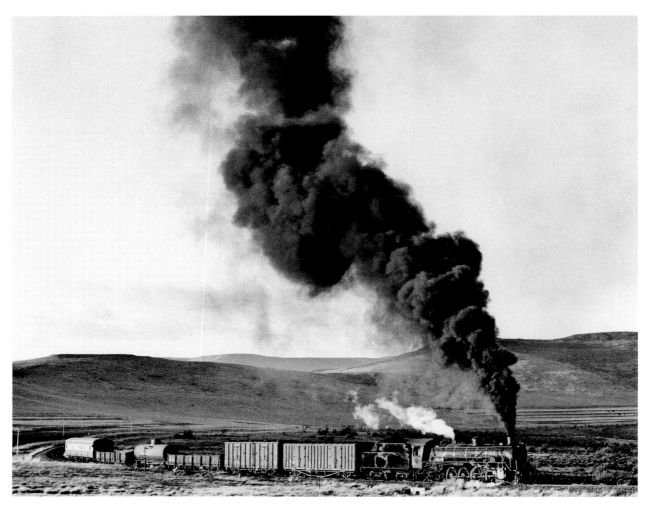

Most SAR steam locos came from British or German manufacturers. No. 3323, seen again near the summit of the East Barkly branch at Motkop (above), was built by the North British Locomotive Company in 1948. Sister loco no. 2698 (below) was delivered by the German firm of Borsig just before the outbreak of the Second World War. In steam days

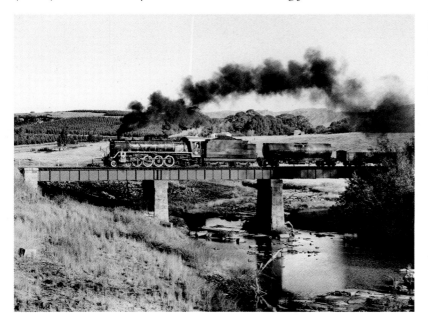

class 19D locos were used throughout South Africa for passenger and freight traffic, mostly on secondary routes and branch lines. No. 2698 performed a run-past over the Wildebeest River with a mixed train from Maclear to Elliott.

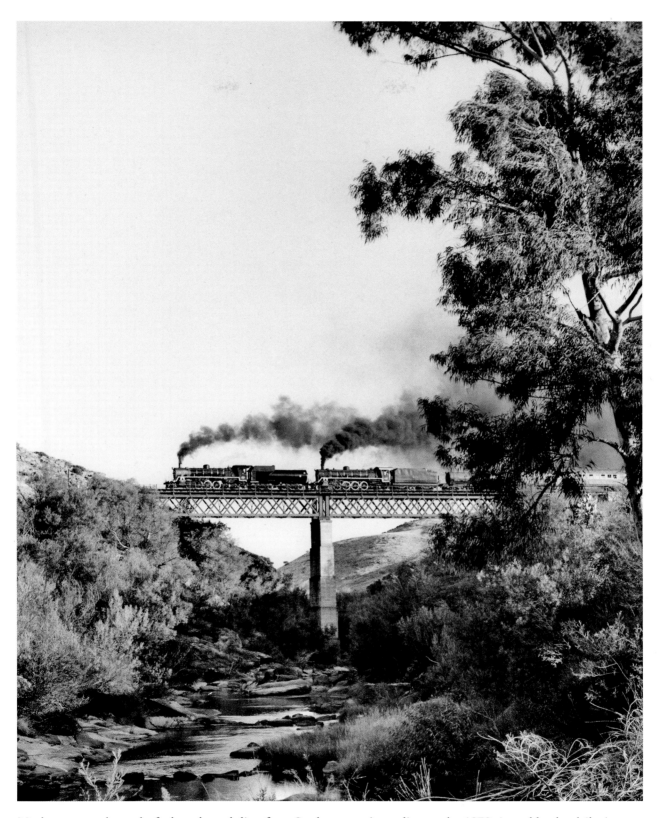

Maclear was at the end of a long branch line from Sterkstroom. According to the 1979 timetable, the daily (except Sundays) passenger train took ten hours to cover the 174 miles. In a 1995 recreation, class 24 2-8-4 no. 3635 and class 19D no. 2698 double-headed the Drakensberg Farewell tour across the Xalanga viaduct en route from Sterkstroom to Elliott.

Earlier in their journey, the locos were beautifully lit by the morning sun near Glen Wallace.

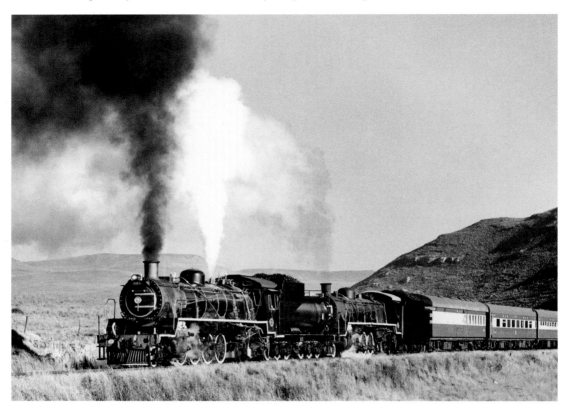

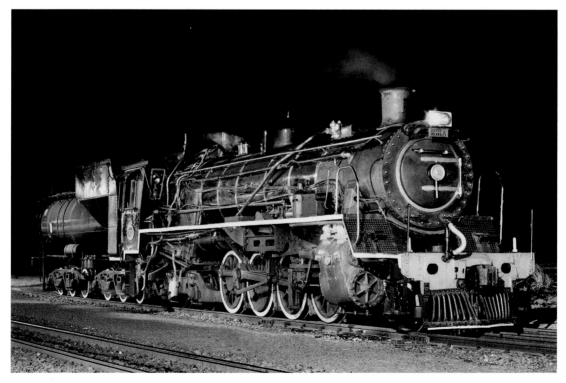

A hundred class 24 locos were constructed by the North British Locomotive Company in 1949/50. No. 3635 carried the name *Rika*. She was photographed during the overnight stop of the Drakensberg Farewell at Elliott.

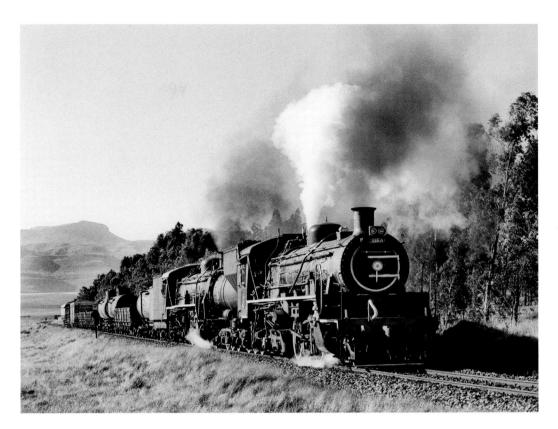

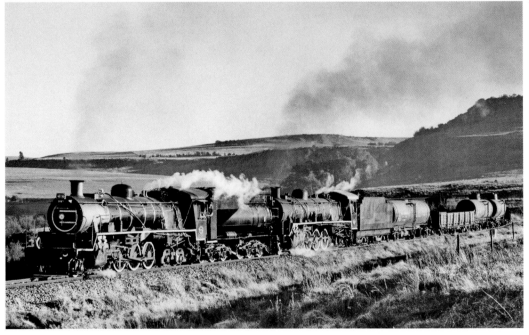

The return from Maclear to Sterkstroom was by a succession of mixed trains over two days. A word of explanation for the non-enthusiast reader: a mixed train is one conveying both passengers and freight. In this case, the tour participants travelled in a coach at the back of a rake of goods wagons. Nos 3635 and 2698 were photographed as they climbed away from Elliott (top) and later as they rounded a double horse-shoe curve between Ulin and Ella (bottom). Despite the somewhat unimaginative standard angles at which these two photos were taken, I like them. The first captures double-headed locos in full cry. Visually the pleasure of the second is down to the lighting effect created by the last of the afternoon sun.

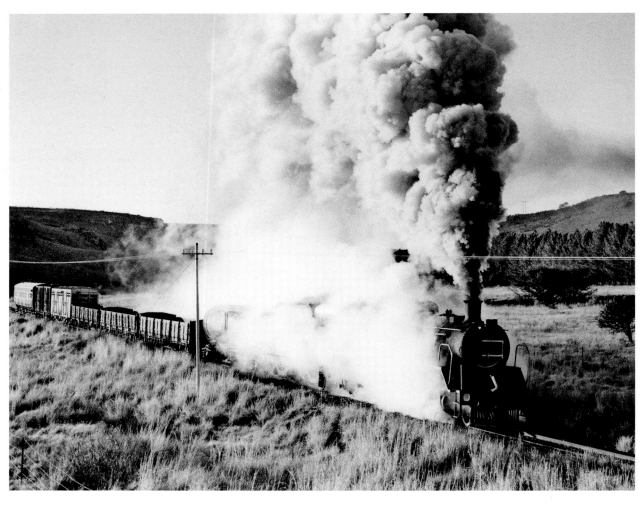

The next day, the mixed was hauled by no. 2698 on its own. July is mid-winter in South Africa. Leaving Indwe, there was still frost on the ground as no. 2698 struggled on an icy rail. This photo needs a soundtrack.

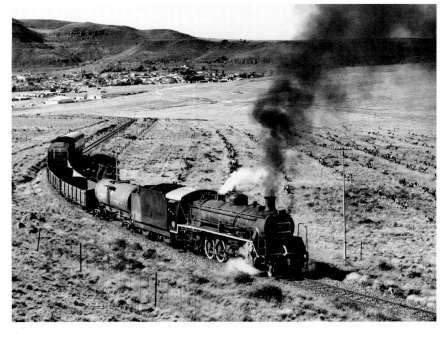

There was a lengthy stop at Dordrecht to service the loco and so there was time to explore the town. In fact, with no obvious diversions to engage a tourist, there was more than enough time. The local council was asked to help with the servicing of the loco in some way – water and/or coal, perhaps – so a courtesy call on the town clerk, as a fellow bureaucrat, seemed an appropriate way of passing the time. Whilst expressing no regrets or ill will towards the end of apartheid, he appeared to be adjusting to the new era and was uncertain of the future implications for his council and the town. After the servicing stop, no. 2698 performed a run-past on the climb out of Dordrecht.

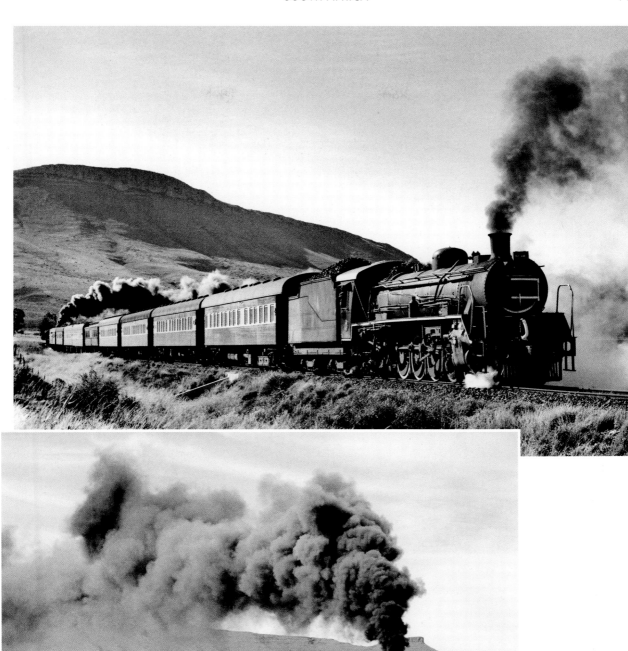

The Lootsberg Pass was much frequented by photographers in the heyday of South African steam. There were fierce gradients on both sides of the summit. Serious locomotive work was required. By 1995 regular traffic over the Pass had ceased but the route remained available for out-of-the-ordinary occasions such as the passage of the Drakensberg Farewell. On the north side, in a scene reminiscent of the days when there was a regular dining-car train from Johannesburg to Mossel Bay, on the Indian Ocean coast, two 19Ds – no. 2698 at the front, no. 3324 at the back – were photographed at Rooihoogte (top) en route to the top of the Pass. The Lootsberg is a bleak place, especially in winter when snow is not unknown. On the other side of the Pass, no. 2698 was captured on camera with a mixed train near Blouwater (bottom).

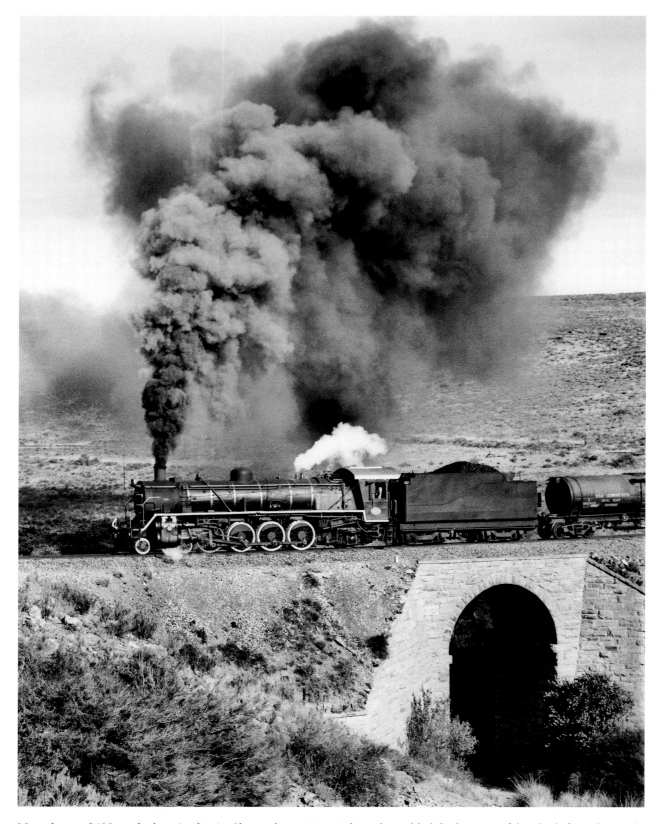

Next day, no. 2698 worked a mixed train. She made a stirring sight as she tackled the last part of the climb from the south.

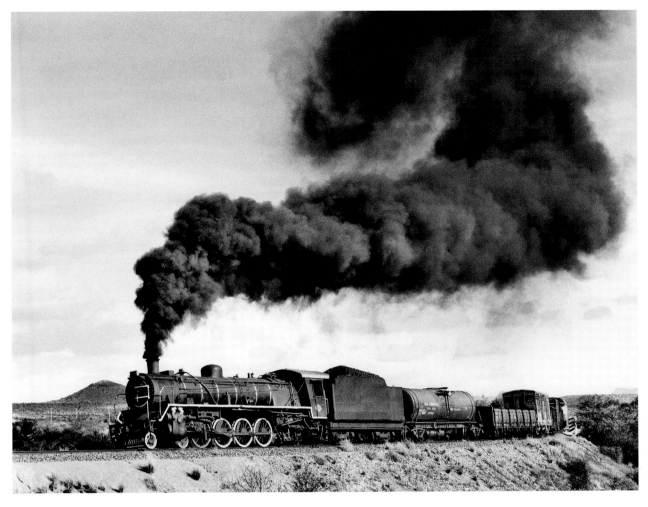

Two more views of no.
2698 on the southern
climb to the summit, at
Letskraal (above) and
Elandskloof (right).
Photographing trains from
less conventional angles
makes for interesting
compositions, especially if
it's possible to incorporate
something of the landscape.

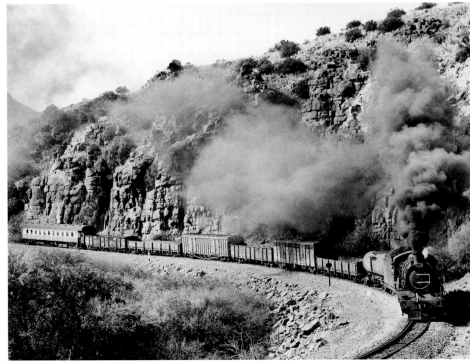

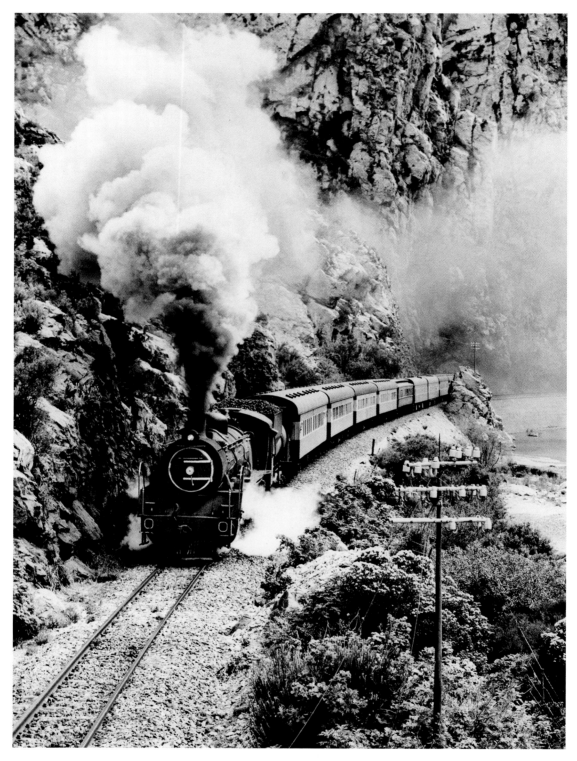

After crossing the Lootsberg Pass the route of the former Johannesburg to Mossel Bay passenger train would have taken it through Klipplaat and Oudtshoorn, a line famous for the Toorwaterpoort canyon of the Oliphant River. In this spectacular setting, class 19D no. 3324 storms by with the Drakensberg Farewell. Much earlier that day, after breakfast in the dining car, I had gone back to my cosy compartment. The train started to move. I dozed. Sometime later I woke to find we were still at the same station. How did that happen? Surely I hadn't imagined the motion of the train. It transpired that whilst I'd been asleep there had been a run-past against the dawn sky. The train then returned to the station where presumably the jolt as it stopped had roused me.

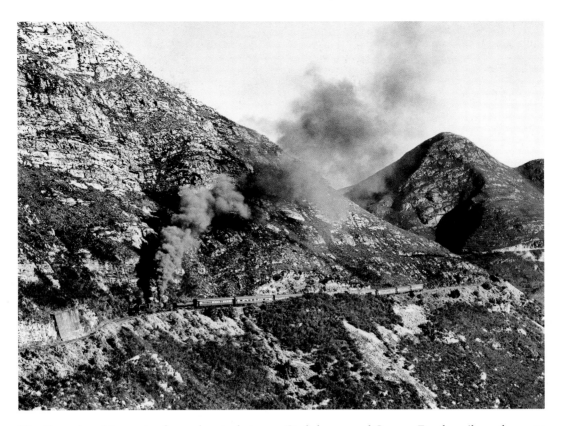

The Outeniqua Mountains form a barrier between Oudtshoorn and George. For the railway, the route across is via the Montagu Pass. I'd travelled this way in 1979 when the Cape Town to Port Elizabeth trains were still steam-hauled on this part of their journey. The thrash up the Pass from George was an unforgettable experience. George is at 800ft above sea level. The head of the Pass, appropriately named Topping, is at 2,400ft. It took over ninety minutes to climb the 14 miles, much of it at a gradient of 1 in 37, though there was a midway stop for water. The locos used over the Pass were class GMAM Garratts. From George they always worked tender first so that the cab and its crew were ahead of the chimney when going through tunnels. What had once been a daily scene was replicated in July 1995 as the Drakensberg Farewell made its way from George to Topping hauled by GMAM no. 4072. With a 4-8-2 + 2-8-4 wheel arrangement, she came from the German firm of Henschel in 1952.

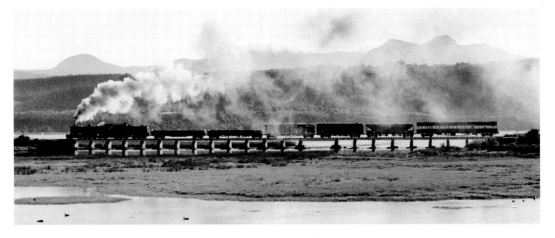

George was the junction for a line to the coastal town of Knysna. For much of the way the line was in sight of the sea and the regular service trains were well patronised by tourists. In July 1995 a mixed train was photographed crossing a lagoon at Sedgefield behind a class 24 2-8-4.

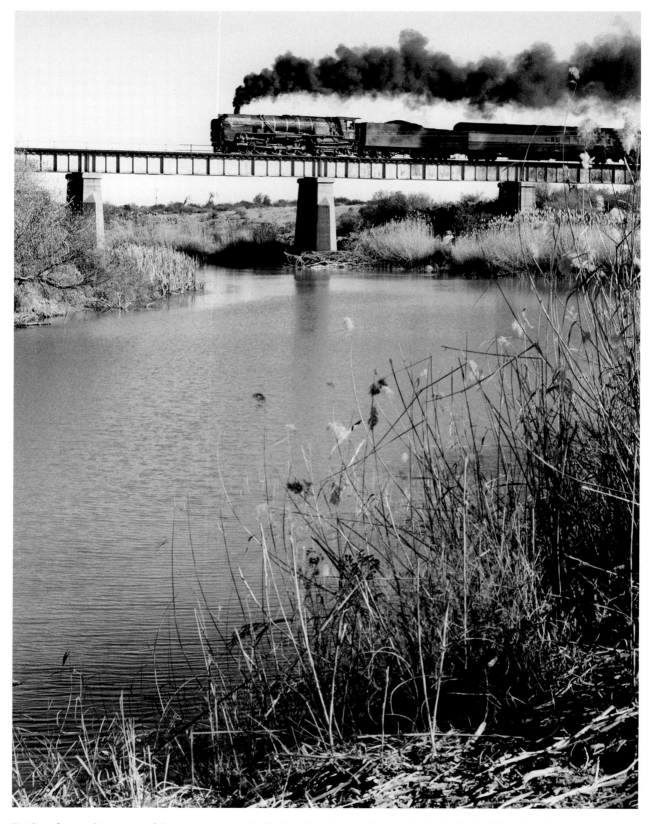

Bridges featured in many of the run–pasts on the Drakensberg Farewell tour; the leader had a liking for their photographic potential. Class 25NC no. 3410 crossed the Modder River at Perdeberg, on the mainline from Kimberley to Bloemfontein. It was a shame about the shadows caused by the drifting smoke.

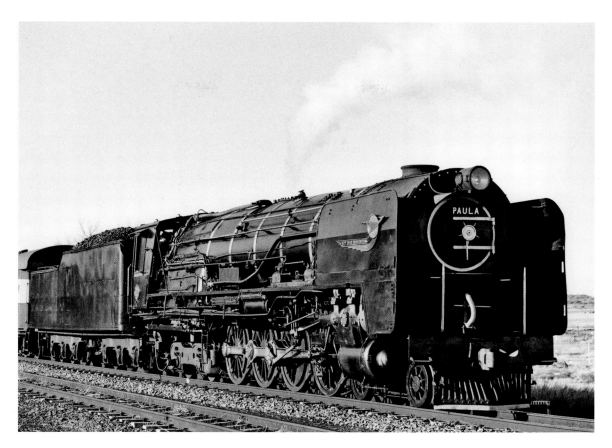

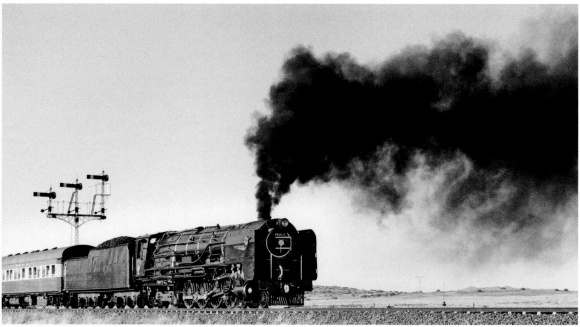

Whilst working from Bloemfontein to Kimberley, no. 3410 stopped at Priors. Here was the chance to have a closer look (top). What an impressive machine for a gauge no wider than 3ft 6in. With a 4-8-4 wheel arrangement she was one of a batch of eleven locos built by the North British Locomotive Company in 1954. Round about the same time, a further thirty-nine were delivered by Henschel, proof again of the mix of British and German manufacturers favoured by SAR. After being admired by all concerned, no. 3410 performed a false start (bottom) for the benefit of the photographers.

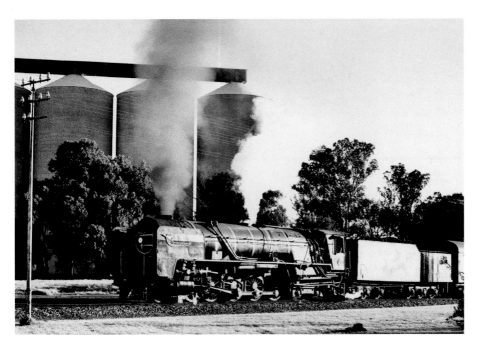

The last rays of the evening sun catch no. 3410 as she arrives at De Brug in July 1995.

Another beast. The class GO Garratts were a slightly smaller version of the class GMAM. No.2575 made a spectacular departure from Elgin in July 1995 with a mixed train for Cape Town. She was a 1954 product of Henschel.

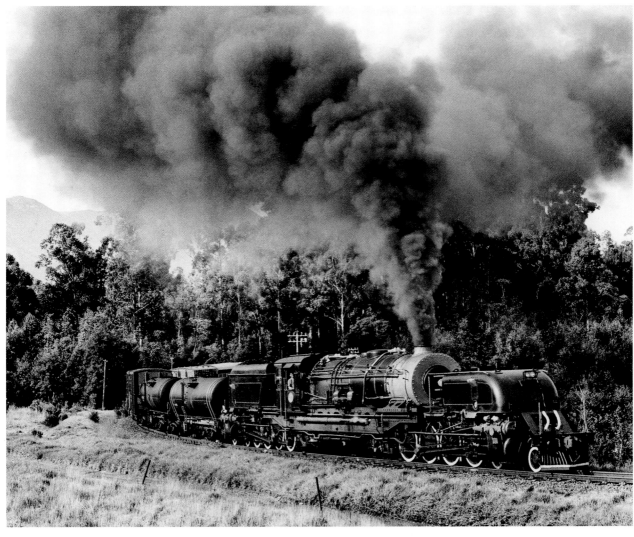

As a final look at South Africa, two shots of class 19Ds heading the Drakensberg Farewell, in contrasting environments. At Fauresmith the branch line from Springfontein ran slap bang through the middle of the main street (right). As evident by the vines in the foreground (below), Franschoek is in the Cape wine area. At dawn we had to wait for the sun to be high enough in the sky for this photograph. For the record, the locos were nos 3324 and 3321 respectively. Both were North British Locomotive Company products from 1948.

7. Cuba

If China, with its uniform classes of locos and bitterly cold winters, was at one end of the world steam spectrum, Cuba was at the other. Here a fascinating motley collection of engines on a variety of gauges could be enjoyed under a tropical sun. Add vintage American automobiles, cigars, cocktails and friendly people, who could resist? Not me – hence two visits, in 1995 and 2000. Until real steam finally disappeared in 2003 or thereabouts, most years witnessed a goodly number of steam enthusiasts during the sugar harvest season, roughly February to April. Many of the sugar mills had railway lines extending into the cane fields. According to one author, sixty-three mills used steam locos in the mid-1990s. However, workings were unpredictable. Weather was a big factor; a mill might harvest in March one year but have finished by the same month the following year. Some mills didn't operate every year. Spare diesels from non-steam mills could be drafted to others at short notice. Cane wasn't cut when it was wet. Mill machinery might be temporarily under repair. Trains might run at night to clear a backlog. They certainly didn't run to any timetable. Finding trains could therefore be somewhat hit and miss. Looking back, I suppose the uncertainty was part of the fun though it didn't always appear so at the time.

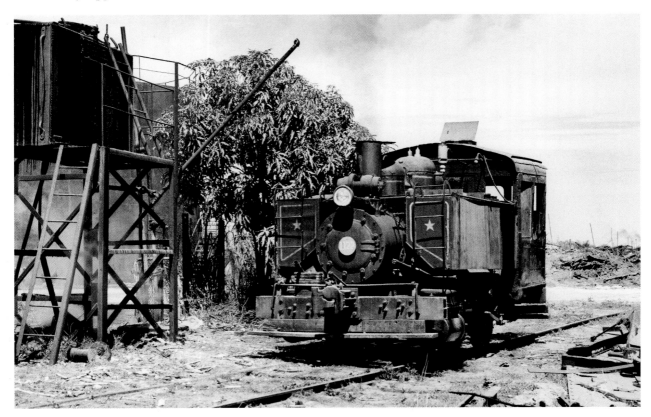

Most visits to a mill started at the loco shed to see if there was anything in steam. Smoke was, of course, a good clue, as at Jose Smith Comas mill where, in February 1995, 0-4-0 tank no. 1122 was found to be taking a siesta. She was a standard gauge 0-4-0 tank and, like the majority of Cuban steam locos, was of American origin. Of 1909 vintage, no. 1122 was built at the Porter Locomotive Works, Pittsburgh.

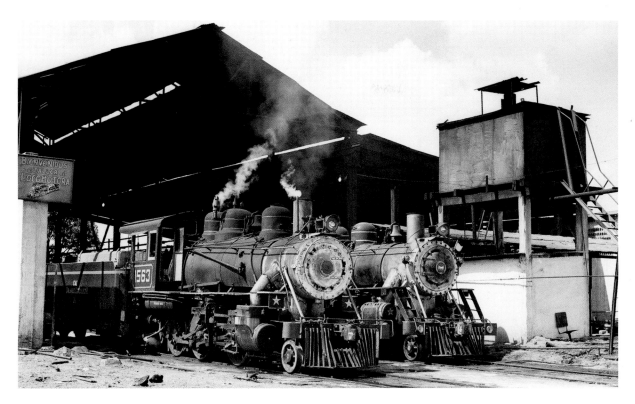

In February 2000 there was the prospect of activity at Orlando Gonzalez Ramirez mill where the locomotive workshops (top) boasted a 'welcome' sign. No. 1563 was a 2-6-0 built by the Baldwin Locomotive Company in 1920. After the sheds, the next place to visit was the Traffic Office to find out when and where trains were running. At Simon Bolivar mill (bottom), an unidentified Baldwin 2-8-0 was waiting for instructions outside the office. The gauge of this mill's railway was claimed by some visiting enthusiasts to be 2ft 3¾in and by others 2ft 3½in. Either way, it was unique.

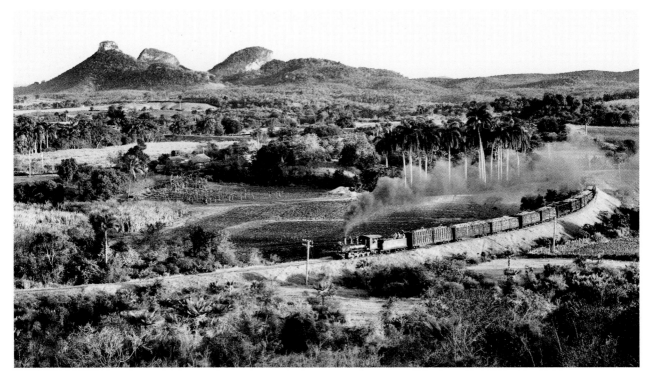

If trains were running, it was off to the countryside to find one. Without a shadow of doubt, the most photogenic of Cuba's sugar lines was the 2ft 6in gauge system based on Rafael Freyre mill, not far from the tourist resort of Guadalevica, and the most scenic location of all was a hill overlooking the curve at Bariay. Getting a good photograph here could be a fraught experience. Loaded trains returning to the mill tended to do so in the afternoon, at the end of a day's harvesting. Often it was dark before a train appeared. Even in daylight, drifting smoke and rogue clouds could be a problem. On this occasion, in February 2000, all was well, although the train was shorter than was usually the case.

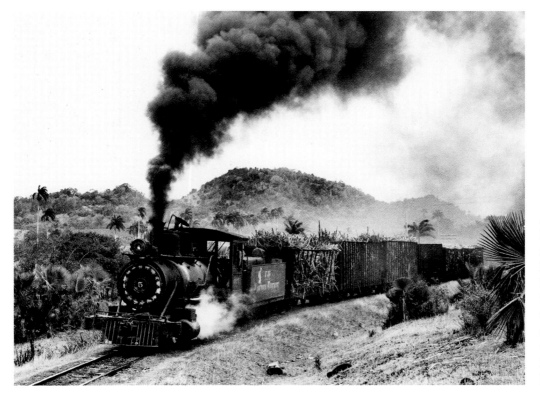

At the foot of the hill, one of the mill's fleet of seven Baldwin 2-8-0s, built between 1905 and 1919, was working hard against the grade with a train of loaded wagons bound for the mill.

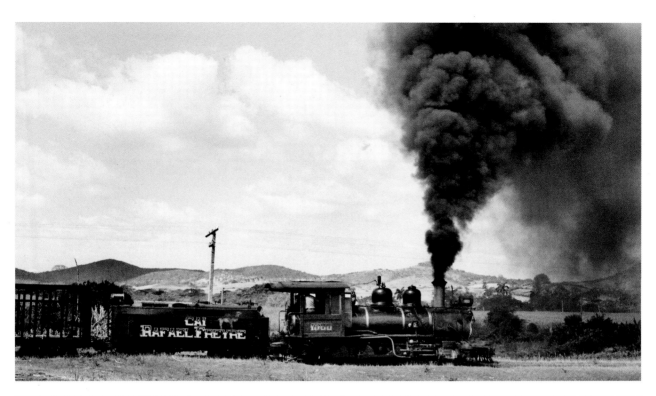

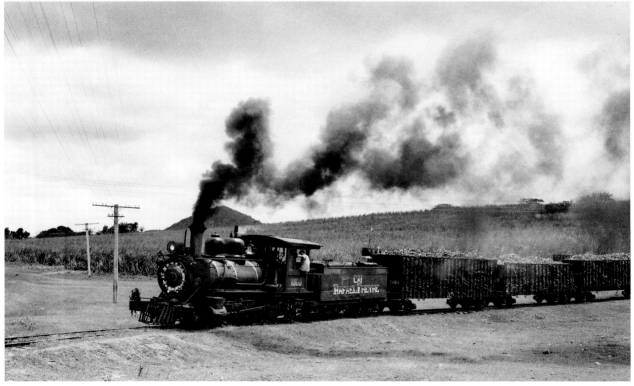

In February 2000, no. 1386 backed its train of empty wagons into the loading point at Luciano (top) and later left with a full load (bottom). The painting on the side of the tender is explained by the loco's name *Gibara* – 'camel' in Spanish.

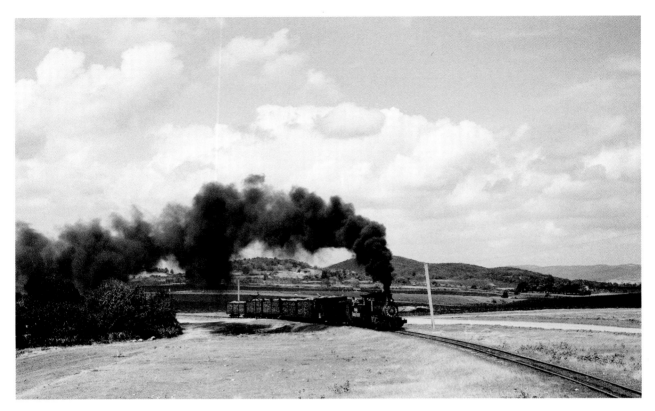

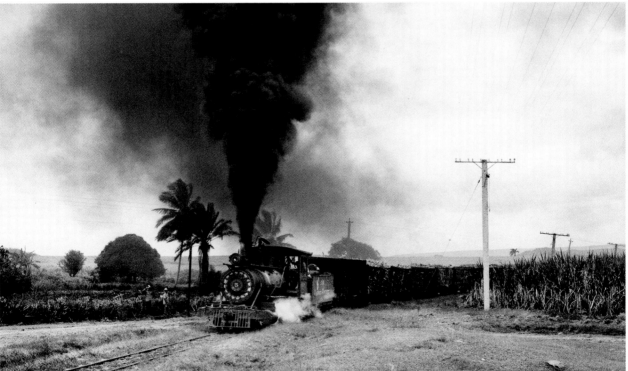

Running through rolling countryside, the lines at Rafael Freyre boasted some steep gradients. There was serious locomotive work to be done as at La Esperanza where, in February 2000, no. 1388 (top) was seen heading for the mill. The fiercest climb was at Altuna. As they approached the foot of the bank the crew of no. 1387 (bottom) were determined to have a go at getting their train to the top in one go. They failed. After reversing to the bottom, they divided the train … and (opposite) tried again. Success.

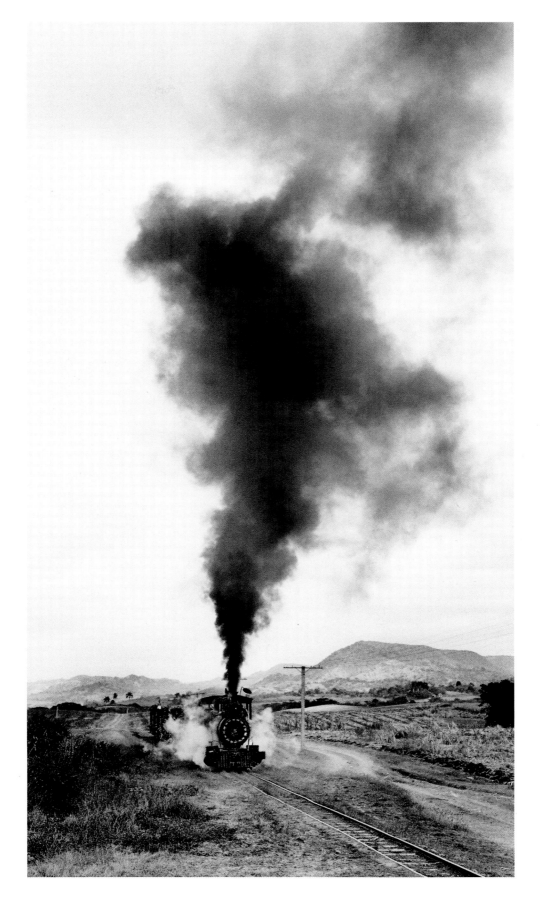

Staying with the narrow gauge, Espartaco mill, in the province of Cienfuegos, had some chunky 2-8-0s, one of which, no. 1328, was photographed in February 2000 entering the mill yards with a load of cane. She was built by the Baldwin Locomotive Company in 1915. Like many Cuban sugar lines, the track looked a tad rickety.

In contrast, the locos at Pepito Tey mill seemed quaint. Who could resist their charm? In February 2000, the sugar harvest was in full swing. Four locos in steam were needed to handle the traffic. On shed, surrounded by banana trees, no. 1164 was being serviced. All of the locos at this mill were Baldwin products. No. 1164 was a Mogul (i.e. having a 2-6-0 wheel arrangement), built in 1919.

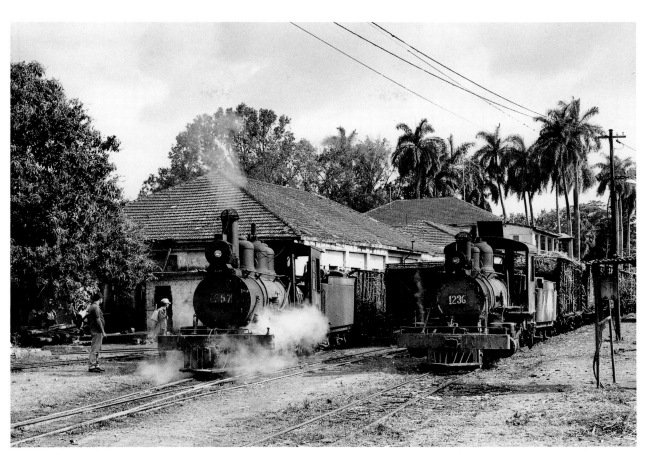

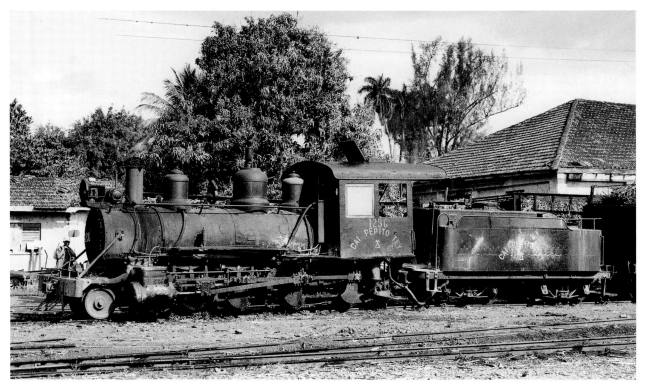

Two loaded trains had just arrived from the cane fields (top). Built in 1909, no. 1357 – on the left – was the oldest loco at the mill. No. 1236 was a year younger. Both were 2-8-0s. These small yet powerful locos deserve a closer look (bottom).

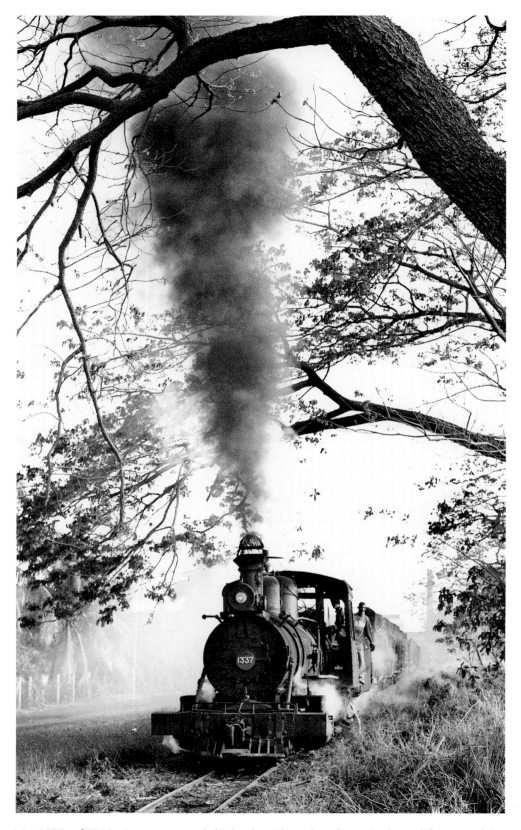

No. 1337, of 1919 vintage, stormed the bank with a rake of empties bound for one of the loading points. Smoke from the constant procession of trains had blackened the branches of the overhanging trees.

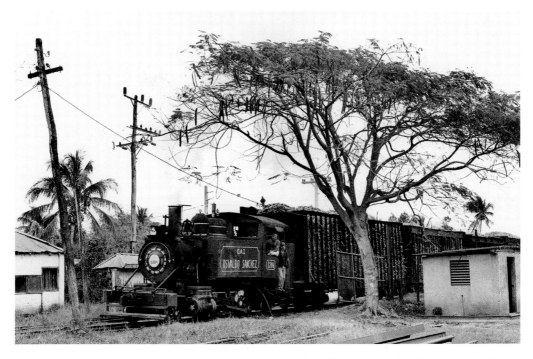

Osvaldo Sanchez mill had steam on two gauges, standard and 2ft 6in. On the former, no. 1204 was a real old-timer, having been built by the Rogers Locomotive and Machine Works, New Jersey, USA as long ago as 1894. She was a 2-4-2 tank, photographed at the mill in February 2000.

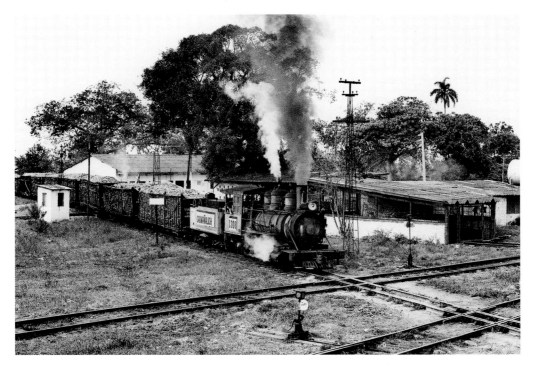

Only a short drive from Havana, Gregorio Arlee Manalich was another mill with steam on two gauges. Seen from the balcony of the Traffic Office, Baldwin 2-8-0 no. 1308 on the 2ft 6in gauge was about to cross the mill's standard-gauge track with a full load of cane. When photographed in February 2000, she was 100 years old. This mill was one of the last in Cuba to use steam locos on a regular basis. However, the Cubans have belatedly woken up to the tourist potential of sugar railways and some mills have been turned into working museums offering steam-hauled rides into the cane fields.

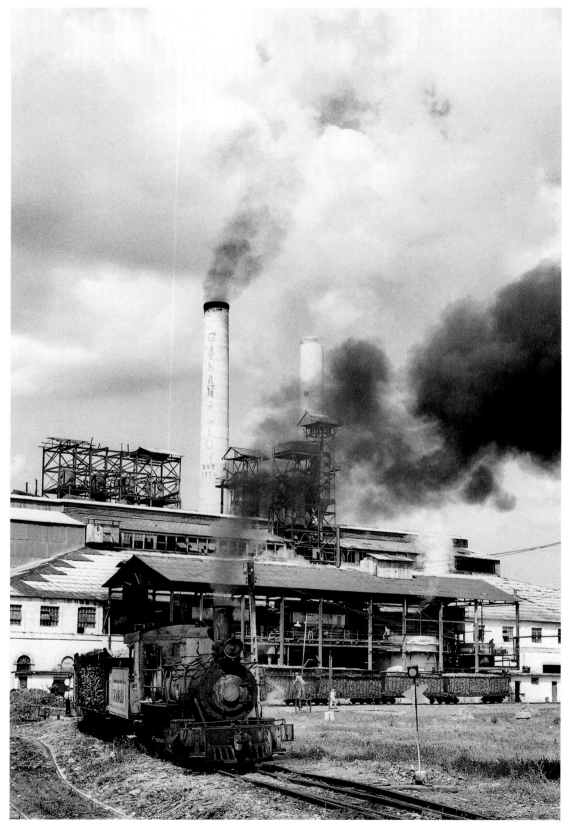

After arrival from the cane fields, wagons were shunted into the mill for unloading, as captured on film in February 2000.

In February 2000 the standard gauge at Gregorio Arlee Manalich mill was being worked by 2-6-0 no. 1510. I didn't manage a decent photograph of this loco at the time. However, I had seen it five years previously when it was based at Boris Luis Santa Coloma mill. In the photograph to the right, it had just arrived from the cane fields and was shunting its train in the mill yard. As this was on the side of a hill, much sand was used to counteract spinning of the wheels. The sand was carried in the forward dome which was filled from the top – hence the spillage down the side of the boiler. One would have thought that the arrival of a sugar train was a regular enough occurrence not

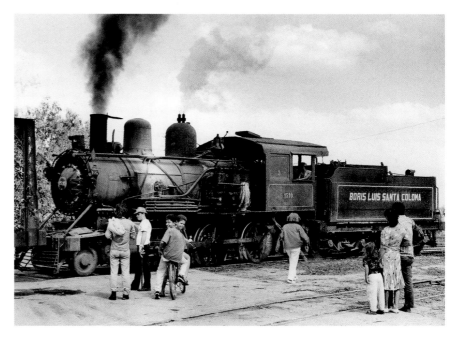

to attract the locals' attention. A trick of the camera angle has turned a couple of boys into what at first glance appears to be a two-headed person. No. 1510 was built by the American Locomotive Company in 1907.

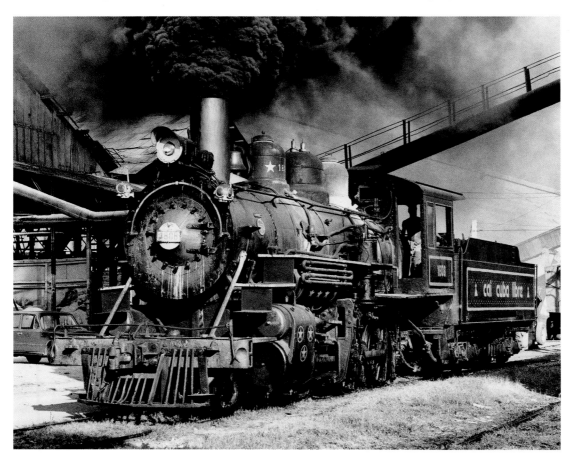

No. 1808 was one of three standard-gauge Baldwin 2-6-0s at Cuba Libre sugar mill in February 1995. The pall of smoke hanging over the sheds could be seen a long way off.

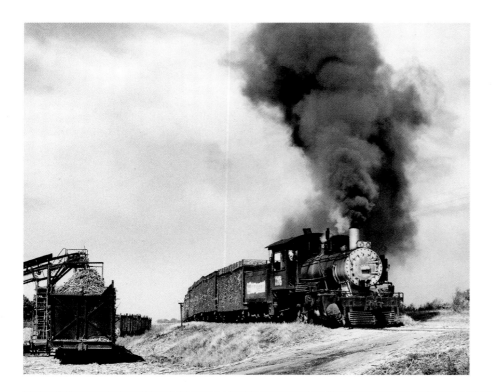

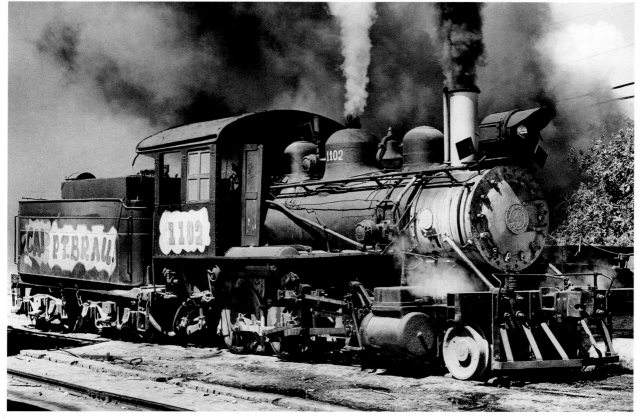

West of Havana is the province of Pinar del Rio where the best tobacco is grown. In February 1995, Mogul no. 1703 (top) left one of the loading points in the cane fields, heading for Pablo de la Torriente Brau mill. She was one of the few German-built locos in Cuba, having come from Henschel in 1920. Maximum effort was required to lift the train to the mill where 2-6-0 no. 1102, built in the USA by the Vulcan Iron Works in 1915, was shunting the yard (bottom).

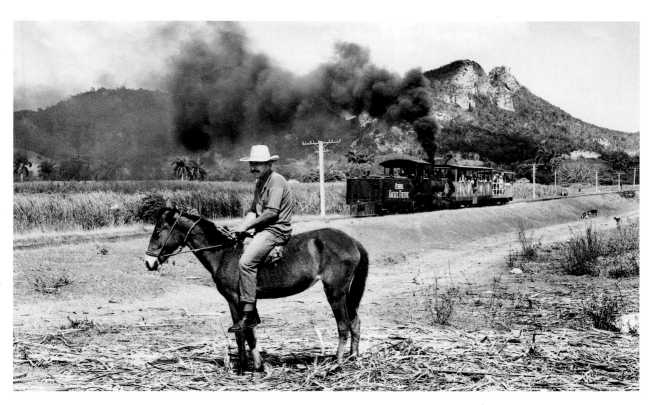

The shape of things to come. With one of Cuba's coastal resorts just down the road, the management at Rafael Freyre mill had, by February 2000, begun to realise the tourist potential of steam. A few years later the sugar industry throughout the country suffered a severe contraction and the harvest of 2002 proved to be the last for Rafael Freyre. In 2003 the mill was reported as closed, but it has since become a heritage centre and runs tourist trains some of which may be steam-hauled.

In this chapter there's been much reference to the Baldwin Locomotive Company. Above left was the plate fitted by the builders to the smokebox door of Rafael Freyre's no. 1387. When acquired new in 1905, at which time the mill was called Santa Lucia, she was no. 5 on the mill's roster. Above right is proof that not all of Cuba's locos came from the USA. This was the builder's plate on Brasil mill's no. 1370, which appears on page 144.

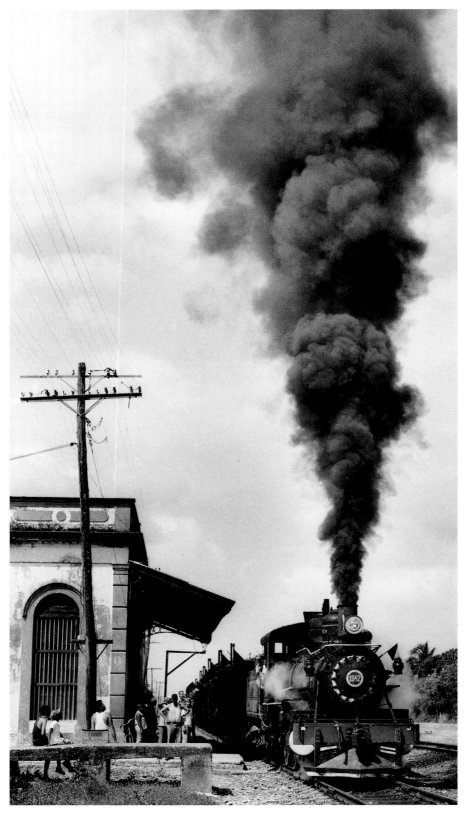

To reach Marcelo Salado mill, some trains had to use a stretch of track belonging to the national railways. No. 1342, a 4-6-0 supplied new to the mill in 1911 by the Baldwin Locomotive Company, was photographed in February 2000 leaving the colonial-style station at Remedios with a load of cane. Again, the locals had come to watch.

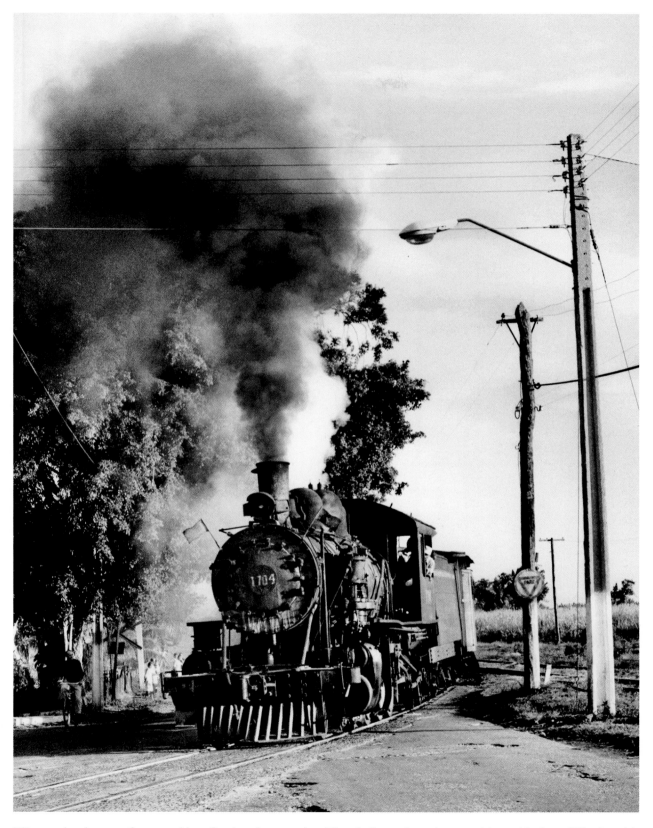

Wires and poles are often a problem for the photographer. The challenge is to do something with them. Whether this picture succeeds is for the reader to judge. No. 1704 was a 2-8-0 built by the Vulcan Iron Works in the USA in 1919. She was seen in February 1995 storming into the yards at Eduardo Garcia Lavandero mill.

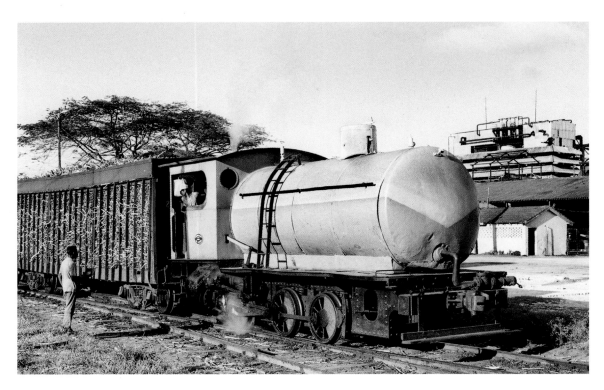

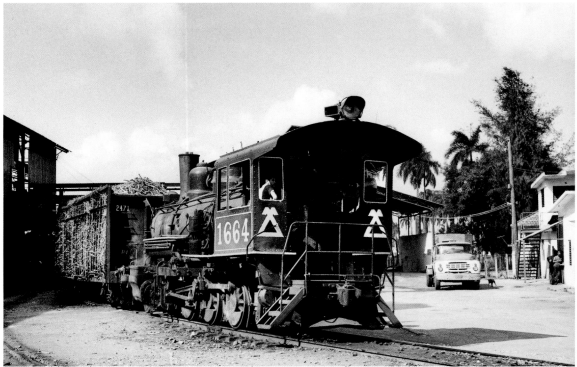

Once again, a couple of oddities for the connoisseur. Fireless locos were sometimes used at factories where there was a high risk of sparks setting things alight, paper mills being an obvious example. This type of loco was seen at three of Cuba's sugar mills in February 2000. No. 1370 was one of the fireless locos at Brasil mill (top). What appears to be the boiler is in fact no more than a steam reservoir. When empty, it is refilled from a stationary boiler. At Noel Fernandez mill, a 'proper' loco had been converted into fireless mode. As there was no fire, there was no need for a tender. Before conversion, no. 1664 (bottom) had originally come from the Baldwin Locomotive Company in 1920.

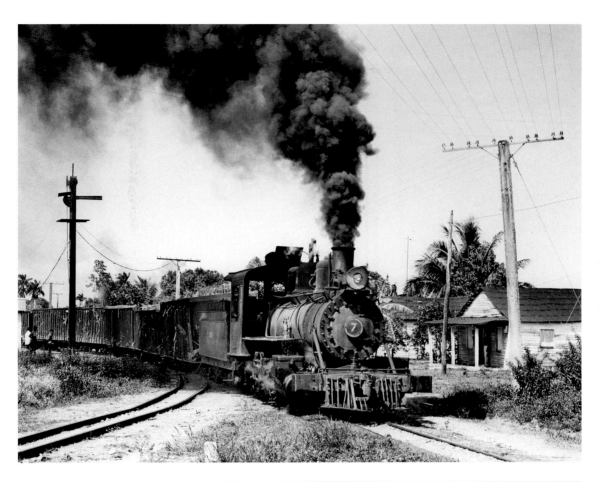

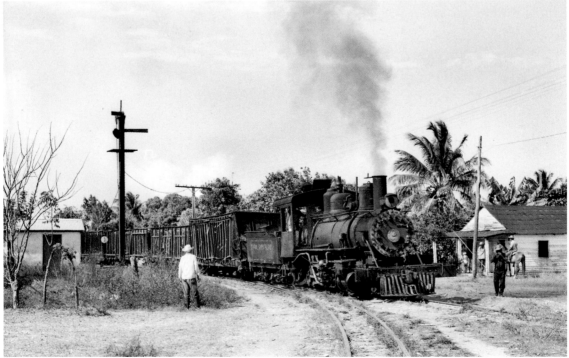

The lines which served Obdulio Morales and Simon Bolivar mills met at Centeno, photographed in February 1995 (top) and five years later (bottom).

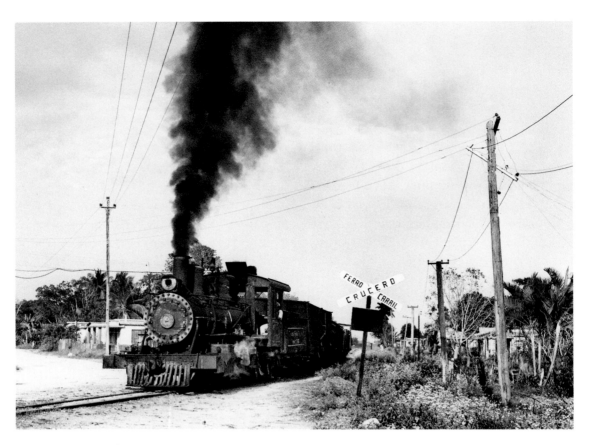

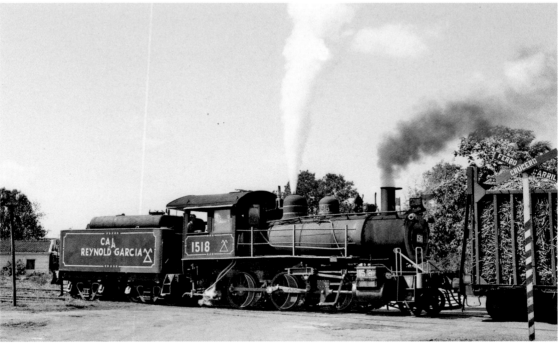

A final look at Cuban steam – both narrow and standard gauges – in February 2000. On the Simon Bolivar system, Baldwin 2-8-0 no. 1360 built in 1917 was photographed heading a loaded train (top). Despite what it said on her tender, no. 1518 (bottom) was hard at work in the yards at Jesus Rabi mill. She was constructed in the USA by the Vulcan Iron Works in 1916. Some obtrusive poles and wires have been excised from this scene so as not to detract from what was a handsome locomotive. CAI stands for *Complejo Agro Industrial*, though each mill was more commonly known as a *Central*.

8. Finale

I t's impossible to cover all the countries visited in the last forty years. The aim of this book has been to concentrate on parts of the world which have been personal favourites for steam photography. That said, this chapter features some other places which have given more than the usual amount of pleasure because of a particular locomotive or the general scene. Let's start with South America. Patagonia was a long way to go to find real steam but well worth the effort. Now no more than a tourist operation, the 750mm line from Ingeniero Jacobacci to Esquel in Argentina, immortalised by Paul Theroux in the *Old Patagonian Express*, was still a real railway in December 1992. True, there was only one train a week each way. But what a journey – 250 miles through rugged scenery – and with a dining car which served steaks and chips accompanied by red wine.

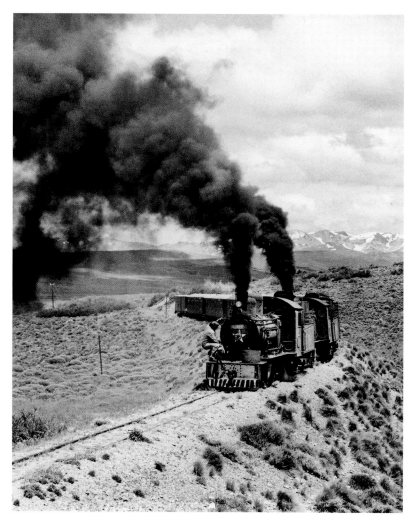

The train from Esquel was photographed near El Mayoco … and again near El Maiten (next page, top). The locos were 2-8-2s built by Henschel in 1922. No. 114 was leading. I failed to make a note of the second engine's number.

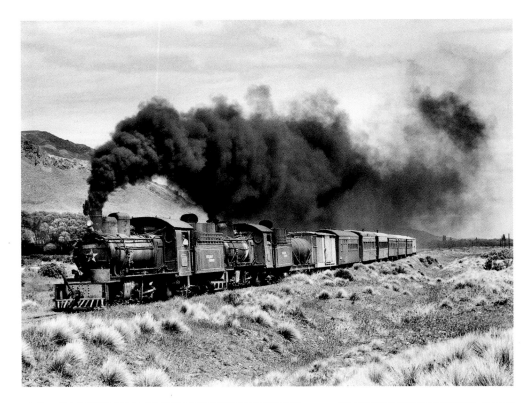

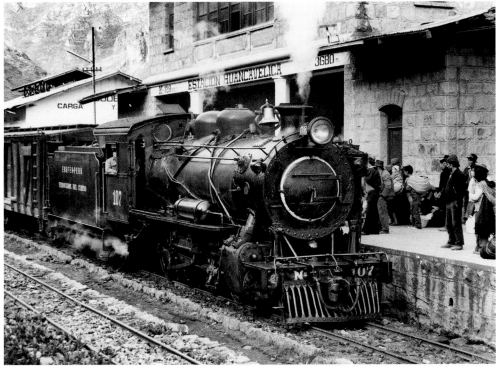

In December 1981 the 3ft gauge railway from Huancayo to Huancavelica high in the Peruvian Andes still saw steam – just. 2-8-0 no. 107 came from the British firm of Hunslet in 1936. She was photographed pulling the stock of the daily mixed into Huancavelica ready for the journey to Huancayo. '3680m and 128km' said the station nameboard. That meant just over 12,000ft above sea level and almost 80 miles from Huancayo. To quote *World of South American Steam*: 'into those miles are packed all the requisites for a great mountain railway route with narrow gorges, swirling river torrents, tunnels and bridges, steep grades and rattling descents.' It was an exhilarating ride.

Paraguay was memorable for demonstrating the frustrations of steam photography. Cancelled flights, long bus journeys over dirt roads, locos running out of steam, derailed trains, tropical heat, high humidity, and hotels with no air-con were just some of the difficulties encountered during two visits. That's right, two – because for all the problems, there was a fascination about a railway on the verge of dereliction and 100 per cent steam to boot. The mainline, if it could be called that, ran from the capital Asuncion to the country's southern border with Argentina. Roughly halfway was San Salvador, where no. 60 was photographed in December 1992. She was built by the North British Locomotive Company in 1910 and, like all of Paraguay's locos, was a wood burner.

To return to the theme of dramatic scenery, the railway from Durango to Silverton in Colorado, USA must be in anyone's top ten of spectacular train rides. Originally part of the extensive 3ft gauge Denver and Rio Grande system built to tap the mineral wealth of the Rocky Mountains south and west of Denver, the line runs 45 miles, much of the way making use of the Animas River gorge. The Rio Grande described itself as the 'scenic line of the world'. Whilst we Brits may dismiss this as typical American hyperbole, one has to admit that the scenery is pretty good.

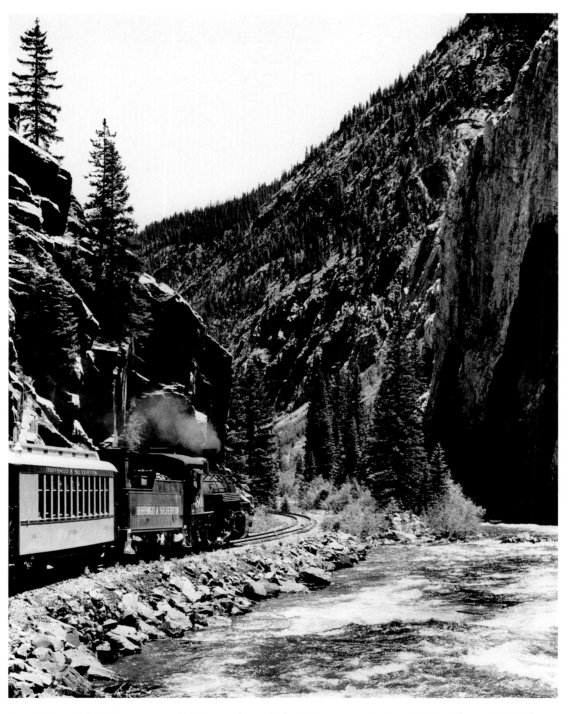

A train bound for Durango wended its way through the Animas gorge in June 1990 with no. 480 in charge – a rare photo-out-of-the-window success.

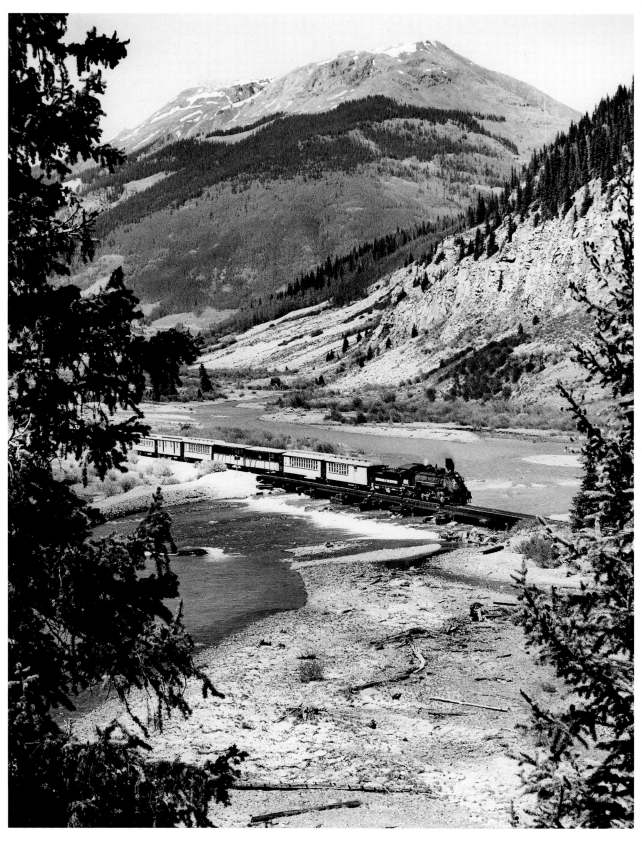

Shortly after leaving Silverton, trains cross the Animas River at the head of the gorge. In early summer there was still snow on the mountain tops.

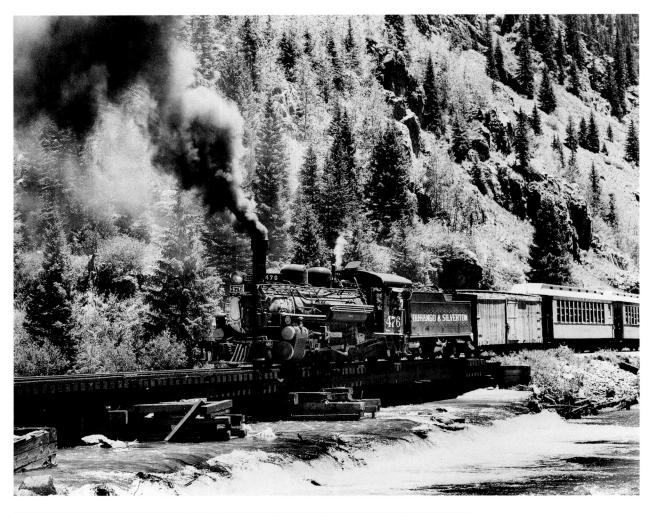

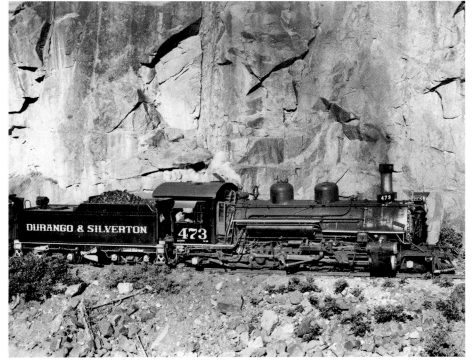

The same bridge from
ground level. These days this
railway is purely a tourist
operation but it's none
the worse for that. Here is
American railroading as
in the heyday of steam. To
British eyes the locomotives
may not be beautiful but they
are the real thing. Moreover,
as Silverton is some 2,700ft
higher than Durango, they
have to work hard. As
'museum' operations go, it's
up there with the best. Nos
476 (above) and 473 (left)
were in a batch of 2-8-2s
supplied by the American
Locomotive Company to
the Rio Grande in 1923. The
broadside view below was
taken near Rockwood.

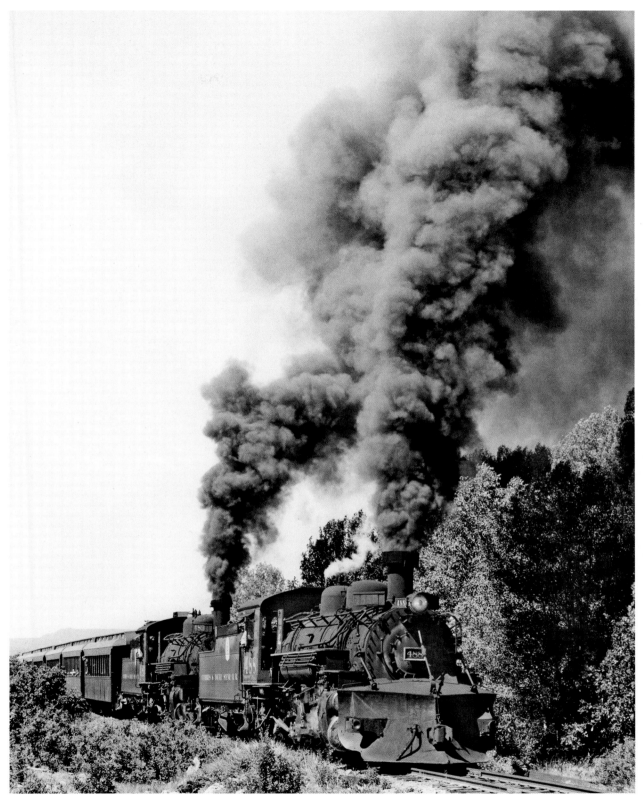

Another preserved section of the former Denver and Rio Grande 3ft gauge system runs from Chama, New Mexico to Antonio, Colorado, a distance of 64 miles. Reaching a summit of 10,015ft above sea level, this line is noted for its severe gradients. Trains are therefore often double-headed, as in this June 1990 photograph of the morning departure from Chama. The sound of the two locos could be heard a mile away.

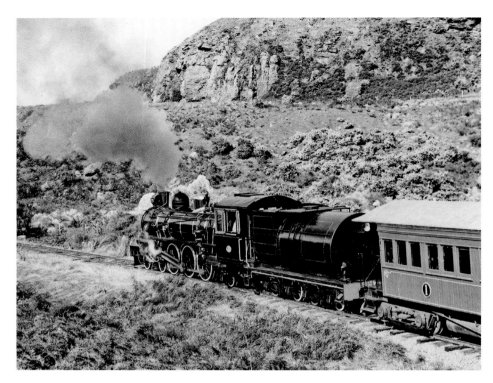

New Zealand too can boast about its scenery – everything from sub-tropical beaches in the north to glaciers in the south. Photos of the heritage railway affectionately known as the Kingston Flyer have appeared in previous books, but I can't resist another as the Class Ab Pacific no. 778 (above) is, at least for me, a most handsome machine. In October 1991 she was used for a special train chartered by half a dozen photographers, and I had the pleasure of riding in the cab with the driver. New Zealand's government-owned railways (3ft 6in gauge) had their own workshops where no. 778 was built in 1925.

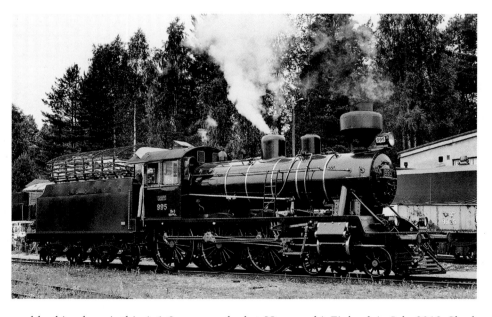

Another very good looking loco is this 4-6-0 seen on shed at Haapamaki, Finland, in July 2013. She has two features which are unusual, at least to British eyes. First, she runs on the Finnish standard gauge which, at 5ft, is the same as Russia's. Second, she burns wood, producing a lovely aroma very different to that from a coal or oil-burner. Class Hv3 no. 995 was built at the Lokomo workshops in Tampere, Finland in 1941. Until recently, Scandinavia has not featured on the radar, but as real steam disappears from its last strongholds in China, preserved steam in countries not previously visited looks increasingly attractive.

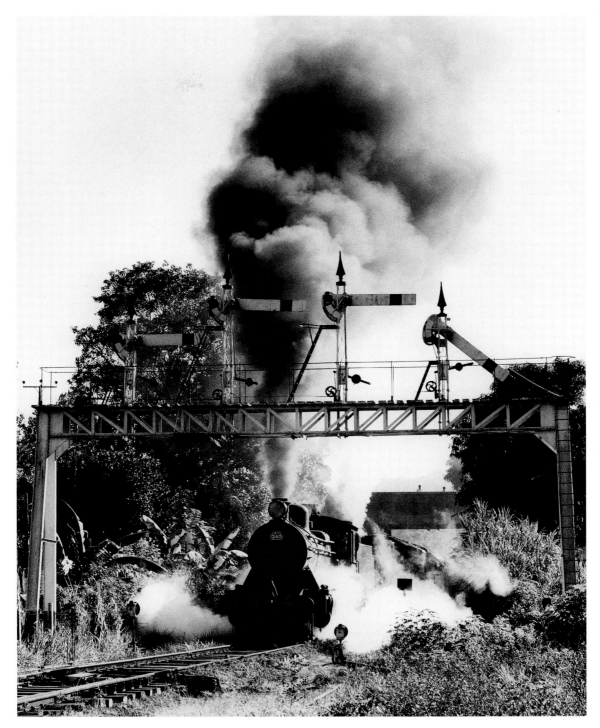

This photo is here for one reason, and one reason only – the signals. In GWR fashion they go down rather than up. But don't be fooled. The location is far away from God's Wonderful Railway. It's Sri Lanka. Peradeniya Junction to be precise, where in February 1994 a train from Kandy was about to take the line to Badulla. In the course of its journey, it stopped at Great Western, a station which served a tea plantation of that name. With Hugh Ballantyne as leader, a week of steam in lush tropical countryside amongst the friendly local people made for a very pleasant trip. A particular memory is of an exciting night-time footplate ride on an uphill route which included tunnels. I needed a wash after that. But first we had to be taken by bus to our hotel in Nurwara Eliya, a hill station with mock-Tudor architecture so liked by the British in colonial times. The clock at the front of the bus showed 1013. '*County of Dorset*, for those of the true faith,' said Hugh, who loved all things GWR.

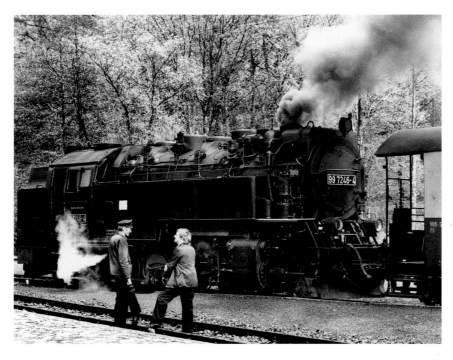

How have I so far managed to avoid mentioning Germany? At this distance in time, it's easy to forget just how much steam was there in the early 1970s. Indeed, after mainline steam finished in the UK in 1968, West Germany became popular with railway photographers. Real steam in Communist East Germany lasted even longer, well into the 1980s. Post-unification it still survives on a goodly number of narrow-gauge lines, though it has to be said this now owes much to tourism. A week in the East before the fall of the Iron Curtain, provided steam on both standard and metre gauges. To cope with severe gradients, 1 in 30 being not uncommon, the metre gauge Harzquerbahn has a fleet of massive 2-10-2 tanks, most built in the mid-1950s. No. 99.7246-4 paused at Ilfeld with a train from Nordhausen to Wernigerode in May 1986. To ride on the open balcony of the first coach was a thrilling experience, especially when the loco was working uphill bunker-first on a wet rail.

There's something fascinating about a full-size railway running through a street. One reason for this may be boyhood memories of the Channel Islands boat trains inching their way along the quayside at Weymouth. Trams and docks aside, street-running in the UK was rare. Perhaps that's why it has been fun to come across places where this still happened. On the outskirts of Amman, the capital of Jordan, a specially chartered train was photographed in September 2008. The loco is a 2-8-2 constructed by the British firm of Robert Stephenson & Hawthorn in 1951.

10.00	14.00	18.30	ab	Steyr Lokalbahn	an	09.30	13.00	18.00
10.06	14.06	18.35		Unterhimmel-Christkindl		09.24	12.54	17.54
[10.12]	[14.12]	[18.40]		Schloss Rosenegg		[09.18]	[12.48]	[17.48]
[10.18]	[14.18]	[18.45]		Pergern		[09.12]	[12.42]	[17.42]
[10.26]	[14.26]	[18.52]		Neuzeug		[09.04]	[12.34]	[17.34]
[10.31]	[14.31]	[18.56]		Letten		[08.59]	[12.29]	[17.29]
10.37	14.37	19.01		Aschach an der Steyr		08.53	12.23	17.23
[10.45]	[14.45]	[19.09]		Sommerhubermühle		[08.43]	[12.15]	[17.16]
[10.54]	[14.54]	[19.18]		Waldneukirchen		[08.35]	[12.06]	[17.06]
11.00	15.00	19.23	an	Grünburg	ab	08.30	12.00	17.00

As recounted in Chapter 2, my first experience of overseas steam, in February 1974, included the narrow-gauge Steyrtalbahn in Austria. At that time, the line was a fully operational railway carrying both freight and passengers and was 100 per cent steam. Now a *museumsbahn*, the railway runs trains on summer weekends and in the Christmas period, over a 12-mile section of the original route between Steyr and Grünburg. The 2014 timetable makes an interesting comparison to that for 1974 on page 9.

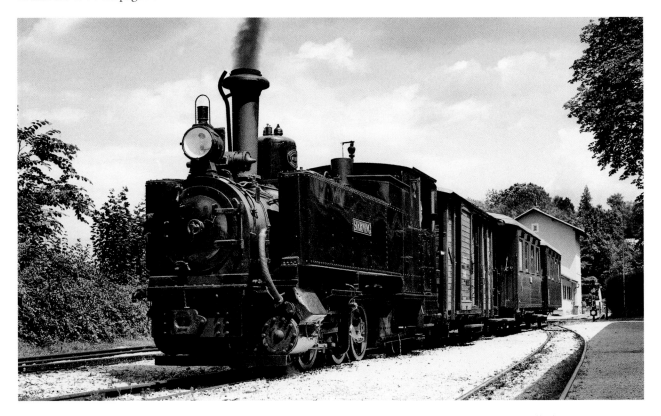

The fortieth anniversary of that first overseas trip was marked by a return visit to the Steyrtalbahn in June 2014. To celebrate in style, I chartered a train to replicate one of the trains in which I had travelled in 1974. The only passengers were my wife and myself, plus the railway's General Manager. The whole railway was at our disposal for an afternoon, there being no other trains on the line. With the co-operation of the footplate crew, there were photo stops and run-pasts galore – so many in fact that it took us four hours to cover the 12 miles. The train, seen above prior to departure from Steyr, was headed by loco no. 2 *Sierning*, built for the opening of the railway in 1889. She has already appeared on page 10 of this book when in 2004 she carried her former Austrian State railways number, 298-102.

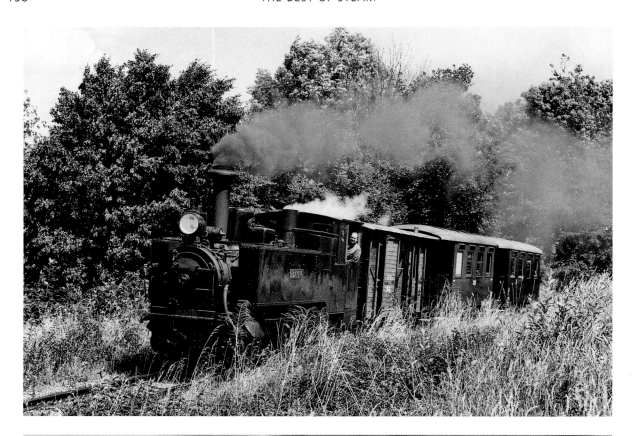

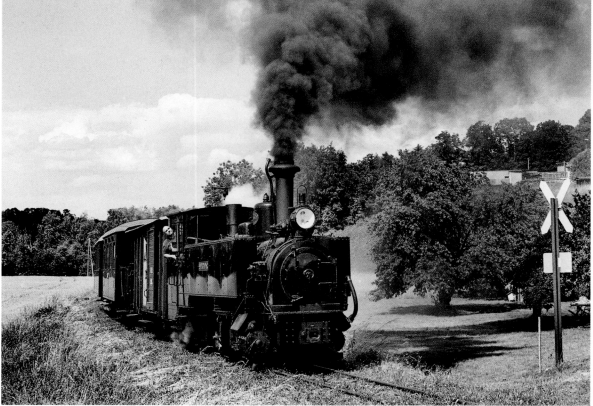

Three of the many run-pasts were near Unterhimmel–Christkindl (top), approaching Neuzeug (bottom) and arriving at the wayside station of Sommerhubermühle (opposite top).

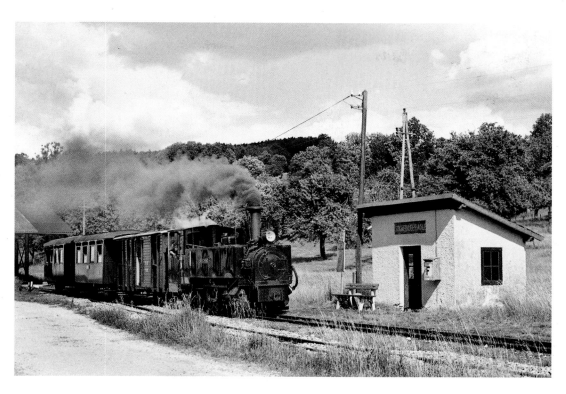

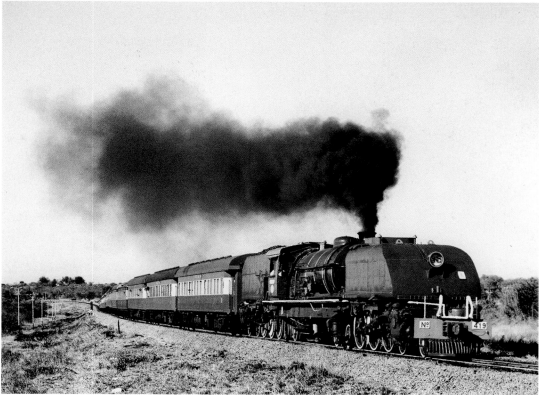

From A to Z – from the charm of Austria's narrow gauge to the might of Zimbabwe's steam giants. The reminiscences in this book started in Zimbabwe with loco no. 1 (on page 7), so it's appropriate to end there as a reminder of the days when steam ruled the world's railways. In July 1989 there was a once-a-week international passenger service from Bulawayo to Johannesburg which was steam-hauled as far as the border town of Plumtree. In this photograph, Class 15A no. 419 was in charge of the train.

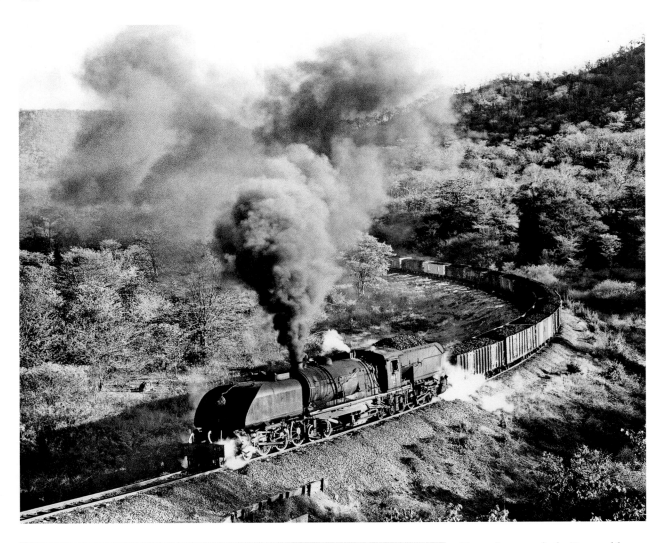

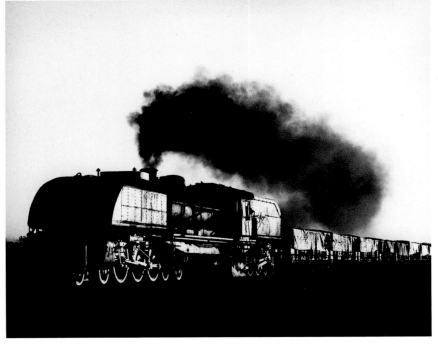

From dawn to dusk. On a cold winter's morning in July 1989, no. 415 presented a stirring sight and sound as she strained to lift a heavy coal train around the horseshoe curve at Hwange (above). The last rays of the setting sun caught no. 424 (left) as she stormed through Sandown with a freight train from Plumtree to Bulawayo.